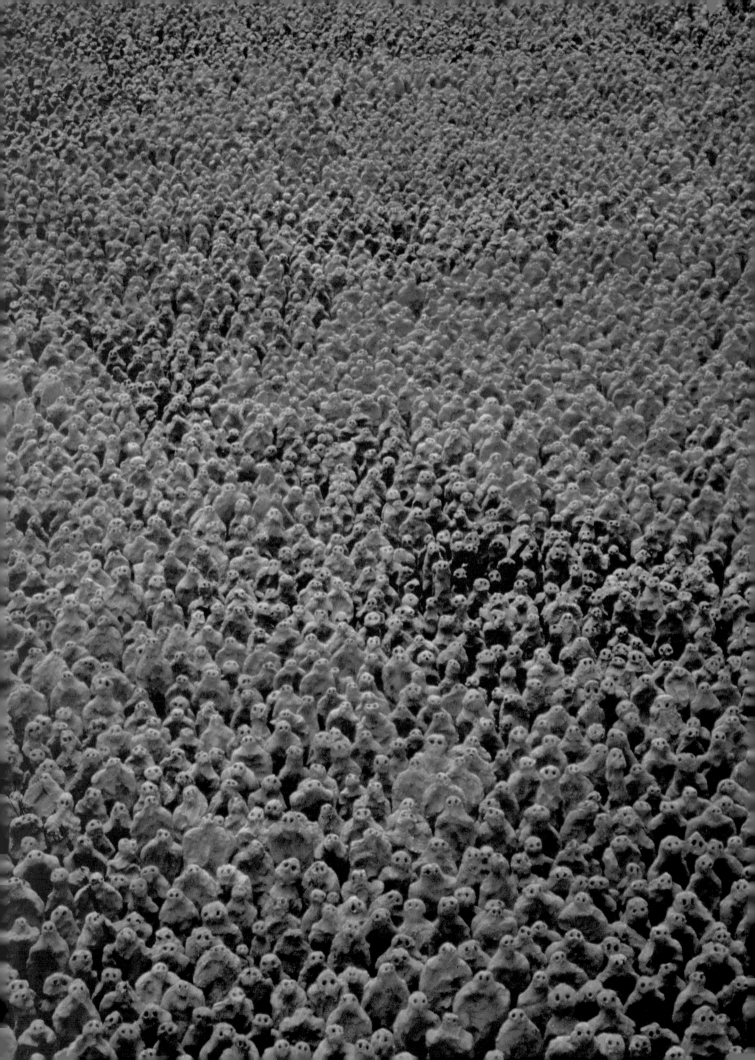

McDONALD INSTITUTE MONOGRAPHS

Substance, Memory, Display
Archaeology and Art

Edited by Colin Renfrew, Chris Gosden &
Elizabeth DeMarrais

Published by:

McDonald Institute for Archaeological Research
University of Cambridge
Downing Street
Cambridge, UK
CB2 3ER
(0)(1223) 339336 (Publication Office)
(0)(1223) 333538 (General Office)
(0)(1223) 333536 (Fax)
www.mcdonald.cam.ac.uk

Distributed by Oxbow Books
 United Kingdom: Oxbow Books, Park End Place, Oxford, OX1 1HN, UK.
 Tel: (0)(1865) 241249; Fax: (0)(1865) 794449; http://www.oxbowbooks.com/
 USA: The David Brown Book Company, P.O. Box 511, Oakville, CT 06779, USA.
 Tel: 860-945-9329; Fax: 860-945-9468

ISBN: 1-902937-24-4
ISSN: 1363-1349

Edited for the Institute by Chris Scarre (*Series Editor*) and Dora A. Kemp (*Production Editor*).

Cover illustration: *Trench 10* (detail) by Simon Callery.
Frontispiece: *Field for the British Isles* by Antony Gormley.

Printed and bound by Short Run Press, Bittern Rd, Sowton Industrial Estate, Exeter, EX2 7LW, UK.

Contents

Contributors vi

Chapter 1 Introduction: art as archaeology and archaeology as art
COLIN RENFREW, CHRIS GOSDEN & ELIZABETH DEMARRAIS 1

Chapter 2 Art for archaeology
COLIN RENFREW 7

Chapter 3 Making and display: our aesthetic appreciation of things and objects
CHRIS GOSDEN 35

Chapter 4 The art of decay and the transformation of substance
JOSHUA POLLARD 47

Chapter 5 Segsbury Project: art from excavation
SIMON CALLERY 63

Chapter 6 Making space for monuments: notes on the representation of experience
AARON WATSON 79

Chapter 7 **The pot, the flint and the bone** and *House Beautiful*
ANWEN COOPER, DUNCAN GARROW, MARK KNIGHT & LESLEY MCFADYEN 97

Chapter 8 Unearthing displacement: Surrealism and the 'archaeology' of Paul Nash
CHRISTOPHER EVANS 103

Chapter 9 Art of war: engaging the contested object
NICHOLAS J. SAUNDERS 119

Chapter 10 Art as process
ANTONY GORMLEY 131

Chapter 11 Contemporary Western art and archaeology
STEVEN MITHEN 153

Illustration sources 169

Contributors

Simon Callery
41 Senrab Street, London, E1 OQF, UK.
Email: callery@madasafish.com

Anwen Cooper
Cambridge Archaeological Unit, Department of
Archaeology, University of Cambridge,
Downing Street, Cambridge, CB2 3DZ, UK.
Email: ajc1011@cam.ac.uk

Elizabeth DeMarrais
Department of Archaeology, University of
Cambridge, Downing Street, Cambridge,
CB2 3DZ, UK.
Email: ed226@cam.ac.uk

Christopher Evans
Department of Archaeology, University of
Cambridge, Downing Street, Cambridge,
CB2 3DZ, UK.
Email: cje30@cam.ac.uk

Duncan Garrow
Department of Archaeology, University of
Cambridge, Downing Street, Cambridge,
CB2 3DZ, UK.
Email: djg1003@cam.ac.uk

Antony Gormley
15–23 Vale Royal, London, N7 9AP, UK.
Email: ag@antonygormley.com

Chris Gosden
Pitt-Rivers Museum, University of Oxford,
South Parks Road, Oxford, OX1 3PP, UK.
Email: chris.gosden@pitt-rivers-
museum.oxford.ac.uk

Mark Knight
Cambridge Archaeological Unit, Department of
Archaeology, University of Cambridge,
Downing Street, Cambridge, CB2 3DZ, UK.
Email: mk226@cam.ac.uk

Lesley McFadyen
McDonald Institute for Archaeological Research,
Downing Street, Cambridge, CB2 3ER, UK.
Email: lm10012@cam.ac.uk

Steven Mithen
Department of Archaeology, University of
Reading, Whiteknights, Reading, RG6 6AB, UK.
Email: s.j.mithen@reading.ac.uk

Joshua Pollard
Department of Archaeology, 43 Woodland Road,
Bristol, BS8 1UU, UK.
Email: Joshua.Pollard@bris.ac.uk

Colin Renfrew
McDonald Institute for Archaeological Research,
Downing Street, Cambridge, CB2 3ER, UK.
Email: des25@cam.ac.uk

Nicholas J. Saunders
Reader in Material Culture, Department of
Anthropology, University College London,
Gower Street, London, WC1E 6BT, UK.
Email: nicholas.saunders@ucl.ac.uk

Aaron Watson
Department of Archaeology, University of
Reading, Whiteknights, Reading, RG6 6AB, UK.
Email: a.j.watson@reading.ac.uk

Introduction: art as archaeology and archaeology as art

Colin Renfrew, Chris Gosden & Elizabeth DeMarrais

Contemporary art and archaeology seem of increasing relevance today: each undertaking is relevant to the other. In the papers which follow, aspects of that relevance, and of the interactions between the two activities, are discussed. It is our hope that these contributions will encourage additional work and widening reflection which may further help to explore the ways in which contemporary art can broaden the thinking and the creative imagination of the archaeologist who is seeking to obtain a better understanding of the human past. These papers may, in addition, prove to be of interest to artists who, as Simon Callery and Antony Gormley reveal here and indeed, like Paul Nash more than half a century ago, have been influenced by the practices of archaeology and by the material record of the past.

The original intention of two of the editors (Gosden and Renfrew) had been to hold a Symposium on the theme 'Art as Archaeology and Archaeology as Art' in order to explore these relationships. As it happened, however, a Symposium with rather different objectives on the theme 'Rethinking Materiality: the Engagement of Mind with the Material World' was also being planned by DeMarrais and Renfrew, arising in part from their experience in teaching together a course on this topic. We all felt on reflection that the two themes were sufficiently close in their perspectives and in their subject areas to allow us profitably to collaborate in running the two symposia together sequentially. The participants in both could thus be involved throughout. The two symposia were therefore held over four days, 28–31 March 2003. The intention has always been to produce two separate volumes arising from the meeting: the second of these is currently in press (DeMarrais *et al.* in press). The first is presented here.

It should be understood that the emphasis here, along with a consideration of archaeology today, is upon contemporary or at least modern art, rather than on the art of more ancient times. It carries with it the awareness that the practices of the contemporary artist, involving fresh approaches to the uses of materials and to the notion of display, may be instructive to the archaeologist who strives to understand such practices in much earlier times. As Renfrew

points out in the introductory paper which follows, the notion of 'art' as understood in the post-Renaissance western world as the creation of professional artists working for connoisseurs cannot unproblematically be applied to the products of other cultures and other eras. In general the papers in this volume do not use the term as it might be employed in an atlas of 'world art', as simply to mean the use of pattern or of images to produce something that is visually interesting (see Onians 2004, 10). We have no reason to criticize the colloquial use of the term in that way. But we do see contemporary art as working usually with a much keener self-awareness, and with a more self-conscious appraisal of the undertaking. Such a perception arises directly from the exalted notion of the artist as genius which culminated in the High Renaissance, and is in part a reaction against it. That self-critical appraisal is as much a feature of the 'modern' era of the early twentieth century, with artists such as Marcel Duchamp or with the self-conscious (indeed sometimes 'subconscious') products of Dada, as it is of 'post-modern' initiatives today. Our interest as archeologists is to see how the work of contemporary artists in all its rich variety can aid us in our own attempts to tackle the interpretive problems and to undertake the initiatives involved in gleaning information and understanding from the material cultures of past ages. Such aspirations as these underlie the introductory papers of Renfrew and of Gosden, as well as that of Pollard, and also the final remarks of Mithen.

Substance, as it appears in the volume's title, refers to the material nature of all works in the field of the visual arts, at least until the de-materialization associated with recent conceptual art (Lippard 1973; Renfrew 2003, 185). It refers equally to the material culture which forms the starting point for the archaeological endeavour. As such it is central to the focus of the sister volume *Rethinking Materiality* (DeMarrais *et al.* in press). In a different way it is central also to the paper, contributed here by Pollard, who deals in particular with the instability of some substances and with the formation of the archaeological record. His concern is with the notion of transience: 'focusing on the transformation of objects and materials through the processes of attrition, decay, mutation and metamorphosis'. This brings him into contact with the work of a number of contemporary artists, including that of Cornelia Parker, discussed here at greater length in the paper by Renfrew.

Memory is central to all coherent thought, and both produces and is produced by material culture. Personal experience and shared narrative are essential components, for it is doubtful whether memory can be derived from material culture in isolation. Many of the developments in contemporary archaeology, from the renewed interest in landscape archaeology (Edmonds

1.1 Substance: *Monsieur Plume with Creases in his Trousers (Portrait of Henri Michaux)* (1947) by Jean Dubuffet.

1991) to the recovery of the social lives of artefacts (Appadurai 1986; Gell 1998) are founded upon the mnemonic powers of material things. This has been an important theme in recent ethnography also (e.g. Roberts & Roberts 1996). It underlies the preoccupations of a number of papers here, notably that of Evans. For memory is implicit in most art, not least in that of the Surrealists, where remembrance and the subconscious world interpenetrate.

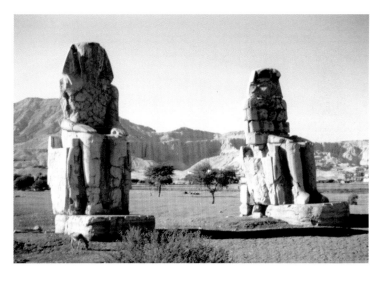

Display is an integral component of the consumption of contemporary art and hence of its production. Indeed since the time of artists such as Duchamp or Beuys it has been seen to serve almost as a definition of art, so that an art gallery or art museum is now a place where art is generated as well as curated (McShine 1999; Putnam 2001). But of course the art gallery and the archaeological museum stand side by side. The very origins of archaeology are associated with those of academic display and with the Renaissance cabinet of curiosities (Schnapp 1996). These are matters which are touched upon in the paper by Gosden. But he takes the matter further by dealing with display not just in the contexts of contemporary art and archaeology but also in ancient times, from the Romans back to the prehistoric period. These three concepts, of substance, memory and display, highlight some of the issues which are of relevance simultaneously to the contemporary artist and to the archaeologist of today.

We are particularly pleased to be able to include in this volume two papers

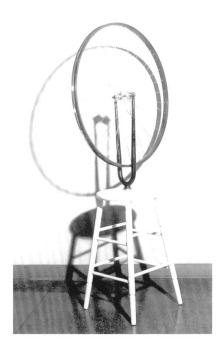

by practising artists who are certainly not also professional archaeologists. The contributions by Callery and by Gormley perhaps give us the other side of the coin, revealing interests and concerns which are not quite those of the archaeologist, despite the common ground. Simon Callery's account of the way his encounters with the practice of archaeology and with the physicality of the chalk landscape have changed his own approach to the artistic endeavour is of particular interest. Through his work, and also from this account, archaeologists may come to feel a new degree of awareness of some of the experiences which they themselves undergo during the course of excavation.

1.2 Memory: Two colossal statues of Amenophis III, Thebes, Egypt.

1.3 Display: *Bicycle Wheel* (1913) by Marcel Duchamp.

It gives us further ground, moreover, for speculation as to how those constructing monuments in very much earlier times may have experienced their own activity. Antony Gormley's informal account of the development of his own work likewise touches in many ways upon the interests of the archaeologist. Above all it is his sustained meditation upon the body and on the condition of embodiment which offers a starting point for anyone concerned with the human condition. In this case the notion of substance relates first to corporeal materiality, and to the space which the form and volume of the body defines and which it occupies. He has also been concerned with processes of becoming, with the experience of learning to use the senses and the mind. And as he observes: 'Art is not a noun: it's a verb, it's a process'. The discussion which followed his talk, recorded here, indicates the diverse lines of thought which his images and his observations generated.

The brief contribution by Anwen Cooper, Duncan Garrow, Mark Knight and Lesley McFadyen, illustrating images from their animations, likewise relates to the actual *praxis* of working with materials, in this case using the techniques of the archaeologist. Although the animations to which they refer are in part a lighthearted comment upon stereotyped conventions of archaeological interpretation, they go much further. By investigating the digging process of the archaeologist through the activity of doing more digging, their procedures bear comparison with those of contemporary artists like Cornelia Parker or Simon Callery. Their originality lies in their exploring the nature of the archaeological process of excavation and of the conventions of archaeological explanation using exemplification rather than verbal analysis.

Aaron Watson is likewise actively concerned in exploring the implications of the archaeological undertaking. His emphasis, however, is less upon the practice of the excavation process than on the task of recording what we see and what we experience when we attempt to record, describe or transcribe the reality of an ancient site or monument. As he shows clearly with his graphic illustrations the representation of experience is a dauntingly complex task. At a first reading 'the representation of experience' may be taken to refer to the work of the archaeological draughtsman endeavouring to give an account of a site or monument through plans, elevations and photographs. But of course the same expression, 'the representation of experience' could readily be taken as a definition of the intentions of the artist.

Chris Evans has different intentions in his examination of one of the most interesting British artists from the earlier half of the twentieth century. It can certainly be argued that the work of Paul Nash, like that of his contemporary John Piper, played a key role in developing a somewhat romantic view of the English landscape. Interest in the field monuments of Britain goes back, of course a long way, to the roots of British antiquarianism. But, as Evans shows, it was in the 1930s that a much broader interest developed in the field monuments of the English countryside, influenced by approaches such as that

of Nash. Anticipated by the druidical romanticism of Stukeley in the eighteenth century, this interest flourished between the wars, encouraged by Nash and his contemporaries, and then found new directions after the Second World War, when contemporary artists in Britain and the United States turned again to such monuments for inspiration, with initiatives which have rather loosely been described together as 'Land Art' (see Lippard 1983).

Trench art, produced during the First World War offers a different series of insights, as Nicholas Saunders shows. The context is the special one of the front line during the Great War. The material characteristic is the process of re-cycling, which gives the subject a particular allure to the archaeologist. Again, in most cases, this is anonymous art, like so many of the products of the archaeological record, in contrast to the contemporary art discussed elsewhere in this volume.

In his concluding remarks Steven Mithen relates how for him, as for many of the contributors here, experience of contemporary art has had an important role in forming his view of the past and hence in shaping his development as an archaeologist. But at the same time he aspires, as do many of us, to 'objective knowledge', however remote that goal may remain. Archaeology and contemporary art may be parallel undertakings, as we have been exploring. But they are not often the same thing. It could be a mistake to imagine that they are.

Acknowledgements

The participants in the amalgamated symposium were: Manuel Arroyo-Kalin, Laura Basel, Nicole Boivin, Katie Boyle, Richard Bradley, Elizabeth Brumfiel, Simon Callery, John Clark, George Cowgill, Elizabeth DeMarrais, Timothy Earle, Chris Evans, Clive Gamble, Duncan Garrow, Antony Gormley, Chris Gosden, Peter Gow (paper *in absentia*), Lotte Hedeagar, Mary Helms, Lila Janik, Niels Johannsen, Andrew Jones, Dora Kemp, Carl Knappett, Sheila Kohring, Kristian Kristiansen, Susan Kus, Lambros Malafouris, Lynn Meskell, Robin Osborne, Steven Mithen, Joshua Pollard, Colin Renfrew, John Robb, Mike Rowlands (paper *in absentia*), Nicholas Saunders, Chris Scarre, Marie-Louise Sørensen, Fraser Sturt, Trevor Watkins (paper *in absentia*), Aaron Watson, David Wengrow.

The practical aspects of the Symposium were in the capable hands of Dr Katie Boyle, to whom we are very grateful both for her efficient organization and for her subsequent editorial work upon the papers. We are greatly indebted also to the McDonald Institute's Production Editor, Dora Kemp, for her considerable care in the production of the volume, not least in her attention to the illustrations. Our thanks for assistance in the compilation of illustrations go to the authors of the papers and to others who have supplied images or authorized reproduction, as acknowledged below. We thank Manuel Arroyo-Kalin for his assistance during the Symposium. We are indebted to the British Academy for a conference grant for the Symposium and to the Management Committee of the McDonald Institute for their financial support both for the Symposium and for its publication here.

References

Appadurai, A. (ed.), 1986. *The Social Life of Things: Commodities in Cultural Perspective.* Cambridge: Cambridge University Press.

DeMarrais, E., C. Gosden & C. Renfrew (eds.), in press. *Rethinking Materiality: the Engagement of Mind with the Material World.* (McDonald Institute Monographs.) Cambridge: McDonald Institute for Archaeological Research.

Edmonds, M.R., 1991. *Ancestral Geographies of the Neolithic: Landscapes, Monuments and Memory.* London: Routledge.

Gell, A., 1998. *Art and Agency: an Anthropological Theory.* Oxford: Oxford University Press.

Lippard, L.R., 1973. *Six Years: the Dematerialization of the Art Object from 1966 to 1972.* New York (NY): Praeger.

Lippard, L.R., 1983. *Overlay: Contemporary Art and the Art of Prehistory.* New York (NY): Pantheon Books.

McShine, K., 1999. *The Museum as Muse: Artists Reflect.* New York (NY): Museum of Modern Art.

Onians, J. (ed.), 2004. *Atlas of World Art.* London: Laurence King Publishing.

Putnam, J., 2001. *Art and Artifact: the Museum as Medium.* London: Thames and Hudson.

Renfrew, C., 2003. *Figuring It Out: the Parallel Visions of Artists and Archaeologists.* London: Thames and Hudson.

Roberts, M.N. & A.F. Roberts, 1996. *Memory: Luba Art and the Making of History.* Washington (DC): Museum of African Art.

Schnapp, A., 1996. *Discovering the Past.* London: British Museum Press.

Art for archaeology

Colin Renfrew

Over the past century the contemporary visual arts of the Western world have transformed themselves. They have transcended their traditional preoccupation with accurate visual representation and with beauty and have embarked upon a direction that is much more radical. Today the visual arts have transformed themselves into what might be described as a vast, uncoordinated yet somehow enormously effective research programme that looks critically at what we are and how we know what we are — at the foundations of knowledge and perception, and of the structures that modern societies have chosen to construct upon these foundations. Artists do this through their engagement with the material world and in this respect they have much in common not only with archaeologists, whose approach to the past is mediated by such an engagement, but also with the societies and actors of earlier times who have themselves brought about changes in their condition through their engagement with the world. As a recent symposium on Materiality has sought to investigate (DeMarrais *et al.* in press), it is through different kinds of knowledgeable engagement between human societies and the material world, engagement which has its cognitive as well as its physical aspects, that long-term social change as well as technological change comes about in human societies.

In this paper the focus is upon the visual arts as a source of insight for the archaeologist. For that ongoing research programme in the contemporary arts has, I shall argue, much to offer us as archaeologists in our attempts to grasp an understanding at what was happening in earlier periods, to understand the processes that made possible new social orders and new ways of living. The approach of Engagement Theory (Renfrew 2001a; Renfrew in press; Malafouris in press), with its emphasis upon materiality, is a promising one for the archaeologist, precisely because our subject matter is inherently material. What we find, what comes down to us from the past, does so in material form. Materiality is an enduring condition. It is a condition about which the visual arts, with the variety and ingenuity of their explorations, have much to teach us.

Moreover it is clear that one of the most significant of human capacities, in most or all cultures, is to ascribe values to material things. Human beings and human societies create categories of valuables, and recognize specific commodities as of particular social significance and worth. Thus in many

societies materials such as gold, or jade, or amber come to be regarded as particularly suited for some social and/or ritual function: they are seen as valuable (Renfrew 1986). The result is that these valuables do not simply stand for a particular quality or property: they embody it. Thus an object of a material which we in the modern world consider to have intrinsic value holds an inherent worth, which we tend to think of as more than conventional: its value is a palpable reality. That is what Marx (1886, 76–7) termed the 'fetishism' of commodities. In doing so he was making reference not only to the idols or 'fetishes' respected in the religious faiths of far off-lands but to religious beliefs nearer to home, where sanctity inheres in icons, in sacred relics or in consecrated things. He was referring also to the propensity of capitalist societies to convert the specific values and taboos of traditional societies into the generalized valuation assigned to the commodity. The visual arts, which work with the assignment of meaning to material things, may be able to offer us guidance when we seek to penetrate some of these mysteries of immanence and transubstantiation (Renfrew 2003).

That there is an interaction between archaeology, notably the monuments of prehistory, and the visual arts is not a new idea. Already, before the middle of the twentieth century, artists such as Paul Nash, Henry Moore and Barbara Hepworth were inspired by the earth monuments and standing stones of British prehistory (Beardsley 1984). Lucy Lippard (1983) was one of the first to examine the interaction systematically. Several exhibitions in recent years have drawn upon comparable relationships, including *From Art to Archaeology* at the South Bank Centre in London in 1991 (Chippindale 1991), *Excavating the Present* at Kettle's Yard, Cambridge in the same year (Esche & Palmer 1991), and *Time Machine* in the Egyptology Department at the British Museum in 1994 (Putnam & Davies 1994).

Often, moreover, it has been the findings of archaeology which have served to inspire the artist. In this paper the emphasis is in the other direction, and our aim is to use some of the experiences of contemporary art to expand the perceptions of the archaeologist.

Some clarifications

The term 'art' is open to misunderstanding. In this paper I am referring to the visual arts and will not be dealing with the arts of other senses, such as music. Moreover it is clear that the term 'art' in our own modern Western society, has come to mean an activity where the artist deliberately sets out to produce a product for a knowledgeable audience, and where the transaction between them usually has a commercial dimension (Gimpel 1969). I have recently attempted several more precise definitions of 'art' in this sense (Renfrew 2003), but none of them seems particularly satisfactory. In this paper the term 'art' is usually used in this specific and contemporary sense, implying Contemporary Western Art (CWA). Nor is the term intended to exclude

contemporary artists in the east or indeed elsewhere who are working today in the knowledge of the post-Renaissance aesthetic traditions and of the conventions of the contemporary West.

Such a definition does exclude the painting and the sculpture of periods prior to the Renaissance, although the Renaissance aesthetic had its roots in the classical worlds of Greece and Rome. For that reason I would prefer not to use such terms as 'prehistoric art' or 'early art', since the visual products of those times were evidently not produced within the very specific context of CWA. But, as a form of shorthand, the term Early Art (EA) may perhaps be used to refer to the sculpture, paintings and other figurative products of early (i.e. pre-Renaissance) societies. Its use does however imply, in the light of the preceding discussion, that the term 'Art' is not really a very suitable one for use in coherent discussion outside the field of Renaissance and Contemporary Western Art.

The same observations apply to what used to be termed 'primitive art' or ethnographic art. The formal qualities of much African and Polynesian sculpture came to be much admired in the early years of the twentieth century, not least by such early Modern masters as Picasso and Braque (Rubin 1984). The aesthetic understandings of their makers are, however, not often well understood today. It used to be assumed that there was something more direct, more authentic, perhaps even more instinctive about such productions, as the early enthusiasts for 'primitive' art were wont to explain, even when they were extolling its merits and sometimes for that reason rejecting the appellation 'primitive'. But while we may admire the product, there is no reason for us to think such work to be necessarily either more direct or simpler than our own. The sculptures, paintings and craft products of other societies were produced in a whole series of different contexts, working to different aesthetic conventions about which it is unwise to generalize (Price 2001). We should be careful, therefore, not to think of them as 'art' in our own contemporary sense (CWA), and if the term 'art' is to be used it should perhaps be qualified, for instance as Non-Western Art (NWA). But as Price (2001) rightly warns we should not make the assumption that Non-Western Art (NWA) is necessarily less knowing, less sophisticated in its approach or less reflexive than Contemporary Western Art, even if such may sometimes be the case.

In any event, I should make clear that the intention here of using the experience of art (CWA) to enrich our approach as archaeologists to the early past, is not primarily focused upon the sculpture and painting of earlier periods (EA), but seeks to survey the whole scope of their use of material culture. 'Art for archaeology' in the title above is intended to imply the potential of contemporary art (CWA) for broadening the whole scope of world archaeology: the study of the human past on the basis of the surviving material remains.

Dimensions of contemporary art

The description of the artistic endeavours of the contemporary West as

> what might be described as a vast, uncoordinated yet somehow enormously effective research programme that looks critically at what we are and how we know what we are — at the foundations of knowledge and perception and of the structures that modern societies have chosen to construct upon these foundations (Renfrew 2003, 7)

may give an unwarranted impression of coherence. Artists do their own thing and may well reject this assignment to an allotted place in a 'research programme' however uncoordinated. But archaeology also has its research programme, which again is not coordinated by any central national or supranational agency. Over the past half-century we have, for instance, learnt much more about the origins of food production worldwide, through well-focused programmes of research on different continents. No one has coordinated this research, but it has achieved a certain coherence through the independent scrutiny of the work of one researcher by another. That is how science works: results are published and assessed, and go on to influence the work of others. To some extent this is true also in the visual arts. Artists do not work in isolation, or rarely so, and their work soon becomes known through publication. It has been pointed out (for instance by Hopkins 2000, 172) that the *Double Negative* of Michael Heizer, or the *Lightning Field* of Walter De Maria or the *Spiral Jetty* of Robert Smithson (Plate 11.5: see Tiberghien 1995, 89–93; 220–23; and 261–3) have been seen by few of their contemporaries, being in inaccessible places (and the *Spiral Jetty* usually submerged under the waters of the Great Salt Lake), yet these are among the most influential works in what is sometimes termed Land Art.

That the work of one artist may in a sense be incompatible with that of another, working to different assumptions and preconditions, is not an obstacle. Each, in a different way, can broaden our approach to aspects of the early human past. Performance Art (Goldberg 1979) or Body Art may not be compatible with Minimalism or Conceptual Art (Godfrey 1998), but the archaeologist can learn from all of these. Pop Art (Lippard 1966) may rarely coincide in its preconceptions with Land Art (Tiberghien 1995), but both are among the most illuminating undertakings of the late twentieth century. It should be noted moreover that terms like 'Land Art' or 'Conceptual Art' are collective designations usually imposed by critics, which sometimes serve to confuse, by obscuring differences in approach, as much as they clarify.

To illustrate the very different kinds of insight which may be obtained from different artists it may be appropriate to refer briefly to the work of three contemporary British sculptors which, I believe, has much to offer the archaeologist of today. Since I have referred to all three in my recent *Figuring It Out* (Renfrew 2003) I shall make the reference here concise, and then conclude with a less abbreviated glimpse of the work of a fourth artist, potentially very influential for the archaeologist: Cornelia Parker.

Antony Gormley and the exploration of embodiment

Antony Gormley is perhaps best known in Britain for his *Angel of the North*, and for his *Field for the British Isles* (Plate 10.35), recently on display at the British Museum (Renfrew 2002). He has conducted a sustained analysis through his work utilizing his own body as the physical existence of all of us: of what it is to be embodied, to be at once imprisoned in our corporeal substance and yet seemingly to transcend some of the apparent limitations of such incarnation (see Gormley, this volume). For those of us concerned with the engagement process between the human individual and the material world, the work of Gormley can offer an appropriate starting point (Hutchinson *et al.* 1995; Gormley 2002a,b; Moszynska 2002). There is of course a vast philosophical literature on the human condition of embodiment on which one might draw, part of it sometimes adduced also in relation to the painting of Barnett Newman, which in a different way draws attention to the status and embodiment of the observer (Lewison 2002). Such reflections can lead easily along a philosophical path from the work of Immanuel Kant to the phenomenology of Merleau-Ponty (1962) or the existentialism of Sartre (1958). But it may not be necessary for the archaeologist to embark upon a formidable programme of philosophical research in order to confront some of the most relevant issues. For, in a way, the work of Gormley presents some of these in a graphic manner with all the immediacy of a physical presence.

For the archaeologist one of the most difficult issues is that of *becoming* human. With our own species *Homo sapiens sapiens* we may feel upon safe ground, able to assume that the 'hardware' is the same, that our own physical reality of corporeal embodiment is like that of the Upper Palaeolithic individuals under study — although perhaps that is an assumption which deserves to be questioned one day (Levinson 2002). But with our predecessors — *Australopithecus*, or *Homo erectus*, or indeed *Homo ergaster* (or whatever terminology our colleagues in biological anthropology care to offer us) — what was it like to be hominine? Were their corporeal capacities the same as ours? How long did it take the infant to reach maturity? Which bodily conditions of existence differed from those of their sapient successors, and indeed which mental capacities? How can we make inferences about behaviour in the Lower or Middle Palaeolithic if we do not have answers to some of these questions? These are issues which I believe are highlighted for us more effectively when we, as archaeologists, contemplate the work of Gormley.

Much of his work is a sustained examination of the human condition of incarnation, of being in the body, each in our own body. And some of his most interesting and evocative images evoke the origins of cognition, drawing attention to that still mysterious process, by which the human species achieved self-consciousness, understanding and the capacity to reason. I am thinking here of that remarkable series of sculptures, each using a cast from

his own body, with titles such as *Learning to Be* (1992: Plate 2.1; Renfrew 2003, 119); *Learning to See* (1993: Plate 10.30; Hutchinson *et al.* 1995, 33); *Learning to Think* (1991: Plate 10.32; Hutchinson *et al.* 1995, 38–9) and *Sound* (1986: Hutchinson *et al.* 1995, 80; Renfrew 2003, 122). Each of these may be said to evoke a cognitive aspect of being, and of becoming.

To speak in a facile manner of 'being' and 'becoming' risks obscurity or an unfulfilled aspiration toward profundity. But there is, in reality, a vast field here for the archaeologist to explore, which these remarkable sculptures serve to indicate or to signal. Archaeologists and philosophers of cognition have not yet dealt adequately with the implications of that interesting truism in biology and palaeontology that 'ontogeny recapitulates phylogeny'. For it is a familiar commonplace in the field of early learning that every baby born into the world with normal visual apparatus does indeed need to learn to see — to learn to distinguish objects with continuous existence, to situate these within a coherent spatial framework, to distinguish individual humans, to recognize different animal species and so forth. But how much of that visual learning process is encultured? To what extent does our experience of learning to see and to understand what we see depend upon the culture into which we are born, which is itself the product of a long-term (phylogenetic) process?

That question is more obviously complex in the context of *Learning to Think*. For learning to think is undoubtedly a shared, cultural process where the logics which we employ — of cause and effect, of inductive expectation (e.g. of the daily sunrise), of planning and of mind reading — are learnt socially rather than individually. Some of these logics may be learnt and absorbed situationally, by seeing how other people behave, and through mimesis. But for our own species they depend also upon language and upon concepts that are communicated verbally. So how did they develop in the early days of language, while the capacity to speak, or at least the agreed conventions of a particular speech (a specific language) were not yet fully and communally formulated? These are questions which may always be difficult to answer. But they underlie the very process of becoming human, in the phylogenetic sense of the origins of our species, *Homo sapiens*, and of the early developments of the complex behaviours and experiences (including self-consciousness or self-awareness) which we associate with it.

The sculpture *Learning to Be* (Plate 2.1), which uses the body of a grown man to evoke these early learning processes, promotes interesting reflections. For it is inherent in the human condition that we are born as small babies and that the early learning processes (of seeing, of being, of thinking) are associated with the very early years of growth from infancy (and small bodily size) to childhood. But it did not have to be that way: there are some species that emerge fully formed and fully grown and that have to 'learn to be' with bodies which do not significantly change in size. One can imagine, as that sculpture perhaps invites us to do, what it would be like to come into the

world already fully grown physically, and then to undergo the learning processes of the use of the body, of seeing, of walking, of thinking and of coping.

Such a notion is already present in the myth of the 'birth' of the Greek goddess Athena, who sprang, fully armed, from the head of Zeus. We see it strikingly enacted also in *Emergence*, a work produced in 2002 by the video artist Bill Viola as part of his series *The Passions* (Walsh 2003, 140–45), where a young man, fully grown, emerges with a flow of spilling water from a marble cistern. Although inspired by an early Renaissance *Pietà* or Entombment (Walsh 2003, 56), this is an Entombment in reverse which resembles also a Resurrection, which it is possible to see, as Viola has remarked, as a birth.

These remarkable sculptures bring to our attention these little-understood processes by which the early members of our species and their own ancestors had to come to terms with some of the realities of being, so that their understanding could be passed on to successive generations in the learning processes of infancy. They can remind us also that every one of us is born into the world with much the same physical and mental equipment as our Upper Palaeolithic ancestors. Modern molecular genetics suggests that the genetic basis (in terms of DNA) of our ancestors of 40,000 years ago may be very little different from that of ourselves. In that sense, as noted above, the hardware is the same. It is the software that is different. Our species has 'learnt to be' and 'learnt to think', along different trajectories of development, so that 'being' and 'thinking' and perhaps even 'seeing', for instance in the Pre-Columbian societies of Mesoamerica, was not at all the same as in contemporary societies in Europe or for their contemporaries in China. These are issues which we find difficult to address. Indeed it is often difficult for us to formulate the questions and to grasp adequately what the underlying issues are. The work of Gormley offers us some firsthand experiences, if we are inclined to respond to it, which sharpen our awareness of the underlying issues and which bring to the foreground the mysterious condition of existing as corporate beings whose very terms of existence are governed by that corporeality.

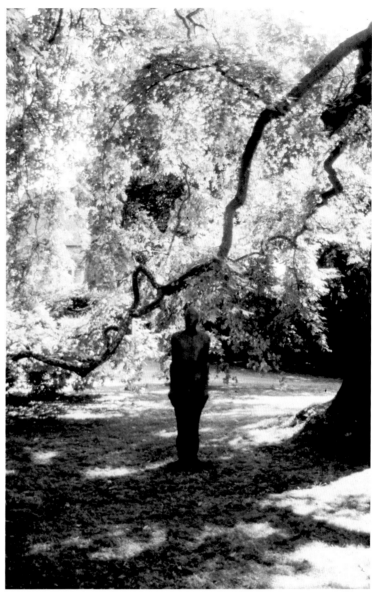

2.1 *Learning to Be* (1992) by Antony Gormley in the grounds of Jesus College, Cambridge.

Richard Long, marking and the construction of memory

Turning now to Richard Long, we are confronted with a whole series of different issues. In Richard Long's work we do not, in general, see the human form. Handprints and a few footprints are as close as we get. What we do see are images of interventions in the landscape, often in distant places (Fuchs 1986; Seymour 1991; Long *et al.* 2002). These discreet changes — a line of stones re-arranged from those found nearby, a circle of powdered snow, a splash of water on the dry rock face — offer much to interest the archaeologist (Renfrew 1990). For in some cases what Long has undertaken is akin to the creation of a monument. Such is not entirely his intention: his fundamental activity is walking. Each work he produces is a record of a walk undertaken. But all of his work is, in a sense, about the leaving of traces. Every one of his works is a record, and in some senses a physical record, of his presence in the places experienced in the course of a walk.

Moreover, in a remarkable way, his work invites us to share personally some of the experiences of the walk. From the material documents offered — the photograph, or the installation in the gallery — we come to feel something of what he has felt, and the walk and the places he evokes take on a certain reality for us. What I have found is that this experience of the work of Richard Long has sharpened my senses and my awareness, so that when I now contemplate a monument in the landscape, the realities of its early construction and its continuing presence are heightened for me. There is a renewed immediacy; and features which I might previously have taken for granted take on a new presence, an enhanced reality.

The outcome of such an experience may be a renewed respect for the makers of early monuments, such as the megalithic tombs and long barrows of Neolithic Britain and northwestern Europe. One may have an enhanced sensitivity to their place in the landscape, a renewed awareness of their functioning as markers, which continue today to have an active role as notable features of the landscape and in some senses as repositories of memory, even if the anecdotal details are lost or modified. Now these are sensitivities and awarenesses which may be activated by other means. Christopher Tilley (1994) in particular has advocated a phenomenological approach, in which he records his impressions walking along linear monuments, and others also have stressed that what we think of as the 'landscape' is in large measure the work of human action over the years. Chris Scarre (2002) and his colleagues have emphasized how natural features of that landscape may have been influential in the formation of the work of the first megalith builders.

There is the risk also that each of these approaches may be a shade solipsistic. For just as Richard Long is an artist who walks alone, are not the landscape archaeologists and indeed the phenomenologists, inclined to think in terms of personal and individual rather than collective experience? But once stated, in relation to Long's work, this observation can be assessed. He

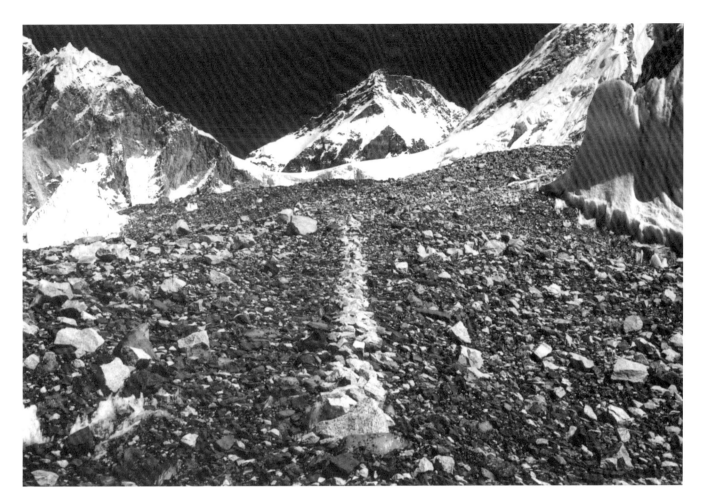

A LINE IN THE HIMALAYAS
1975

sensitizes us to the effects of the work of one man, although there are
moments in his work when we feel the significance of shared action — for
instance when he adds a stone to a pre-existing cairn. This invites us to
consider the emotional and social effects of cooperative work when an entire
community joins together in shared labour in order to construct a chambered
cairn (Renfrew 2001b). For just as the art (and in some senses the artistic
personhood) of Richard Long has been constructed by his works, so the social
reality of many early communities may have been constructed or at least
enhanced through their communal endeavour. In such ways the work of Long
can promote analysis and reflection. Through its contemplation we may be
able to analyze more closely what the early landscape and the monuments
which it contains may have to tell us.

In some ways it is the minimal qualities in the work of Richard Long, the
very modesty of his interventions in the world, which hint at the key towards
our understanding of some of the mysteries which surround the creations of
monuments and the powerful effect which they can have upon us. There can
be few simpler ways of indicating a presence, which soon becomes merely a

2.2 *A Line in the
Himalayas* (1975) by
Richard Long.

record of a presence and thus in a sense what has become an absence, than *A Line in the Himalayas* (1975: Plate 2.2; Seymour 1991, 62). At a superficial view it simply involves the re-arrangement of some locally available stones into a linear form in a high mountain pass. Indeed the very extreme of such simplicity was achieved by Long already in 1965 when he produced *A Line Made by Walking* (Seymour 1991, 26; Renfrew 2003, 35), which is the result of his walking up and down in a meadow and thus flattening the grass along the line of his walking. But when one sees these works, whether in the large photographic prints which are often the end-product of his work, or in gallery installations, they have a much more powerful effect than a prosaic narrative of their making might suggest.

For Long has discovered, or rather re-discovered, that there is something fundamental which attracts and retains our attention in these markings, these traces of human activity. One component of their effectiveness is that in most cases these are clearly deliberate markings. They are traces which have been intentionally constructed in such a way that they signal not only that Long was here, but that he wanted this record of his presence to mark his activity and to be a visible record of it. In that sense all of these works are symbols which represent both human presence and agency. These works are the very embodiment of agency, and in some cases of very little else.

When we as archaeologists turn to the work of Long, we recognize it at once as something in some ways familiar to us. Just why this should be so may be a complex question, but some elements are clear. Those of us who have been interested in early field monuments — in earthworks or megalithic cairns — have often been impressed by what are often now their 'minimal' qualities. The erosive effects of time mean that often today they are difficult to discern, sometimes visible indeed only through aerial photography, although shortly after their creation they were probably much more obvious. But underlying this rather superficial similarity is the more fundamental one, that they too were the product of agency and often of little else. A megalithic chambered cairn may have been made with the intention of containing the remains of the dead of the community, but it was above all made to be seen and to be noted. Such monuments were conspicuous, which is often why they survive today. They were built as monuments. Their primary statement indeed was and remains a proclamation of their existence and hence, by implication, of the act of their creation. They remain a presence, which recalls the actual presence of those who made them. They thus work in just the same way as a work by Long which recalls the presence of its maker, and usually the walk which he was undertaking when he made it, of which it is the only record.

We are led, therefore, to look at this process of being there, and of leaving a mark which records that brief presence. It is a mark which becomes an enduring presence. It was intended to have an existence after the time of its

creation and in that sense it is therefore a monument — a construction or indication which deliberately evokes memory. Or if traditions have subsequently been ruptured so that there is no continuity of mnemonic tradition, then it suggests memory — a record of forgotten memories.

For the archaeologist it is interesting that this process of marking and memorializing is such a powerful one. Indeed it is more than that, for it is increasing clear, as Tilley (1994) emphasized in his *Phenomenology of Landscape*, that it is largely by this means that the landscape is constructed. A landscape is a palimpsest of indications of human life and experience. Some of these are primarily functional — the households, the fields, the roads. But others are mainly symbolic, indeed historical, reminding us of remembered history and indeed also of the past which is now forgotten, of time immemorial. As noted above, many of these symbolic constructions are all the more powerful for being not just the work of a single individual but of whole communities.

One part of the fascination of Richard Long's work, of particular relevance to the archaeologist, is that he has through his work found the key to some of the mysterious ways by which the human presence is recorded, by which memory is created and conserved, and by which landscape is constructed. His work has many other merits. For the archaeologist it has the particular fascination that he illuminates and even re-vitalizes the power of these early acts of symbolic communication.

David Mach and the artefact of desire

The work of David Mach is very different from the preceding, being set firmly in the modern world of the late twentieth and early twenty-first centuries, with none of the timeless quality which we meet both with Gormley and with Long. He works entirely with artefacts (Ash & Bonaventura 1995; Mach 1995b). Moreover these artefacts are the consumer durables of the contemporary world, and often the multiples which we are used to meeting in large numbers. He has worked with great quantities of newsprint, seen in surging waves which support favourite examples of mechanized production — motor cars or refrigerators. He has used great accumulations of rubber tires to build a submarine, in *Polaris* (1983: Mach 1995b, 10) or a replica Greek temple, in *Temple at Tyre* (1994: Renfrew 2003, 23).

He is a master of contemporary material cliché, with a particular penchant for the Barbie Doll. In one remarkable work, *The Wild Bunch*, which he displayed at the 'Sculpture in the Close' exhibition at Jesus College in 1996, we saw a whole assemblage of charity figures travelling unsteadily in a Land Rover. These were the stereotyped figures employed by various charities — the guide dog of Help the Blind, the orphan of Dr Barnardo's etc. But here they were holding intimidating domestic appliances — power saws, screwdrivers brandished as weapons — and threatening a breach of the peace.

In a remarkable work, *The Trophy Room* (Plate 2.3; Mach 1995a; Renfrew

2003, 155) he caricatures the display of stuffed tigers' heads and reindeer antlers in the billiard room of a baronial hall by arranging that each of these stuffed animal heads on the wall should hold in its mouth some consumer durable of the present age. We see television sets, and refrigerators, sporting appliances, a lawn mower, even a grand piano, held up in this extraordinary way. The trophies of the hunt and the shoot have now become the triumphs of the shopping mall. Shop till you drop! And the Victorian display of man's domination over the animal kingdom has now become a satirized version of an Ideal Home Exhibition.

For the archaeologist, Mach succeeds in highlighting in an illuminating way and offering for our examination the place of artefacts in the modern world. The multiples to which we give so little regard — the newspaper, the car tyre — have indeed in his work multiplied to swamp us, or to become the building material of urban monuments. And the symbolic status of what we may think of as useful domestic appliances — the washing machine, the refrigerator — is highlighted in an effective way. His work problematizes the role of such artefacts today. It could be taken as an illustration of Thorstein Veblen's cynical view of competitive emulation through material goods (Veblen 1925), of Keeping Up with the Jones's. But it goes further in its embodiment of the tastes of commercialism and in its epitomization of the sentimentality of much popular culture, as in his *Hundred and One Dalmatians*.

2.3 Study for *The Trophy Room* (1995) by David Mach.

For the archaeologist it is the focus upon artefacts which particularly characterizes the work of David Mach. The experience of being swamped by newsprint, by thousands indeed millions of copies of the same newspaper (Mach 1995b, 58) or of being diminished by the sheer scale of a submarine made out of car tyres, or by a vast temple podium made out of containers (Renfrew 2003, 23), gives a sudden new reality to the notion of mass production. That the material culture of today is governed by endlessly repeated stereotypes is a theme already explored in the 1960s by Andy Warhol with his boxes of soup tins, and his multiples of Marilyn and of Chairman Mao. It is approached with fresh wit and irony by Mach, for instance in his enthusiastic use of Barbie Dolls (Mach 1995b, 97 & 98).

As noted above, however, he manages to catch something of the special qualities of modern material culture, like his contemporary Jeff Koons, in a way which is of interest to the anthropologist. Some contemporary artefacts achieve a special status as objects that are desirable and to be coveted. In an earlier generation it was the Rolls Royce, or at the time of Elvis Presley, the Cadillac. Today it is the Alpha Romeo or the Ferrari (Mach 1995b, 94). Mach highlights for us in an interesting way, this remarkable and widespread human propensity to collect objects associated with prestige and value, which we see in the archaeological record already from the early inception of ranked society in many parts of the world (for instance in the Wessex culture of early Bronze Age England, or the finery of the Aegean early Bronze Age, as seen at Troy or in Crete, or the status object of Late Formative Mesoamerica).

I have always thought it remarkable that material objects, especially those deemed to be of 'precious' materials, come to take on such a striking significance in the centuries subsequent to the initial formation of sedentary societies, which are usually (but not invariably) based upon food production. The notion of wealth, and the desire to acquire, to consume and to display, becomes an almost universal feature of the economy. Production for export and for profit comes to outpace simple production for consumption at the domestic level. The acquisitive propensity which underlies these processes and developments is something which Mach illustrates and investigates very effectively. We can experience these feelings in our own time, and of course we do so in many ways in our own consumer-oriented society. Mach focuses, in a manner which is informative and interesting for the archaeologist, upon the inherent desirability of the products of material culture.

These three artists have each a range of insights to offer the archaeologist. There are many other themes which one could choose, using the work of other contemporaries. In our own time there are many artists, like the French sculptor Arman or like Tony Cragg, who focus upon the use, or the re-use or indeed the creation of artefacts. Their work invites us to look at artefacts in new ways. The work of Rachel Whiteread, to take another individual, with its use of space and its evocation of vanished spaces, has much to offer the

archaeologist. And the whole field of communication by signs is subject to commentary and to subversion in contemporary art in ways which the archaeologist may find informative. Photographers like Cindy Sherman or Andreas Gursky give, in their different ways, many insights not only into life but also into materialities of different kinds. Contemporary art has much to offer the student of past material culture.

Archaeology for art

It is not the intention here to say much about the impact of archaeology upon the visual arts: the present emphasis is upon the converse. Yet this too is a rich field. Many artists have a fascination with the past and the relics of the past: recent work on the curiously still and timeless townscapes of de Chirico (Barber 2002) is revealing about the relationships between his childhood memories of Greece and the pervasive classical undertones. In the field of psychoanalysis, the archaeological metaphor of stratification is often applied to the levels of the conscious or unconscious mind (Thomas 2004). The rather modest collection of antiquities collected by Sigmund Freud and now visible in the Freud Museum in London is often quoted as indicating his interest in archaeology, and indeed it was one of the sources for Susan Hiller's remarkable work *After the Freud Museum* (Hiller 2000; Renfrew 2003, 101).

There are several strands or lines of influence from archaeology upon contemporary art. In the first place there are all the legacies of the classical world which have flowed into art since the Renaissance, surfacing, for instance, in some of the line drawings and prints of Picasso (for example in the *Vollard Suite*), or, as noted above, in the early paintings of de Chirico. This is a vast field, bravely tackled in the recent exhibition *D'après l'antique* at the Louvre (Cuzin *et al.* 2000).

Then there are the direct influences of the monuments of British and European prehistory, as noted earlier, seen in mid-century upon such artists as Henry Moore or John Piper. Subsequently, in the 1970s and 1980s, with the various developments of what has been called Land Art (Lippard 1983; Tiberghien 1995), the influences became wider. Earthworks and standing stones became a preoccupation of several contemporary artists. And solar alignments, such as those embodied in Nancy Holt's *Sun Tunnels* (1973–6) and Robert Morris's *Observatory* (1970–77) show an evident debt to prehistoric alignments like that at Stonehenge, or perhaps to the astronomical observations of North American Indians.

In the work of the American artist Charles Simonds we see what Edward Lucy Smith (1980, 106) has termed 'mock archaeology', where 'miniature fantasy landscapes' (Lippard 1983, 234) offered reconstructions of the homes of the Little People in forms which hark back to the surviving structures of the Anasazi in the American Southwest.

In some of these cases the contemporary artist was receiving inspiration

both from notions of the early past and from the archaeological procedures used to recover information about it. More recently the processes of archaeological research have become a specific focus for the artist. The American sculptor Mark Dion has simulated the procedures of archaeology in *Raiding Neptune's Vault* and *The Tate Thames Dig* in a way which poses for the archaeologist interesting new questions about the nature of archaeological practice (Coles & Dion 1999; Corrin *et al.* 1997).

In recent years, artists have also become more self-conscious about the use of the museum. Indeed the museum, including the archaeological museum, has become a place of inspiration for the artist (see McShine 1999; Putnam 2001). Certainly in the Museum of Jurassic Technology in Los Angeles (Wechsler 1995; Mangurian & Ray 1999) the boundaries between museum exhibit and installation art become disconcertingly hard to define. Archaeology, and the processes of investigation and display associated with it, have certainly made many contributions to the work of contemporary artists. It is appropriate now, however, to return to the principal theme of this paper, which is the inspiration which the practice of contemporary art can give to us as archaeologists in our task of reconstructing and understanding the past.

Material transformations and the persistence of memory: the art of Cornelia Parker

That the undertakings of the archaeologist can be informed and illuminated by the work of contemporary artists who have reflected upon our experience of the material world is further illustrated by one such contemporary: Cornelia Parker. But of course we should at once recognize that to comment upon these features from the standpoint of the archaeologist, and with the preoccupations of the professional student of the human past, may risk overlooking other vibrant aspects of her work upon which the dimension of time may not hang so heavily. For archaeologists are daughters and sons of time. We may contemplate the world *sub specie temporalis* or we may take the longer view, *sub specie aeternetatis*. But either way the fourth dimension is always with us.

The primal experience for the digging archaeologist is delving in the earth of the excavation trench. The archaeologist shifts earth, and does so with an attentive care in order to discern fragments, to recover almost-vanished objects, which constitute the sole remaining traces, shadows and figments of the remote past. The aim of the undertaking is to gather information: the production of data pertaining to the past. Its reality is a material one. We are handling matter, with its mass, moisture, texture, colour. These green traces may be corroded copper. This brown, soft stuff seems to be poorly-preserved bone which, with careful excavation and conservation may be recovered with its form preserved. Each site, each trench, with its soil moist or dry, organic-rich or sparse, has its particularities, its richnesses and its disappointments.

If you are digging in volcanic ash or very dry soil you may find a promising cavity which, when filled with plaster of Paris, may recover the form of pieces of wood now decayed — the table of some forgotten inhabitant of Akrotiri on Thera, the vanished frame of a musical instrument at Ur of the Chaldees — or even the absent form of the body of a human caught in that ash, as at Pompeii.

In every case one is seeking to recover materials which have been transformed with the passage of the years, which have changed their nature, yet whose original forms may be open to recovery. Their form may be suggestive of their original function, and their context may offer suggestions as to their original meaning for those who made and used them. The formation processes by which the archaeological record is constituted are decisive in determining the nature of that record. The understanding of those processes, the study of taphonomy, is of central importance in the process of achieving an adequate and useful reconstruction.

One fascinating and pervasive feature of the primal experience of the dig is that usually, when digging a specific layer — and the digging process proceeds layer by layer — you are by implication located 'in' a particular time period. That layer is late Roman, this is mid Saxon, those above in the stratigraphic section are twelfth-century medieval, and so forth. Of course one is not in reality 'in' any other time but the present. Yet it is indeed the case that, when digging stratigraphically, one is excavating material set down in a particular period. That is the fundamental principle of stratigraphic excavation. As archaeologists our experience of time seems on occasion direct and immediate, and chronological control is one of our principal methodological preoccupations.

Lurking too in most archaeological reconstructions and interpretations are issues pertaining to memory. For our own personal experience of the past is inevitably based primarily upon our personal knowledge of the past. This comes to us through our own experience of the world and our recollections of that experience. Part of that experience is embodied — through the way we are, through habit and through shared understandings, in effect through what Pierre Bourdieu terms *habitus*. Part comes also from those recollections of past experience which we term memory. So that when we turn to a deeper past, beyond the span of our own personal recall, we approach it, in part, with our own intuitions and understandings of what we know or believe that past might be like. The entanglement of our own personal memories with our attempt to construct or 'reconstruct' an earlier past on the basis of surviving material culture is difficult to unravel. It deserves more sustained theoretical treatment than it has so far received. The disquieting experiences and the strange paradoxes in the field of material culture which Cornelia Parker's work offer invite such theoretical and analytical considerations.

Cornelia Parker's works are often communicative about their own

formation — how they have come to be what they are. The most celebrated of them is undoubtedly *Cold Dark Matter – An Exploded View* of 1991 (Plate 2.4; Morgan *et al.* 2000, 25; Blazwick & Lajer-Burcharth 2001, 52–5; Renfrew 2003, 106–7). She took an ordinary garden shed, such as is found at the bottom of many an English garden, with its bric-à-brac of garden tools, almost discarded oddments of domestic debris, old toys and bits of equipment. This was first displayed in the gallery. Then it was taken to a remote field and, at the request of the artist, blown up, exploded, by military explosive experts. The resulting debris was then recovered and formed the basis for the arresting installation assembled in the gallery, where the recovered fragments were suspended from

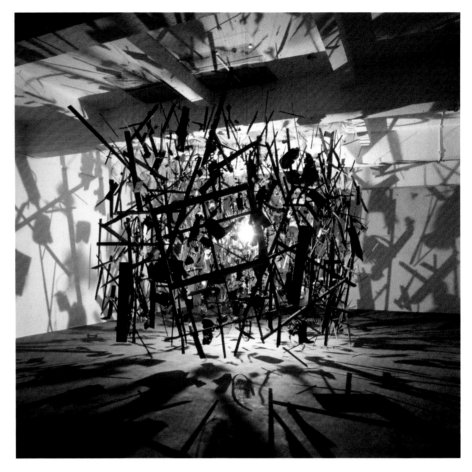

the ceiling by wires, the whole being illuminated by a single light bulb at the centre (Blazwick & Lajer-Burcharth 2001, 54–5; see Renfrew 2003, 107). The resulting work is highly evocative. One is aware that the formation processes here were of explosive brevity, but the analogy to the procedures of the archaeologist are nonetheless obvious. Following the transformations wrought by time (aided in this case by the British Army School of Ammunition) the original material, transformed through those formation process, and bearing many marks of damage analogous to those of erosion and decay (thus mimicking most taphonomic formation processes which are time-dependent) has been reconstructed and put on display.

Reconstruction and display are standard archaeological procedures, but of course here they are subverted by the chosen mode of presentation — suspension by wire — without any attempt to reconstruct the original form of the shed (which might well have been possible) or to place the objects in their original places within it. Such was not the purpose of the artist's project. Instead we have this highly evocative image of the partly reconstituted past of the shed. By the accompanying title we are pitchforked into space, cosmic space. Already the single light with the surrounding darker forms might suggest to us a solar system. Certainly the striking shadows upon the walls

2.4 *Cold Dark Matter — An Exploded View* (1991) by Cornelia Parker.

remind us of shadows cast by the sun. But the title, with its reference to the 'cold dark matter' of modern astronomy transforms that planetary scale to truly cosmic dimensions, and the darkened fragmentary objects, seen as black against the illumination of the bulb, are indeed 'matter' (whose artefactual forms have been blunted). We are invited to imagine the dark matter which cosmologers tell us constitutes more than half the mass of the universe.

It is worth noting that, even without the arresting title, this work would be intriguing and fascinating, particularly if the viewer knew the history of its origins. The title undoubtedly adds another dimension, conjuring up cosmic spaces, and drawing our attention to the constituent materiality. But in this case, unlike that of several other works by Parker, the title is not of pivotal significance.

Much of the power of this work resides in its ability to lead us to recall, and to relate to a tangible past. This is a past which is gone, of course, but it is one to which we can all relate. These are familiar objects re-assembled from that vanished garden shed. This partially reconstructed shed and recovered odd-job room, with its strange miscellany of damaged yet familiar everyday objects, may have been Cornelia Parker's own garden shed, but it could have equally been our garden shed. The very familiarity of the contents makes it evocative. It has become distant from us not because of the strangeness or unfamiliarity of the contents — they are still the bric-à-brac of our daily lives — but through the archaeological process, here strangely accelerated. Time, and the explosives of the British Army School of Ammunition, have taken their toll upon them. They have become archaeological finds, reassembled through forensic procedures that are very much those of the field archaeologist. These processes have been accelerated for us, however, so that we seem almost to be in face of a reconstruction of our own present. It is as if we are excavating ourselves, or at least our own material culture. That is part of the paradox of the work. And for the archaeologist it is a particularly fruitful paradox. For the 'otherness' we feel in face of this work is not the otherness which we so often feel when dealing with the material culture of a time and place that are remote from us. For me the experience is rather like that of visiting, during the Second World War, sites that had recently been destroyed by enemy bombing. The bits and pieces, the bed springs, the broken porcelain tableware which only yesterday were part of a functioning household, each in their natural place, became overnight fragments of a past world, foreign and remote. As an archaeologist I value this work because it brings me into direct contact with the formation processes by which the archaeological record is constituted, and into a personal relationship with the transformations by which the present (today) has become the past (yesterday) which we can now only experience, if at all, as today.

I admire too the way in which, with the title, we are pitchforked into a dazzling whirlpool of cosmic metaphor, where this insignificant debris takes

on an extra-galactic scale. And the use of
the light bulb to cast shadows on the
wall recalls Plato's cave, where all we
mortals see of the real world is the
shadows which are cast upon the wall of
the cave. There is even an echo here of
Marcel Duchamp's *Shadows of
Readymades* (Renfrew 2003, 97–8), where
the work consists of shadows cast onto
the wall, from the light of a single naked
bulb, by Duchamp's suspended
'readymade' objects. All of this is a
reminder to the archaeologist that we are
dealing in our daily work with
transformed things and shadows of
things, out of which we, like Plato's
troglodytes, have to make sense of the
world, in our case a past world.

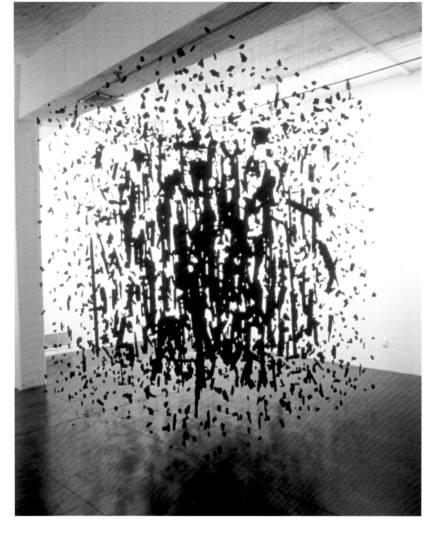

This is an exciting work which
reveals several qualities seen in many of
Cornelia Parker's other sculptures. In the
first place it is about the materiality of
things. We are acutely aware of what the
sculpture consists of — fragments of
wood from the shed, and the bizarre
assortment of objects (paint tins, a
damaged hot-water bottle of rubber, a
bent bicycle) which formed its contents. Secondly there is the dramatic nature
of the transformation by which this matter has been converted into something
rather different, in this case by explosion. In other works by Cornelia Parker
there may be deliberate violence — for instance by the use of the guillotine —
or the consequence of catastrophic natural processes, for instance the impact
of a comet. And then there is the ingenuity by which the title, the short
explanatory text accompanying the work, transforms its meaning, so that the
garden shed is turned into the entire cosmos.

A related work is *Mass (Colder, Darker Matter)* of 1997 (Plate 2.5; Blazwick
& Lajer-Burcharth 2001, 59; Watkins 2002, 24). Here the suspended objects are
all pieces of blackened charcoal. For in this case the starting point was the
wooden structure of a church (the Baptist Church of Lytle, Texas) which was
struck by lightning and consequently destroyed by fire. Here again the title is
not crucial. Even if it were simply termed *Untitled 1997*, without further
history, this would be an impressive work, and the charred wood with its
three-dimensional arrangement, would make an interesting sculpture.

2.5 *Mass (Colder,
Darker Matter)*
(1997) by Cornelia
Parker.

However the knowledge that this church was destroyed in an 'act of God' does undoubtedly give a frisson of violence once the title and comment are available.

As a viewer one is arrested by the irony, by the 'act of God' that has been inflicted upon the House of God. The charred wood seems to bring us face-to-face with the black arts. There is an invitation here to enter into the Christian world of Good and Evil, of sin and punishment, of black and white, and in such a context to be aware that the faithful believe also in the reality of the force of evil and the powers of the Devil. Faith has been betrayed here, and belief shattered.

As a work of art this is enormously effective. The charred remains of the wooden structure have already a somewhat macabre quality even before one knows the ecclesiastical context. And if one is looking with the eye of the archaeologist (which is the ultimate purpose of this paper) one is invited to share once again in what is in some ways an archaeological experience. It is not uncommon for us to find ourselves in the company of the shattered remnants of what was once a monument to the faith of a community, now vanished and remote from us. Some of the religious monuments of Mesoamerica have this compelling presence, so that one feels, in some measure, the intensity of the belief system in which they were built and venerated, even if the specific content of that belief system is unknown to us, or so strange to us that empathetic response is difficult. Such feelings in ourselves today are in my view to be encouraged, and then to be analyzed. For while I do not believe that we can in any meaningful sense recover the feelings of those people who first built and used such monuments, we can hope to sense and understand, in some ways, the communicative methods by which such monuments were effective. That we should experience comparable feelings in the presence of this slightly macabre evocation of a more recent conflagration is of interest in itself.

Formation processes of a different, but again unexpected, kind were at

2.6 *Thirty Pieces of Silver* (1989) by Cornelia Parker (work in progress).

work in *Thirty Pieces of Silver* of 1989 (Cameron 2003, 22 & 23). Here the artist has taken a whole array of objects of antique and modern silver and silver plate — cups, plates, cutlery, vases — and arranged that they be flattened by a steamroller (Plate 2.6). They are then suspended above the ground, again using wires, in horizontally clustering small groups, thirty in number (Plate 2.7). The effect is again arresting. And the outcome is again in a way, archaeological. What we see is a series of assemblages, each of which has been damaged, whether by violence or by the passage of time. It invites us to consider how it came to be this way. And it leads us back to its former use-life, before the 'transform' which took it out of the world of use and brought it to the world of the relic, fit for display as a relic, and fit for further study.

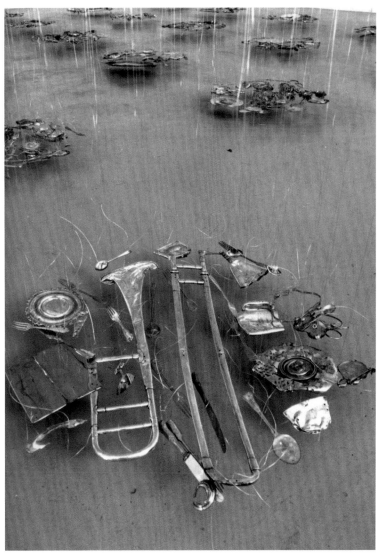

As archaeologists we are used to hoards of silver vessels from the classical and Byzantine worlds — the Mildenhall Treasure, the Treasure of Boscoreale, the Sevso Silver — and the bent and oxidized surfaces of the material are familiar to us. In every case, with such a hoard there is a depositional history, although it is generally obscure to us — except at Boscoreale where the eruption of Vesuvius in AD 79 provides an adequate explanation. Again, as in the case of *Cold, Dark Matter*, it is disconcerting for us to find that the formation processes of the centuries have been telescoped through Cornelia Parker's bold ingenuity, into the work of a single afternoon. Again one is amazed at the theatrical, almost comic decisiveness of the chosen transformational agent: a steamroller. Yet these dislocations in time are instructive to us, when we analyze our feelings as observers. Again Cornelia Parker has reconstructed for us what certainly looks like (and in some sense actually is) an archaeological context.

Again she has, with her title, created in this case an associative context with its reference to Judas Iscariot, of betrayal and rejection. The silver becomes filthy lucre, the wages of sin. Again and again in her work the association of material things with an emotionally charged human context gives a jolt. For the archaeologist, such associations are of crucial importance. The circumstance that this one is fictitious, or at best allusive, opens up interesting issues of association and of authenticity. It alludes, also to the cult

2.7 *Thirty Pieces of Silver* (1989) (detail) by Cornelia Parker.

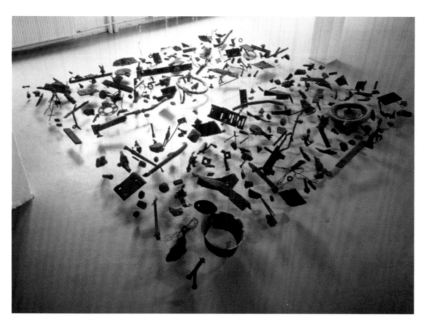

of relics, from the Crown of Thorns in the Sainte Chapelle to the 'Holy Shroud' in the Cathedral in Turin.

Another work where the transformation processes which brought about its formation have a special fascination is *Avoided Object* of 1995 (Plate 2.8; Morgan *et al.* 2000, 13). Here there is an assemblage of corroded metal objects, mainly of iron, some difficult to identify, some representing small pieces of machinery or wheel hubs. The accompanying text is informative: 'Buried objects found in Düsseldorf, Germany with the aid of a metal detector. Suspended above the ground to correspond to the depth discovered'. This time the process is one of recovery, employing the metal-detector equipment familiar to archaeologists, using the very archaeological process of digging down to an appropriate depth to recover them. Here the notion of the *objet trouvé*, already familiar from the work of Paolozzi or Henry Moore, or indeed the 'readymades' of Duchamp, takes on a new significance. For these are sought-for objects, *objets retrouvés*, situated or re-situated in an assemblage which invites one to consider their original context prior to discovery and recovery.

Given that these objects were indeed recovered by what amounts to an archaeological procedure, it is pertinent also to reflect upon the significance of their display. She uses her favoured device of suspending each object by means of a thread or wire. But here there is an element of contextual reconstruction, since the depths of discovery are integrated into the display. The whole issue of display has an important role in the history of archaeology, from the Renaissance Cabinet of Curiosities to the 'artefact as fine art' approach where, for instance, the Metropolitan Museum of Art in New York exhibited the 'Euphronios Vase' (the newly-acquired 'hot pot': see Hoving 1993), spotlit in solitude in an otherwise empty exhibition gallery, after proudly announcing that it had broken all records of price for a Greek vase in purchasing this unprovenanced (and probably looted) antiquity for a sum in excess of a million dollars.

The notion that deliberate display establishes an object as a work of art has been explicit from the initiative of Marcel Duchamp in 1917 through to the vitrines of Joseph Beuys. But it had already been implicit in the history of archaeology from as early as the Renaissance down to the present day. Cornelia Parker here invites us, as archaeologists, to consider the transformative process which the very act of display brings about. There are equivocal

2.8 *Avoided Object* (1995) by Cornelia Parker.

relationships here from which it is not easy to escape, and which remain to be fully analyzed.

A more direct reference to the world of the archaeologist, or at least of the metal-detectorist seeking ancient artefacts is seen in a recent pair of works: *METAL DETECTOR FINDS – lead indians and soldiers. Item #312352357* and the corresponding *MEDIEVAL TO MODERN, UK detector finds. Item #251408912* (Cameron 2003, 54–7). The former is a group of toy soldiers 'unearthed in North Carolina USA, reburied in Battle, near Hastings, England 2003'. The latter is a group of objects, including buckles, thimbles, crotal bells (two with maker's marks), musket balls, lead sack seals, a clay pipe badges etc., which were 'unearthed in Surrey, England, reburied in Las Vegas, Nevada, USA 2003'. The eye of the archaeologist is evidently operative here, as much as in Mark Dion's *Tate Thames Dig*. Yet for the archaeologist, as in that case also, the vision is intriguing. It calls into question the nature of some of our procedures and conventions.

In another interesting series of works, Parker refers to transformations not of damage or decay, but of becoming, of formation. In *Embryo Money* of 1996 ('Ten pence pieces in the earliest stage of production': Brett *et al.* 1996, 8) we see the metal blanks prepared by the Royal Mint prior to the striking of the finished coin. Similarly in *Embryo Firearms* of 1995 (Morgan *et al.* 2000, 23) we see a pair of pistols, or rather the metal blanks before the pistols have been produced from them. 'Colt 45 guns in the earliest stage of production', they come straight from the factory and are presented to us, rather like 'Exhibit A' in a police museum or a court of law. There is something arresting in their incomplete becoming. Of course these exhibits would mean much less without the titles. For it is the reference to embryos which leads the mind at once to the processes of organic formation of life forms, including human ones. These works become arresting

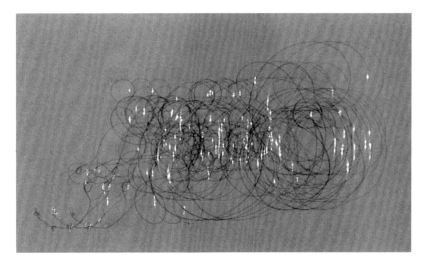

images which inescapably lead one to ask why the titles seem paradoxical, and hence to analyze more closely their process of becoming.

There are many other instances in Parker's work where material transformations or material presences are evocative and thought-provoking. For instance *Wedding Ring Drawing* of 1996 (Plate 2.9; Brett *et al.* 1996, 66; Morgan *et al.* 2000, 44) is a framed coil of thin gold wire, not something initially of great interest without the title. But with the title and the explanatory note, '(Circumference of a living room) Two 22 carat gold wedding rings drawn into a wire', the interest of the 'drawing' is greatly

2.9 *Wedding Ring Drawing (circumference of a living room) (1996)* by Cornelia Parker.

increased. For we now understand that the process of manufacture is that of the jeweller. The knowledge that two wedding rings are involved evokes the relationship of a married couple, perhaps now divorced, and the mention of the drawing room injects an element of domesticity. What was a thin wire of 22 carat gold is now the end point of a domestic history.

The transformation of the materiality of this durable metal is of particular interest. What was gold, and of value, remains gold, albeit in much attenuated form. But what was a thing, or indeed a pair of things, is profoundly altered. The objects have disappeared, to become a mere gossamer floss of gold wire. This homogeneity, the quiddity, of these two rings has become dispersed. Moreover these were meaningful things, symbolizing a state of being (matrimony) and presumably an emotional state (love). This state of being has been diminished, presumably to extinction, with the attenuation of the objects. The basic properties of matter and its associated, emotion-laden meanings, are gainsaid, subverted.

The archaeologist is familiar with the transformations of matter through time, with the transubstantiation of decay. Things change their nature. Flesh disappears. Skeletons are all that is left of once living bodies. Corruption advances. Memory too is attenuated to the point of disappearance. All of these things are suggested by the particular association, in this work, of the deliberate material process of attenuation with the emotional assault (with the presumption of divorce) which the disappearance of the wedding rings implies.

Of course the wire-making techniques of the goldsmith are here only a metaphor for the transformation processes which time wreaks in the archaeological record. But it is a good and effective metaphor. What we see today is gossamer of spun gold. Prior to the transform there were two gold wedding rings, signifying the matrimony of a married couple. Meaning is obscured, but not entirely lost. Perhaps the end product is still evocative of the initial state. Such is the dilemma of the archaeologist.

The work of Cornelia Parker evidently operates in a number of different ways, and different viewers will formulate different 'readings'. What is clear however is that in general there are few completed sculptures (in the traditional sense), no finished objects (hence the title *Avoided Object* for her Cardiff exhibition of 1996). Each work evokes a process. Something is happening, sometimes something dramatic: a church is burnt by lightning, a meteorite

2.10 Cornelia Parker in action at the excavations at the Wardy Hill Ringwork in 1992.

2.11 Flag-ringed clay lump: an 'experiment' by Cornelia Parker at the Wardy Hill Ringwork excavations.

lands, coins or guns are in process of manufacture, pornographic video tapes are dissolved in acid, a doll is cut by guillotine, wedding rings are drawn out to make fine gold wire. Of course there is always an end product. In general everything has a history, sometimes a history which she herself has wrought.

It is here, I think, that her work proves so evocative for the archaeologist. For we ourselves are increasingly preoccupied with the specific details of formation processes, and any work which lays emphasis upon them may offer a focus of concentration for our own subject matter. Cornelia Parker has participated in archaeological excavations (Plate 2.10; see Edmonds & Evans 1991, pl. xv). In doing so she has experimented with the techniques of archaeological recovery, measurement and recording (Plate 2.11). She knows that in the changing materialities of the passing centuries, there are unexpected losses and sometimes exaggerations in the residues which are preserved. Very often in archaeology the part has to serve for the whole, for the whole is no longer available. Loss, damage, and metamorphosis: these are the currency of our work as well as of hers. The catalogue of her Cardiff exhibition *Avoided Object* (Brett *et al.* 1996, 2) begins with a quotation from the photographer Minor White (1957) which is particularly evocative of the sort of transformation process by which the unavoidable objects of archaeology are constituted:

> The swift drop to the floor signalled eager forces into play: gravity was the trigger, clay and shape the material, the loving hand that shaped the bowl — had unconsciously stored an unguessed form in it. With the crash transmutation worked, metamorphosis took a deep breath and an object found itself. The death of the bowl was the birth of the object.

The objects that we as archaeologists look at have had their use lives, and after that they have had their burial lives, each determined by taphonomic circumstance. Forms are changed; meanings are lost or subverted. For this reason the task of the excavator is full of puzzles not unlike those confronting the viewer looking for the first time at a Parker work. Who would guess that these suggestive stains on paper (Brett *et al.* 1996, 62) are drawn in ink formed from the ferric oxide from pornographic video tapes dissolved in solvent — hence the title *Pornographic Drawing*? Who would infer that this small ball, formed of strands of lacquer (Morgan *et al.* 2000, 50), is 'black lacquer residue from the cutting of original grooves in records' and entitled *Negatives of Sound*? Who could imagine that these two black ear plugs (Blazwick & Lajer-Burcharth 2001, 8) were 'made with the fluff gathered in the Whispering Gallery, St Paul's Cathedral' to form *Negatives of Whispers* (Plate 2.12)?

Again and again we meet with objects which have had unexpected

2.12 *Negatives of Whispers* (1997) by Cornelia Parker.

histories, and which have been changed in unimaginable ways so that they take on unanticipated forms. In that respect the archaeologist, when he or she enters the world of Cornelia Parker, finds a universe parallel to our own. This is a world where minute traces often do have a meaning which might be forensically demonstrable if it could ever be imagined. This is a world where structures are reduced to fragments, taking on new configurations. This is a world where our own memory of past events and our own experience is relevant for our understanding of material things which have come down to us from a more remote past. This is an unsettling world where material reality takes on its present nature through oblique sequences of process. It is a world, therefore, like that of Baudelaire (1875), which is not so different from that of the excavating archaeologist:

> L'homme y passe à travers des forêts de symboles
> Qui l'observent parfois avec des regards familiers.

It is a world which the archaeologist can enter with profit as well as with pleasure.

Acknowledgements

Grateful acknowledgement for permission to reproduce sculptures is made to Antony Gormley for Plate 2.1, Richard Long for Plate 2.2, David Mach for Plate 2.3, Chris Evans for Plates 2.10 and 2.11 and Cornelia Parker and Dale McFarland of the Frith Street Gallery for Plates 2.4–2.9 and 2.12.

References

Ash, E. & P. Bonaventura, 1995. *David Mach: Likeness Guaranteed*. London: Academy Editions.

Barber, R., 2002. A *Roman villa* on Greek foundations: Athenian experiences of Giorgio de Chirico. *Apollo* 156(489), 3–11.

Baudelaire, C., 1875. Correspondances, in *Les Fleurs du Mal*. 1920 edition. Glasgow: Collins.

Beardsley, J., 1984. *Earthworks and Beyond: Contemporary Art in the Landscape*. New York (NY): Abbeville.

Blazwick, I. & E. Lajer-Burcharth, 2001. *Cornelia Parker* (exhibition catalogue). Turin: hopefulmonster.

Brett, G., C. Parker, S. Cameron & A. Payne, 1996. *Cornelia Parker – Avoided Object*. Cardiff: Chapter Arts Centre.

Cameron, S., 2003. *Cornelia Parker: A la réflexion – On Second Thoughts*. Geneva: Galerie Guy Bärtschi.

Chippindale, C., 1991. From art to archaeology: from archaeology to art, in *From Art to Archaeology* (exhibition catalogue), ed. A. Noble. London: South Bank Centre, 38–44.

Coles, A. & M. Dion (eds.), 1999. *Mark Dion: Archaeology*. London: Black Dog Publishing.

Corrin, L.G., M. Kwon & N. Bryson, 1997. *Mark Dion*. London: Phaidon Press.

Cuzin, J.-C., J.-R. Gaborit & A. Pasquier (eds.), 2000. *D'après l'antique*. Paris: Musée du Louvre.

Davis, W.V. & J. Putnam (eds.), 1994. *Time Machine: Ancient Egypt and Contemporary Art*. London: British Museum Press.

DeMarrais, E., C. Gosden & C. Renfrew (eds.), in press. *Rethinking Materiality: the Engagement of Mind with the Material World*. (McDonald Institute Monographs.) Cambridge: McDonald Institute for Archaeological Research.

Edmonds, M. & C. Evans, 1991. *The Place of the Past: Art and Archaeology in Britain* (accompanying the exhibition 'Excavating the Present'). Cambridge: Kettle's Yard.

Esche, C. & J. Palmer (eds.), 1991. *Excavating the Present*. Cambridge: Kettle's Yard.

Evans, C., 2003. *Power and Island Communities: Excavations at the Wardy Hill Ringwork, Coveney, Ely*. (East Anglian Archaeology 103.) Cambridge: Cambridge Archaeological Unit.

Fuchs, R., 1986. *Richard Long*. London: Thames & Hudson.

Gimpel, J., 1969. *The Cult of Art*. New York (NY): Stein and Day.

Godfrey, T., 1998. *Conceptual Art*. London: Phaidon.

Goldberg, R.L., 1979. *Performance Art: from Futurism to the Present*. London: Thames and Hudson.

Gormley, A., 2001. *Some of the Facts*. St Ives: Tate St Ives.

Gormley, A., 2002a. *Antony Gormley* (exhibition catalogue). Compostela: Centro Galego de Arte Contemporanea.

Gormley, A., 2002b. *Workbooks I, 1977–92*. Compostela: Centro Galego de Arte Contemporanea.

Gormley, A., this volume. Art as process. (McDonald Institute Monographs.) Cambridge: McDonald Institute for Archaeological Research, 131–51.

Hiller, S., 2000. *After the Freud Museum*. 2nd edition. London: Book Works.

Hopkins, D., 2000. *After Modern Art 1945–2000*. Oxford: Oxford University Press.

Hoving, T., 1993. *Making the Mummies Dance: Inside the Metropolitan Museum of Art*. New York (NY): Simon and Schuster.

Hutchinson, J., E.H. Gombrich & L.B. Njatin, 1995. *Antony Gormley*. London: Phaidon. [2nd edition 2001.]

Levinson, S.C., 2002. Space and place, in *Some of the Facts*, by A. Gormley. St Ives: Tate St Ives, 69–109.

Lewison, J., 2002. *Looking at Barnett Newman*. London: August Media Ltd.

Lippard, L.R., 1966. *Pop Art*. London: Thames & Hudson.

Lippard, L.R., 1983. *Overlay, Contemporary Art and the Art of Prehistory*. New York (NY): Pantheon Books.

Long, R., P. Moorhouse & D. Hooker, 2002. *Richard Long: Walking the Line*. London: Thames & Hudson.

Lucy Smith, E., 1980. *Art in the Seventies*. Ithaca (NY): Cornell University Press.

Mach, D., 1995a. *David Mach at the Zamek Ujzdowskie*. Tokyo: Lampoon House.

Mach, D., 1995b. *David Mach Likeness Guaranteed*. London: Academy Editions.

McShine, K. (ed.), 1999. *The Museum as Muse: Artists Reflect*. New York (NY): Museum of Modern Art.

Malafouris, L., in press. The cognitive basis of material engagement: where brain, body and culture conflate, in *DeMarrais et al.* (eds.).

Mangurian, R. & M.-A. Ray, 1999. *Faces Looking for the Future from the Past: 40 Possible City Surface for the Museum of Jurassic Technology: Wrapper*. San Francisco (CA): William Stout and Houston, Rice School of Architecture.

Marx, K., 1886. *Capital* vol. 1. 1974 edition. London: Lawrence and Wishart.

Merleau-Ponty, M., 1962. *Phenomenology of Perception*, translated by C. Smith. London: Routledge.

Morgan, J., B. Ferguson & C. Parker, 2000. *Cornelia Parker* (exhibition catalogue). Boston (MA): Institute of Contemporary Art.

Moszynska, A., 2002. *Antony Gormley Drawing*. London: British Museum Press.

Price, S., 2001. *Primitive Art in Civilized Places*. 2nd edition. Chicago (IL): University of Chicago Press.

Putnam, J., 2001. *Art and Artifact: the Museum as Medium*. London: Thames & Hudson.

Putnam, J. & W.V. Davies (eds.), 1994. *Time Machine: Ancient Egypt and Contemporary Art*. London: British Museum.

Renfrew, C., 1986. Varna and the emergence of wealth in prehistoric Europe, in *The Social Life of Things*, ed. A. Appadurai. Cambridge: Cambridge University Press, 141–6.

Renfrew, C., 1990. Languages of art, the work of Richard Long. *Cambridge Review* 111, 110–14.

Renfrew, C., 2001a. Symbol before concept: material engagement and the early development of society, in *Archaeological Theory Today*, ed. I. Hodder. Cambridge: Polity Press, 122–40.

Renfrew, C., 2001b. Commodification and institution in group-oriented and individualising societies, in *The Origin of Human Social Institutions*, ed. W.G. Runciman. (Proceedings of the British Academy 110.) London: British Academy, 93–118.

Renfrew, C., 2002. Antony Gormley: making contact. *British Museum Magazine* 44 (autumn), 16–19.

Renfrew, C., 2003. *Figuring It Out*. London: Thames & Hudson.

Renfrew, C., in press. Towards a theory of material engagement, in *DeMarrais et al.* (eds.).

Rubin, W. (ed.), 1984. *'Primitivism' in Twentieth Century Art*. New York (NY): Museum of Modern Art.

Sartre, J.-P., 1958. *Being and Nothingness*, translated by H.E. Barnes. London.

Scarre, C. (ed.), 2002. *Monuments and Landscape in Atlantic Europe*. London: Routledge.

Seymour, A., 1991. *Richard Long: Walking in Circles*. London: Anthony d'Offay.

Thomas, J., 2004. *Archaeology and Modernity*. London: Routledge.

Tiberghien, G.A., 1995. *Land Art*. London: Art Data.

Tilley, C., 1994. *A Phenomenology of Landscape*. London: Berg.

Veblen, T., 1925. *Theory of the Leisure Class: an Economic Study of Institutions*. London: Unwin.

Walsh, J. (ed.), 2003. *Bill Viola: the Passions*. Los Angeles (CA): J. Paul Getty Museum.

Watkins, J., 2002. *Cornelia Parker: a meteorite lands…* Birmingham: Ikon Gallery.

Wechsler, L., 1995. *Mr. Wilson's Cabinet of Wonder – Pronged Ants, Horned Humans, Mice on Toast, and Other Marvels of Jurassic Technology*. New York (NY): Pantheon.

White, M., 1957. Found photographs, in *Photographs, Essays and Images*, ed. B. Newhall. London: Secker and Warburg.

Making and display: our aesthetic appreciation of things and objects

Chris Gosden

Display is a process found in many times and places, not just in the museums and galleries of the contemporary world. The consequences of display vary, but one constant may be found — display singles out things from the general flow of life offering them up for contemplation and thought. This chapter looks partly at the process of separation that display brings about, which can transform a thing into an object — that is an artefact separated from other associated artefacts and from people. Things and objects are contrasted and the role of display considered. The prehistory of Britain may have seen the display of objects of many types, as part of a complex set of links between concealing and revealing. A shift can be seen from the display of human bodies in the Neolithic to the display of objects using the medium of the body in the Bronze and Iron Age. The consequences of such histories for the creation of people, objects and the management of knowledge are considered.

In the Capitoline temple of *Iuppiter Feretrius* in Rome, there was an area paved with ancient worked flints, and flint artefacts were sometimes used in religious ceremonies. Other sources mention a single flint used by the Fetiales for swearing the oaths which made treaties binding (Turner & Wymer 1987). At the Ivy Chimneys site (Witham, Essex), 37 handaxes and 47 other flint artefacts were found within a Roman site of religious or votive character. A number of other Roman religious sites also contained Palaeolithic and Neolithic stone material, such as Kelvedon, Essex, Springhead in Kent and Lancing Down, West Sussex (Turner & Wymer 1987, 55–8).

We generally think of the processes of collection and display as a post-Renaissance phenomenon, originating in Cabinets of Curiosity and culminating in the galleries and museums of the contemporary world. We can see, however, that display is actually a cross-cultural phenomenon found in many times and places. Although not all forms of display were everywhere caused by the same motives, there might be some consequences of display which are general enough to discuss under the same heading. I shall argue in

this chapter that display has the effect of abstracting objects from the overall flow of life, so that they can then be singled out for attention, due to their visual and other aesthetic qualities, or their connections to particular people and events. The singling out of objects and a stress on particular relationships which created them ignores the totality of relations things are made and used within, becoming part of a broader process of creating things as objects. The display of objects through galleries, museums and (above all) shops and in our homes, is an everyday part of our lives, but does need some consideration as to its history and what it says about our relationships to things. Display is partly about making things into objects. The process of objectification is a complex one and only partly linked to display, but the history of display has been considered to be purely recent with its longer-term history ignored. Display creates a form of fiction which necessitates cutting some of the links things have with each other and with people in the processes of everyday life. It is such a constant part of our lives that we take its existence and consequences for granted.

Process and presencing

A display makes objects stand out from the flow of everyday life — we need to think briefly about the nature of those flows. In everyday life material culture is made, exchanged and used in a seamless fashion. As we know well, production can take a number of forms: it can be additive, as in the case of pottery or weaving; when making stone tools reductive techniques are used, or transformative techniques are utilized as in the case of metals or the cooking of food; carpentry is both reductive and additive. Although we can separate these various processes for heuristic purposes in actual practice they are interlinked. Making clothing of skin or fabric requires the sewing of skins or weaving of cloth, but for this to happen needles of bone must have been produced reductively, or spindle whorls by baking clay or shaping stone. Paul Sillitoe's book *Made in Niugini* documents in great detail how all the major items of Wola material culture are made (Sillitoe 1988). For instance, making broad-blade arrows required eight different forms of plants as raw materials for the arrows themselves, and resin and clay to stick things together. Twenty-one different steps were required in manufacture, from preparing chert blades (used together with stone axes for varying tasks), cutting the blade and the shaft of the arrow, joining them together, whipping the joint and weaving a ferrule over the joint (Sillitoe 1988, tables 75 & 76). The plant materials, clay and chert were all acquired during trips out by men to gardens, except for the wood, which is hoop pine and only found in the bush; the work of making was carried out by men. Each arrow takes $c. 3^2/_3$ hours to make with steel tools, where previously they took $c. 4^2/_3$ hours with stone tools. They last between five and six years on average. The arrows were then used for hunting wild pig and cassowaries whose feathers are prized for making ceremonial dress; in earlier times these sharp arrows were use in fighting. The production

of the arrows was not an end in itself, but part of complex patterns of life which have changed over time. Some arrows, with particularly fine decoration (often copied from the neighbouring Huli), are never fired and used as show pieces, featuring in dances and passed down as heirlooms from one generation to the next (Sillitoe 1988, 134). They are thus items of display.

Singling out an element of material culture, a common practice in archaeology, makes it appear apart from the general mass of things, whereas it is in fact immersed in a mass of relations and not separate at all. The moments of production and consumption can never really be distinguished, as acts of production involve the using up of other things — what Marx in the 'Introduction' to the *Grundrisse* (1857) called productive consumption. Marx distinguished this from consumptive production, where, for instance, food is used up in producing bodies and he used these two terms to indicate the linked duality of production and consumption. Marx's terminology alerts us to the fact that what appears commonsense and amenable to everyday understanding may not be. Such a warning is reinforced by Mary Helms's notion (DeMarrais *et al.* in press) of consubstantiality of both matter and life. Consubstantiality has two elements, all things are bound by and created through their physical properties, understood by westerners as the laws of physics; the consubstantiality of life also refers to links between material things and other elements of the universe, such as people, animals, or the spirits of the dead. Artefacts that appear to us inanimate, may have life breathed into them through connections with other elements of the world, so that colour, texture, size and shape may link an artefact to animals or the spirit world (see Hammell 1983; 1987; 1992 on the links between crystals, stones, native copper and various aspects of the spirit world amongst the Iroquois and other Native American groups).

Partly because of the notion of consubstantiality we can see that things have all sorts of links with many aspects of the world, existing not as separate objects but through multiple connections. Wola arrows are linked to other materials such as chert and axe stone, to places such as the garden or the bush in different phases of production; they are reintroduced into the bush through hunting. They enter social relations when given in exchange or used in dances. At a more general level, they are part of the hard, additive technologies seen to be typical of Wola men, contrasted with the more integrated and complex productions of women, employing looping, plaiting and sewing. Things have many links making up their consubstantiality.

I think that it is necessary to complement the idea of consubstantiality with that of transubstantiation. Transubstantiation refers not only to the transformation of one substance to another, but also to the links between different types of substances that then form a broad field of connections between artefacts of related types. For instance, Sherratt (1997, 366–7) points out the links between later Neolithic pottery and stake-frame basketry; Wengrow (2001) takes further the echoes between pottery and woven basketry

in Mesopotamia pointing out that the similarities in decorations in the two media would have formed a broad sensory and semantic field which gave new valences to all forms of material within that field. Transubstantiation can be seen to occur when one substance changes to another, but taking the echo of the first material with it. The smoothness of burnished clay with a painted surface contrasts strongly with the more differentiated texture of basketry, even though visually pottery decoration mimics the structure of a basket. Things appear not as themselves but through fields of resemblances, which exist beyond the divisions archaeologists make of materials, so that the categorization into pottery, stone, metal or basketry may not have been held by people in the past whose sensory awareness ranged across the whole of the material world in which they lived. Transubstantiation has two further implications, one obvious, one less so. Things are altered in the processes of manufacture, so that fired clay may look more like stone than the original wet substance; metals which start off looking like stone when ore, can take on many shapes, colours, surface textures and forms of decoration. As the most malleable of materials, metals may become central to forms of transformation. Pottery echoes metal vessels, as do flint daggers made to look like copper ones. And this may not just be because people are emulating what they cannot afford, but because the plasticity of metal forms open up new fields of resemblances hard to resist. Finally, transubstantiation indicates that people and things can turn into each other and may not be divided as we tend to separate them. Carvings are viewed by Maori as persons; the gods of Mesopotamia were both mobile and active (Postgate 1992, 124).

We need to be aware that in both the processes of production and those of appreciation, things are connected to each other and to people in ways that we now find hard to grasp. Our conceptual difficulties are partly because we have come to see the object world in a different light, one that emphasizes division and comparison. In Table 3.1 I have listed how things may differ from objects, where the former are appreciated through the links that they enjoy with each other and with people which are set up by virtue of their formal qualities. Things exist as assemblages, whereas objects have been disembedded from relations with each other and relations with people. They have generalized values which do not always derive straightforwardly from their physical characteristics. Ox-hide ingots (named after their shape) first found around 1200 BC with a distribution from Babylonia to Sardinia and of a standard weight of roughly 30 kg, for instance, are not objects appreciated for their beauty, but rather because they instantiate a fixed amount of human labour and resulting metal. They could circulate between strangers effectively, showing that it was the metal that was desired, not the social relationship. The processes transforming things into objects are long and complex, reaching a climax with the commodities of capitalism. Our recent views emphasizing that the material world exists as objects, makes it difficult to appreciate the connections that exist between things. We need to capture some sense of these

modes of connectivity, which will give a heightened appreciation of the occasions, such as when things are put on display, when these connections are broken.

If making and using things are best seen as process, display might be termed presencing. Presencing removes an object from the flow of life, either making it appear separate, finished and *sui generis* or putting it into relationship with other exhibited objects. In the contemporary world we are very familiar with objects that have been singled out in particular ways. Indeed, our concept of art has inherent within it classes of objects (paintings, sculpture) which are designed to be contemplated in spaces apart from the rest of our lives. A recent critique of museums sees them as static entities, full of decontextualized objects.

> The museum seeks to be a static hold-all, largely a finished piece … [It] is a kind entombment, a display of once-lived activity (the activity whereby real people collected objects associated with other real people or living things) … [while] collecting is the process of the museum's creation, the living act that the museum embalms (Elsner 1994, 155).

The metaphor of entombment is also used by Kirschenblatt-Gimblett (1991, 416), who sees the museum as a 'form of internment — a tomb with a view'. This is not the view I am espousing here. Museum objects (or those in art galleries, shops and homes) are not decontextualized, they are in a very definite set of contexts. However, they are picked out and removed from everyday life, which gives them special qualities and significances. Maybe this is what Elsner and Kirschenblatt-Gimblett meant by decontextualization.

The contemporary world is full of displays, the most prevalent and persuasive of which are those in shops, where goods are shown off to their best advantage as things to be bought and taken home. The home is also a

Table 3.1. *Things and objects.*

Things of quality	Quantifiable objects
Things are embedded in local sets of social and sacred relations. Their formal qualities are important.	Objects can be disembedded from immediate sets of social relations and can operate in a broad social universe. Objects are dematerialized to some degree in that their physical qualities are not always the basis of their value.
Things form assemblages by virtue of their effects on the senses and their social/cosmological links.	Objects are partible by reference to agreed standards of worth which are often conceptual, rather than physical.
The values of things defy fixed classification and are to some degree ineffable and inexpressible. Value derives from their effects on the senses, rather than being constructed conceptually.	The logic of calculation of value takes abstract forms which can be manipulated conceptually through arithmetic etc.
Production is influenced by cosmological and social considerations — right standing with the powers of the universe is important.	Efficiency and the time, effort and amount of raw materials expended in production become crucial to value.
Exchanges create inalienable links between people, cosmological powers and places. Recontexualization of things is possible, dangerous, but potentially very effective.	Objects are alienable and divisible. They exist within an agreed standard of worth — money being a crucial example. Recontexualization leads to the loss of the original forms of value.
Things form assemblages and are used and consumed as groups, rather than as individualized objects. Assemblages are codified through the qualities of things.	Consumption is one area of life where the qualities of objects are still vital to the social relations they create, but there is a need to amass quantities of objects to obtain items of quality.

centre of display — the best china, pictures, flowers, ducks above the mantelpiece, photographs, souvenirs and heirlooms show off the lives, histories and connections of those in the house. Objects can move from display in a shop to being on view in a domestic setting, concealed only briefly for the journey home. There are obvious historical links between museum/gallery display and those in shops, with the same sorts of display cases, lighting and layout in each case. There are linked histories of display for educational purposes and those for profit, which would merit greater exploration (Carrier 1995). The ubiquitous nature of display and its service to consumer capitalism and contemporary self-creation makes us see this as a modern phenomenon, growing up initially in the Renaissance and finding full expression with department stores, museums and galleries, many of which developed in the last two decades of the nineteenth century. Display, however, has an immensely long history, being far older than the structure of consumer capitalism which has made it prominent. The relics on view in a medieval church or the images and relics in a Buddhist temple single out and separate items for thoughtful contemplation. Maybe with the growth of the modern world, sacred displays influenced the secular, so that the immediate origins of the cabinet of curiosity can be found in existing ecclesiastical practice. Cabinets of curiosity were, after all, initially assembled to celebrate the glories of god's creation.

But even older forms of display can be recognized. Long barrows, with their chambers, may have helped display the bones of the ancestors, as well as allowing them to circulate. The bones themselves may have been revealed after the body had been de-fleshed possibly after exposure for some time, itself a form of display. I want to argue that display has been a constant feature of life, perhaps since the origins of *Homo sapiens sapiens*. But the modern world has given display new significances, making it more pervasive and apparently normal than in earlier times. The whole process of capitalism leads towards objectification; that is, creating things as separable objects, which can be bought, sold and, above all, owned by individuals. The creation of separable objects is closely connected to the creation of separable human beings. Putting things on display, which is to separate them from the flow of life, was a part of objectification, but only one part. The modern fact that things were set apart from each other generally has made the process of display seem more natural and normal; it is within the nature of objects that they can and should be displayed. In times and places where the links between people and things received more emphasis, picking individual items out for display would have had greater impact, separation lending new and unusual significances to objects or people treated in this way. Thus, although display may be a long-term element of human history, its impact has not remained constant, and we, in the modern world, being most used to displays, are least able to appreciate their effects. Prehistoric display may have been an unusual and powerful social force.

The prehistory of display

Display is not new, although some of its significances may be. I want to argue briefly that British prehistory represents a complex dialectic between hiding and revealing things, both artefacts and human bodies. Placement in tombs, concealment as hoards, burial in pits is all part of an overall process of concealing and revealing which was a vital basis for social power. The irony for the prehistorian is that the things most successfully concealed in the past are those most obvious to us, whereas those that were then revealed now are impossible to perceive. However, since Bradley's argument that material in hoards, burials, pits and single finds are best seen as an overall process of deposition, rather than viewed as individual categories of discard, we can start to appreciate that there may have been an overall logic to the things that were concealed from sight (Bradley 1990). It is a short step to complement this argument with the idea that things revealed may also have been structured by, and linked to, concealment.

When considered from the point of view of display we can see that British prehistory represents a shift from the concealment and display of human bodies in the Neolithic to the display of artefacts using the human body as their medium of exhibition in the Bronze and Iron Ages. Many have emphasized that during the Neolithic in Britain human bones may well have circulated between people on a regular basis, cementing links between groups and between people, places and resources (Jones 2001; Pollard 2001; Thomas 1991). An emphasis on circulation needs to be counter-balanced with ideas on how bones were presenced within the landscape. Bones moved, but they also stayed in place, being exhibited, touched, seen and smelled in various locales across the landscape, primary evidence for which are the mortuary structures, such as long barrows. Displays may well have been intimate, affecting the immediate senses of the participants. Death could have involved a series of episodes of display, from the original exposure of the body to various treatments of the bones as they were made evident at different points on the landscape. A site like Hambledon Hill may well have been a centre for the display and subsequent movement of the dead (Mercer 1980, 63). Not that human bones were always a separate category of the material world and they have been combined and displayed with numerous other materials. Pollard (2001) has usefully pointed out that a whole aesthetics of deposition may have been at work in Neolithic Britain, where things, such as axes, pots, animals and humans, were carefully picked out and combined, to be buried together on sites like Etton or Windmill Hill. Burial may have been only one phase in the use of such materials, with manifold forms of use and display prior to burial.

Opinion on stone circles and henges has recently shifted, moving away from seeing these as settings and backdrops to ritualized actions to considering them as important elements of action. In fact, stone circles and chambered tombs have come to be seen as exhibiting the materials from which they were composed. The colour, texture and origins of the stones

making up various monuments, might have been as important as any mobile material culture used in them. Each stone might sometimes have had its own life history, such as those at Avebury (Gillings & Pollard 1999) and erecting the stone in place would have made various histories visible and tangible. Clay from local streams was used to pack some of the Avebury stones, contrasting with the surrounding chalk in colour, texture and smell. Blocks of Middle and Lower chalk were also used for packing and these materials can only be found deep underground — coming to light briefly, before being buried again (Watson 2001). Avebury was a mini-landscape within the landscape, having its own characteristics of sight, sound and feeling. The materials composing Avebury also made present, in a visible or invisible state, features of the surrounding world. Just as contemporary art practice picks out and highlights aspects of the world for our attention and contemplation, so did complex places like Avebury, which combined and made present features of the world not normally found together, allowing extra thought and reflection concerning those features.

The processes of creating places through monuments continues into the Iron Age, at least. Hillfort ramparts, often faced in white chalk to stand out against a green grassy background, would have been forms of display in their own right, but often also incorporated significant materials within them. At the site of Segsbury next to the Ridgeway on the Berkshire Downs chalk from lower down the geological sequence than the local bedrock was incorporated into the rampart and it is obviously unknown whether this material was made public first (Gosden & Lock in press). Similar findings were made for the Late Bronze Age at nearby Rams Hill. Bradley & Ellison (1975, 210) note the number of stones deposited in the ditch terminals of the main entrance and out of 100 samples, 90 were sarsens (of presumed local origin), nine were red sandstone and one piece of corallian limestone. Elsewhere Greenstone was recovered. The exact origin of the foreign material is unknown, but is almost certain to come either from the Vale of the White Horse or the Corallian Ridge bordering it to the north. There is evidence of foreign material at Liddington, a hillfort further west along the Ridgeway, but all of it was given utilitarian interpretations, such as the sling stones from the river gravels and hematite for smelting. It is also noted, however, that there were limestones and sandstones, which might have been used as a bakestones, although none shows evidence of burning or use (Hirst & Rahtz 1996, 48).

Some continuity throughout prehistory can be seen in the exposure of dead bodies, being the predominant rite from the late Bronze Age to Middle Iron Age in southern Britain, with relatively small numbers of human bones incorporated into boundary ditches and pits in various ways (Carr & Knüsel 1997). Otherwise, new forms of display may be evident by late prehistory. New materials of copper and bronze, complementing gold, opened up new possibilities for creating oneself as a person through novel forms of ornament (Renfrew 2001). Weapons and personal ornaments represent by far the largest

category of metal artefacts in many areas. Bradley (1990, fig. 37) shows the categories of 'La Tène' metalwork recovered from the Thames with spears, swords and brooches being the most common categories, with coins the only other type that was numerous. Horse harnesses and cart/chariot fittings were also found in some numbers. Weapons and personal ornaments concentrated attention on the head, neck and arms and were perceived by others mainly through sight, although to the wearer the feel of weight and movement of things would have been the main bodily effects. Personal weapons and jewellery may have been part of what Gell (1992) has called 'a technology of enchantment', the aims of which were to overawe the viewer, weakening their will to resist any of the strategies of the wearer. The fact that the production of metal artefacts may have been seen as the result of miraculous processes of transformation would only have enhanced these effects.

Looked at in terms of display and concealment, British prehistory from the Neolithic to the Iron Age may represent a shift from the display of human bodies to using the human body to display artefacts. The body is throughout a central metaphor and Jones's (2001, 341–2) concept of citation is useful in looking at how links may have been made between bodies and made objects — decorations on lunulae worn round the neck may have found an echo in the decorations on the 'necks' of pots or axes. Once such flexible links can be made, the possibility for defining different sorts of personhood increase, as indeed do the varieties of definitions and values that can be attached to things. Display may have become more complex and varied as prehistory went by, with hillforts, settlements, battle grounds and places for the exhibition of the dead providing many possibilities for links or juxtapositions between places, people and things.

Making a display — final thoughts

In anthropology there has been a rather unhelpful debate as to whether art or aesthetics was a more useful term for approaching was is often called 'the anthropology of art' (Ingold 1996). I feel the debate was unhelpful as the two words allude to different things. Art can be seen to concern making — the exercise of human skill and ingenuity to create things that have some impact on others. Aesthetics is about appreciation, the skills of perceiving, valuing and using artefacts socially and personally. We are used to the thought that to become a competent artist requires training and practice. We are less aware that our senses need educating not just in the skills of perception, but in the skills of attaching values to the things we perceive. Aesthetics, as I have emphasized elsewhere (Gosden 2001), is not just about great art or the appreciation of beauty, but rather concern the full gamut of reactions to the material world and its social implications. If social relations are set up partly through the effects things have on people (as exampled by Gell's technology of enchantment), then it is necessary to be aware of the links between artefacts, their sensory perceptions and the manner in which perceptions give

values to social relations. This means taking seriously the formal qualities of things and the manners in which the senses may have been educated to perceive these qualities.

Display, which helps single out and to presence objects, can be important both in educating the senses and in producing sensory effects. A single object or an assemblage of objects displayed in some way are separated out from the general background of life, from the taken-for-granted nature of much of the material world. Presencing of objects through display makes people conscious of, and thoughtful about, the objects on display and extra sensitive to their special qualities. Making things present is also linked to concealment. I am intrigued by the site of Seahenge, with its circle of half-planked posts and an up-turned tree in the middle (Pryor 2001, fig. 24). Presuming that the posts were the height of a person or more, they would have restricted the view of those outside the circle. The central tree may have been a symbol in its own right, and it might also have been used for displays of bodies and/or artefacts. There is a complex set of links between concealing internal actions to those outside and revealing various things inside. Of course, the posts would have concealed from sight the activities within the circle; but those without could still hear and smell what happened within. However, only those within would have seen anything displayed on the tree. Many cultures put emphasis on restricted knowledge, with only initiates able to take part in various rituals, to see various forms of artefacts and art, or to understand their full significance (see Morphy's (1991) skilled examination of Aboriginal systems of knowledge in relations to art). Display and concealment are crucial elements of the management of knowledge.

Display is important in many times and places. When combined with strategies of concealment its consequences are important and powerful. The creation of persons and of artefacts, as well as the management of knowledge, can all be brought about by display and the presencing of objects. Display is not simply a feature of the post-Renaissance world and has its own complex histories. These histories can provide considerable insights into prehistoric worlds, as well as the recent historic past.

References

Bradley, R., 1990. *The Passage of Arms: an Archaeological Analysis of Prehistoric Hoards and Votive Deposits.* Cambridge: Cambridge University Press.

Bradley, R. & A. Ellison, 1975. *Rams Hill: a Bronze Age Defended Enclosure and its Landscape.* (British Archaeological Reports 19.) Oxford: BAR.

Carr, G. & C. Knüsel, 1997. The ritual framework of excarnation by exposure as the mortuary practice of the early and middle Iron Ages of central southern Britain, in *Reconstructing Iron Age Societies: New Approaches to the British Iron Age*, eds. A. Gwilt & C. Haselgrove. (Oxbow Monographs 71.) Oxford: Oxbow Books, 167–73.

Carrier, J., 1995. *Gifts and Commodities: Exchange and Western Capitalism since 1700.* London: Routledge.

Elsner, J., 1994. A collector's model of desire, in *The Cultures of Collecting*, eds. J. Elsner & R. Cardinal. London: Reaktion, 154–63.

Gell, A., 1992. The technology of enchantment and the enchantment of technology, in *Anthropology, Art and Aesthetics*, eds. J. Coote & A. Shelton. Oxford: Clarendon Press, 40–67.

Gillings, M. & J. Pollard, 1999. Non-portable stone artefacts and contexts of meaning: the tale of the Grey Wether (www.museums.ncl.ac.uk/Avebury/stone4.htm). *World Archaeology* 31, 170–93.

Gosden, C., 2001. Making sense: archaeology and aesthetics. *World Archaeology* 33, 163–7.

Gosden, C. & G. Lock, in press. The aesthetics of landscape on the Berkshire Downs, in *The Earlier Iron Age in Britain and the Near Continent*, eds. C. Haselgrove & R. Pope. Oxford: Oxbow Books.

Hamell, G.R., 1983. Trading in metaphors: the magic of beads: another perspective on Indian-European contact in northeastern North America, in *Proceedings of the 1982 Glass Bead Conference,* ed. C.F. Hayes III. Rochester (NY): Rochester Museum, 5–28.

Hamell, G.R., 1987. Strawberries, floating islands and Rabbit Captains: mythical realities and European contact in the northeast during the sixteenth and seventeenth centuries. *Journal of Canadian Studies* 21, 72–94.

Hamell, G.R., 1992. The Iroquois and the world's rim: speculation on color, culture and contact. *American Indian Quarterly* 16, 451–69.

Helms, M., in press. Tangible materiality and cosmological others in the development of sedentism, in *Rethinking Materiality: the Engagement of Mind with the Material World*, eds. E. DeMarrais, C. Gosden & C. Renfrew. (McDonald Institute Monographs.) Cambridge: McDonald Institute for Archaeological Research.

Hirst, S. & P. Rahtz, 1996. Liddington Castle and the battle of Badon: excavations and research 1976. *Archaeological Journal* 153, 1–59.

Ingold, T. (ed.), 1996. *Key Debates in Anthropology*. London: Routledge.

Jones, A., 2001. Drawn from memory: the archaeology of aesthetics and the aesthetics of archaeology in earlier Bronze Age and the present. *World Archaeology* 33, 334–56.

Kirschenblatt-Gimblett, B., 1991. Objects of ethnography, in *Exhibiting Cultures,* eds. I. Karp & S. Levine. Washington (DC): Smithsonian Institution Press, 411–23.

Marx, K., 1857. *Grundrisse,* translated by M. Nicolaus. 1973 edition. Harmondsworth: Penguin.

Mercer, R., 1980. *Hambledon Hill: a Neolithic Landscape*. Edinburgh: Edinburgh University Press.

Morphy, H.. 1991. *Ancestral Connections: Art and an Aboriginal System of Knowledge*. Chicago (IL): Chicago University Press.

Pollard, J., 2001. The aesthetics of depositional practice. *World Archaeology* 33, 315–33.

Postgate, N., 1992. *Ancient Mesopotamia: Society and Economy at the Dawn of History*. London: Routledge.

Pryor, F., 2001. *Seahenge: New Discoveries in Prehistoric Britain*. London: HarperCollins.

Renfrew, C., 2001. Symbol before concept: material engagement and the early development of society, in *Archaeological Theory Today*, ed. I. Hodder. Cambridge: Polity Press, 122–40.

Sherratt, A., 1997. *Economy and Society in Prehistoric Europe: Changing Perspectives*. Edinburgh: Edinburgh University Press.

Sillitoe, P., 1988. *Made in Niugini: Technology in the Highlands of Papua New Guinea*. London: British Museum Press.

Thomas, J., 1991. *Rethinking the Neolithic*. Cambridge: Cambridge University Press.

Turner, R. & J. Wymer, 1987. An assemblages of Palaeolithic handaxes from the Roman religious complex at Ivy Chimneys, Witham, Essex. *The Antiquaries Journal* 67, 43–60.

Watson, A., 2001. Composing Avebury. *World Archaeology* 33, 296–314.

Wengrow, D., 2001. The evolution of simplicity: aesthetic labour and social change in the Neolithic Near East. *World Archaeology* 33, 168–88.

The art of decay and the transformation of substance

Joshua Pollard

Theories of representation have been central in archaeological studies of material culture. There has been a focus on understanding objects as signs and symbols, carrying and projecting message and meaning (e.g. Hodder 1982). At one level, objects are seen as a medium of communication, transmitting information about social authority, wealth, identity, gender and theological allegiance. At a more abstract level, they become word-like signifiers within a chain of meaning that provides the building-blocks of systems of cultural order (Tilley 1990); or they serve as material metaphors for concepts that are complex and often difficult to articulate (Tilley 1999). As representations, things are seen to stand for other things, ideas, people or places which are absent: they operate as forms of memory-work (e.g. Finnegan 2002; Kwint *et al.* 1999) and as a means of 'external symbolic storage' (Renfrew & Scarre 1998).

A tacit assumption that objects should embody a degree of stability and durability underpins all these ideas of material representation. After all, stability is often considered necessary to retain any sense of fixity in meaning or value, and is therefore important in allowing the participation of objects in human social projects. In the context of signification, it can be argued that material symbols have to maintain a fixed external appearance for consistency of meaning to be retained. It would seem to follow that changes in state and appearance invoke alterations in meaning, and that if objects serve to create and sustain social relationships, the 'death' of an object through decay or destruction implies the death or transformation of those relationships. This is not to say that the meanings and values of objects are in any sense static, or determined by any inherent essential qualities, as recent studies of the social lives and biographies of artefacts ably demonstrate (e.g. Appadurai 1986; Kopytoff 1986; Thomas 1991; Marshall & Gosden 1999). These illustrate how shifting and contingent the roles, meanings and values of objects can be, and how a transformation in an object's context will often bring about a change in its meaning. As with human agents, the shifting 'identities' of objects are shaped by their involvement in the lives of people and other objects, and by their unique historical trajectory. But even in the context of 'the social life of things', so much of our understanding of material culture is

predicated on the assumption that matter remains in a stable state, or at least undergoes transformation in such a way that its original identity is still apparent (e.g. as in the case of Mediterranean axe amulets: Skeates 1995). However, recognizing that things can have lives to some extent commensurate with those of people forces us to consider more closely the temporality of objects, and therefore the physical as well as ontological changes that objects can undergo through their existence. Miller writes of three temporal qualities in things: longevity (establishing connections beyond individual lives); temporal identity (a temporal equivalence between persons and things); and transience (an ephemeral nature) (Miller 1994, 413). In this context, material transience is identified in terms of the currency of certain things (e.g. fashion items); such ephemerality frequently, but erroneously, being registered as a peculiar condition of modernity (Miller 1994, 413).

What I would like to do here is explore the notion of transience in a different sense, focusing on the transformation of objects and materials through the processes of attrition, decay, mutation and metamorphosis. This will be achieved through reference to both archaeological case studies and contemporary artworks. I would like to suggest that the instability of certain things and substances is just as interesting as the stability of others, because it shifts attention from a focus on representation to a more involved comprehension of materiality and material agency. By materiality I mean how the material character of the world is comprehended, appropriated and involved in human projects.

The transformation of matter brings with it transformations in its physical and ontological qualities, significance and meanings. This is reasonably well understood in the context of productive technology, but perhaps less so when considering decay and attrition. Within archaeological practice the prior destruction and decay of objects is imbued with largely *negative* connotations, particularly since it is viewed as creating a distortion in an archaeological 'record' that hinders the successful reconstruction of past social life.[1] The result has been the formulation of a science of decay and transformation specifically directed at establishing ways of filtering-out such 'post-depositional' processes (Schiffer 1976; 1987). Rarely do we consider that some things were perhaps intended to break and decay as a part of their role in social practices, and that such transformation might have carried with it *positive* connotations. Just as human death might be inextricably linked with physical, symbolic or spiritual regeneration (Bloch & Parry 1982), so too might that of materials; as seen through processes of recycling, for example. There are also cathartic properties to the destruction and riddance of those things that carry with them an 'excess' of unfavourable associations.

Dealing with fragmentation

Influenced by a biographical approach to material culture, a number of studies have recently explored how broken and transformed materials

operated within varied social strategies during later European prehistory.

The destruction of material symbols as part of social displays has been recognized for some time, principally in the context of votive deposits of weaponry (Bradley 1990). Such practices have a long ancestry. Deposits of deliberately broken pots and fire-transformed flint axes have been recovered from Neolithic settlements, enclosures and megalithic tombs in southern Scandinavia (Tilley 1996, 303; Larsson 2000). Larsson has made the interesting observation that the burning of axes may have been undertaken in order to transform the colour of the flint from black or grey to white, mimicking the effect achieved in the cremation of human remains (2000, 609). As with later metalwork deposits, however, conspicuous destruction and offering 'intended to impress human as well as supernatural beings' is the rationale favoured by Larsson for these transformative practices (Larsson 2000, 609).

Recognizing the way in which people and objects are mutually constituted through their involvement in social projects, Chapman (2000a) has recently provided a more sophisticated interpretation of deliberate object breakage. In a study of the Neolithic and Chalcolithic of the Balkans, he argues for the widespread breakage and structured deposition of objects as a part of strategies designed to mark formal relationships between people. Objects were, according to Chapman, broken and divided between individuals as tokens of a relationship, or to conclude some kind of transaction. Further fragmentation could occur with an extension of these transactions to include third parties; with the formal deposition of artefact fragments occurring upon the close of these relationships (Chapman 2000a, 6). Breakage, and the subsequent distribution of broken parts, therefore facilitated a linking of people through a process of enchainment. People as 'dividuals' (see Strathern 1988) were exchanging something of themselves as they exchanged fragmented objects, creating a chain of personal (and object) relations (Chapman 2000a, 5). Fragments could stand not only for an individual transaction and a single party, but for the whole, *pars pro toto*. In the context of enchainment 'each part of a fragmented object stands for not only the rest of the artefact but both persons concerned with the exchange' (Chapman 2000a, 37). Although identifying such practices archaeologically might prove difficult, the strengths of Chapman's elucidation of enchainment lies in the possibilities it offers for understanding how particular material conditions may have been imbricated in complex social strategies, and in drawing attention to the significance that objects may continue to hold beyond their formal 'death'.

A similar extension of personhood over long temporal and spatial domains can also operate in the context of accidental artefact breakage. Woodward has described how early Bronze Age amber beads from erstwhile necklaces and portions of broken Beakers sometimes possessed surprisingly long lives by functioning as heirlooms or relics (Woodward 2002). Perhaps 'stored' in middens to be later retrieved and re-deployed, portions of pottery

vessels were occasionally deliberately curated (Woodward 2002, 1041), seen in a recent find of two broken Beakers in association with a hoard of gold armlets and a copper dagger from Lockington, Leicestershire (Hughes 2000). Woodward argues that the ancestral connotations of these fragmented objects were significant, serving as mnemonic materials to facilitate 'remembrance of things past' (2002, 1041). In the case of pottery, a sense of connection with a vessel's original maker or owner could be maintained through their secondary use as a source of grog to be incorporated into newly fabricated vessels, 'thus the essence of important pots belonging to significant individuals or families could be preserved and passed down through the generations in a finite and often visible form' (Woodward 2002, 1041). In some instances grog pieces were left sufficiently large to remain visible in the walls of newly constructed pots (Brown 1995, 127).

At the very least these studies demonstrate how fragmented objects can acquire a more central social role than simply as materials with recycling potential. They touch upon an interesting material extension of personhood, and hence human agency, and define an extension to object lives beyond that conventionally accepted. However, at heart, the substance stays the same and original identities are retained: a sherd still stands for the pot from which it originally came, a bead for a necklace and an axe fragment for an axe. I would argue that we should go beyond these limits and begin to consider how the transformation of things through processes of breakage, decay and attrition opens up possibilities for new materialities to emerge; situations which allow the coming into being of new and sometimes unimagined and unintended object forms and kinds of substance, and which allow the conceptualization of new ontological states. This involves working at the boundaries of commonly accepted archaeological approaches to material culture — moving beyond the concept of symbol, and thinking of kinds of material agency that are more than a proxy or extension of human agency. It is here that direction may be provided by those forms of art practice — both western 'concept' and 'environmental' art, and certain non-western 'traditional' art — which engage with the mutable potential of materials. Here art has the potential to inform our understanding of materiality, creating an intellectual space in which to think through the materialness of human and artefact existence (see Renfrew 2003).

Thinking through artworks

From the outset, I do not think we need perpetuate the unhelpful distinction often drawn between art and artefact. As Gell (1996) states, the distinction between 'artworks' and mere 'artefacts' is often very fragile, resting upon the reactionary premise that one embodies certain aesthetic qualities, skills of production, and is 'authored' by an acknowledged artist rather than artisan, while the other is simply 'functional'. This distinction dissolves in the post-Duchampian tradition of concept art, where art categories may not have

particular rarified visual qualities ('beauty'), nor embody great craftsmanship in production, but work as art because they are vehicles for the contemplation of complex ideas. Of course, artefacts too can be vehicles for the contemplation of complex, polysemic and often ambiguous or unresolvable ideas, as attempts at recovering the 'meanings of things' ably demonstrate (e.g. Edmonds 1992).

Environmental art and material transformation

Art is frequently conceptualized as a medium that remains stable, enduring and timeless. Much western art has been produced to transcend time, and so to memorialize both the artist and/or those subjects which it seeks to depict. But the process of commodification defines another motivation for the creation of inherently stable and permanent artworks, beyond that of their role as memory-works. Since the beginning of the early modern period, and the increasing secularization of image, artworks have been reconfigured as alienable commodities that might be openly bought, sold and exchanged. In consequence, the conservation of painting and sculpture has become a major concern, since decay of the art object is seen as the loss of something of both cultural *and* monetary significance.

The rarification and commodification of the art object was radically challenged from the 1960s onwards with the emergence of conceptual and environmental art (Kastner & Wallis 1998; Wood 2002). Early forms of environmental art in particular, such as that of Robert Smithson and Michael Heizer (the son of an archaeologist), openly worked in resistance to a culture of acquisition, challenging the 'static and fetishized character of modernist sculpture' (Wallis 1998, 24). In 1969 Robert Morris, who was involved in the influential 1968 'Earthworks' project, wrote that:

> what art now has in its hands is mutable stuff which need not arrive at a point of being finalized with respect to time and space. The notion that work is an irreversible process ending in a static icon-object no longer has much relevance. (quoted in Wallis 1998, 24)

Despite the massive scale of many of these works (there at the beginning with *Double Negative*: 1969–70), Heizer and others were fascinated by the temporary nature of their creations — they were as much anti-monuments as monuments. They embodied a concern with the decay, dispersion and replacement of materials, with the transfer of energy through processes such as decomposition and sterilization, and with transgressive qualities which questioned the distinction between 'natural' forms and those generated by human agency (Wallis 1998, 29). This was artwork with the potential to take on new and unimagined directions, and which often worked beyond the control of the artist. Entropy — the degradation of matter and energy in a trend to disorder — was an intellectual issue in Robert Smithson's *Partially Buried Woodshed*, installed at Kent State University, Ohio, in 1970. Here, a wooden shed was partially buried by soil and allowed to rot slowly, leaving the subsequent form and composition of the work to be dictated by natural forces (Kastner & Wallis 1998, 99).[2]

This engagement with ephemeral matter can be traced in the work of contemporary British environmental artists such as Richard Long and Andy Goldsworthy. Long's work is well known to archaeologists (e.g. Renfrew 1997; 2003), and indeed often takes its inspiration from prehistoric monuments (Fuchs 1986). His repertoire of work includes structured landscape walks, and simple constructed geometric forms in unmodified materials such as stone, mud and wood. Physical impermanence lies at the heart of his work, perhaps operating as a resistance against the dominant belief that art objects should somehow serve to project visions of the present into an unbounded future (Fuchs 1986, 45). Impermanence is conceived by Long as a way of making artworks more human, 'their limited physical existence in the world resembling the impermanence and reality of human life' (Fuchs 1986, 45).

Goldsworthy's work has a particular vibrance. At one level he is engaged in producing sculptures of an undeniable aesthetic quality, combining mixed media in rich colours, forms and textures (Goldsworthy 1999; 2000; 2001). But, like Long, the power of his work also lies in its challenge to established understandings of art and materiality. Many of his sculptures are very transitory and ephemeral, being constructed from natural materials such as stone, sand, wood, ice, snow, clay and leaves. An explicit awareness of time and process, and the way in which time is embedded within places and things, is a dominant theme, as with *Midsummer Snowballs* (2000) and the *Arch* (1999–2000). Constructed over the turn of the new millennium, the latter spanned both space and time; while the material-filled snowballs positioned around central London were made at the very end of the twentieth century and 'released' at the very beginning of the twenty-first century, on Midsummer's Day 2000 (Goldsworthy 2000; 2001). Goldsworthy's and Long's work captivates not just because of its aesthetic quality — its symmetry, geometry, texture and colour — but also because of its unfolding process.

For Goldsworthy the interaction between the processes of growth and decay, construction and deconstruction is an integral part of a work's purpose (Friedman 1996, 7). He sees the work as becoming 'stronger and more complete as it falls apart and disappears' (Goldsworthy 2000, 7). This is explicit with *Snowballs* where the materials contained within them — cow hair, chalk, pine needles, branches, barley and metal — are slowly released as the snow melts, generating new and often uncontrolled patterns (Goldsworthy 2001) (Plate 4.1).[3] The work's strength derives in large part from this aleatory quality. Goldsworthy talks of 'energies' within his sculptures and materials; this energy coming from movement, growth and decay, but also from the momentary intensity of certain works (fleeting times when pieces come 'alive') created through accidental illumination or transformation (Goldsworthy, quoted in Friedman 1996, 10). In an interview with John Fowles, Goldsworthy expanded on this sense in which his work generated or channeled 'energies':

PEBBLES

METAL

Working with nature means working on nature's terms … Movement, change, light, growth and decay are the life-blood of nature, the energies that I try to tap through my work. I want to get under the surface. (2000, 189)

Intriguingly, the talk of 'energies' and tensions between surfaces and inner qualities has resonance with certain, non-western indigenous understandings of artworks, for example Huichol votive bowls (Shelton 1992) and *malanggan* sculpture. For the Huichol of Mexico the true world is one of essences hidden behind the appearances of everyday 'reality', such essence (*iyári*: 'food of the heart') being considered essential to life and inherent in all physical things (Shelton 1992, 231). This essence can only be perceived through skilled and tutored perception that sees beyond the 'skin' or surface of the thing itself.

Malanggan

Traditions of deliberately ephemeral 'artworks' are also known from Oceania and western Africa, notably amongst objects produced as a part of funerary rituals. These include the *rambramb* of the Solomon Islands, the *malanggan* of New Ireland, the *mbitoro* of the Papuan Gulf, and the *ndavos* of Cameroon (Küchler 1997; Argenti 1999). Here sacrificial objects are produced that will become temporary receptacles for the 'life-force' or 'vital energies' of the dead, which are then released through the destruction of that object. The process is one intended to presence and contain potentially dangerous forces which are then dispersed in such a manner that they will not haunt or harm the living (Küchler 1997, 40). The 'destruction' of such objects can take the form of

4.1 *Snowballs* (after Goldsworthy 2001).

deliberate breakage, decomposition or physical removal (including by western collectors).

The most extensively documented of these are the *malanggan* of New Ireland (Bodrogi 1987; Küchler 1992; 1993; 1997): the name refers both to memorial festivals in honour of the dead, often held several months or even years after death, and the carvings used in these ceremonies. Combining anthropomorphic and zoomorphic elements, the sculptures are elaborately carved and painted. They can represent a specific dead person, generally related to the departed, or particular mythic characters (Bodrogi 1987, 26).

A simple distinction between sentient subjects and inanimate objects is dissolved in *malanggan*. Their creation is a process that is seen as analogous to conception and the generation of life (Küchler 1992, 96). The process of carving is itself lengthy, involving periodic drying and maturing of the wood, and is broken by episodes of feasting and ceremony. The carving is called 'the making of skin' (*tetak*) (Küchler 1992, 103), and is a generative practice which is seen to allow the gradual materialization of a hidden interiorized form (Küchler 1993, 94). Carving also captures the energy or 'life force' (*noman*) that is released following the death of an individual and which is seen to grow alongside bodily decomposition. That force is channeled into the carving so that the sculpture itself becomes alive as a container for the life force. In fact, the sculpture simultaneously synthesizes seemingly disparate aspects of social reproduction: as a vessel for the life force of the deceased marking relationships between mourners; and, via the places from which wood is taken for the carvings, reinstating relationships between the living, the dead and the land (Küchler 1992, 104). *Malanggan* are, therefore, not simply representational 'artworks', but act both as vehicles for a raw generative energy and as memory-works tied into structures of inheritance and landholding.

As highly potent objects housing potentially dangerous spirit agencies, the lives of *malanggan* are rigidly finite. Following brief display during funerary rites in specially constructed enclosures, they must be destroyed, allowed to decay, or taken away either 'to forestall their use in sorcery' (Gunn 1987, 74), or to counteract any malevolence on the part of the life-force inhabiting the sculpture. Their 'accessibility' is consequently limited to just those few hours when on display (Küchler 1992, 95). *Malanggan* ceremonies revolve around a process of riddance and forgetting which links together the decomposition of the corpse and sculpture, and the burning of the house of the deceased and the destruction of their gardens (Küchler 1992, 105). Following this the sculptures only exist as recollected images that are owned as a form of mental property. Their very potency resides in their impermanency.

Avoided Object: the work of Cornelia Parker

There is a material violence to certain traditions of deliberately ephemeral funerary sculpture, including that of *malanggan*, which finds resonance in the

work of British conceptual artists such as Damien Hurst and Cornelia Parker (see Renfrew, this volume). But this 'violence', seen in the cutting, crushing, combusting and colliding of materials, stems from a concern with the transmutability of matter and the transformations achieved via the different contextual states that matter can move through. Much of Parker's work is about the transformation of seemingly solid objects, involving acts of creation and re-contextualization through destruction (Cameron 1996). While pieces like *Cold Dark Matter*, an exploded and reconstituted garden shed (1991), and *Thirty Pieces of Silver*, a collection of silver plate crushed by a steam roller (1988/89) (Plate 4.2), have an undeniable comic or cartoonish character, they also serve as metaphors for release from binding conventions (Brett 1996, 18). Original references are lost and new connections are generated:

> through the process of the work, discrete objects are rendered fallible; they become galaxies of permeable fragments, at once anchored and drifting and, as such, their meanings are contestable; they invite new narratives. (Payne 1996, 43)

Drawing the fragments together

What connects the work of Richard Long, Andy Goldsworthy, Cornelia Parker and *malanggan* sculptors, beyond an interest in the transformative nature of materials, and how can such work help us in our understanding of past materialities? To begin with, it avoids the kinds of essentialism seemingly implicit in the archaeological studies of object fragmentation cited above. These have tended to see the transformed object as a fraction of its former self. In such a perspective, no matter how much you break something down and rework it, it still retains an 'essence' of its original state. But these artworks ably demonstrate quite the opposite. Breakage, decay and attrition have the potential to create entirely new kinds of substance, and often novel and unimagined points of connection between different materials and ontological states. Secondly, and in part because of their mutability, we find ourselves faced by object creations that do not always display an immediate and containable meaning, in the sense of being 'signifiers' for a separated

4.2 *Thirty Pieces of Silver*, detail (after Parker 1996).

'signified', be that a concept, person or thing. This is not to say that such artwork is 'meaningless', but that any reading inscribed upon it is secondary to the act of its creation and subsequent transformation. At the very least, the generation of meaning is not their primary purpose; these are works that are created to elicit an emotive response, or to facilitate the channeling of creative 'energies', be that the 'life-blood' of nature talked about by Goldsworthy or the *noman* of *malanggan*. Of course, to talk of energies is to be complicit in the 'indigenous' readings offered by artists and object creators, since it runs counter to established western scientific and philosophical traditions of materiality. But as archaeologists seeking to engage with the possibilities of different and even quite alien ways of understanding, we are not, I hope, interested in simply reproducing the specificity of western scientific discourse in our accounts of the past.

By shifting the focus from meaning to effect, consideration has to be given to the aesthetic currency of these creations and their agency (here aesthetics relates to culturally-specific judgements of the effective qualities of things or actions: Coote & Shelton 1992, 9). In each instance, this agency seems most evident at the point of transformation, where a heightened awareness of the qualities of material and its departure into new configurations becomes visibly apparent. Gell's (1998) influential study provides a starting point, but in his formulation objects act as agents only in so much as they provide a derivative or extended form of human agency. In response, Gosden (2001, 165) has suggested that things should not be perceived as 'secondary' agents (as an index of a person's effective action and desires), but that they operate their own form of agency in the manner of *things* rather than the manner of people:

> An object with new or subversive sensory qualities will send social relations off down a new path, not through any intention on the part of the object, but through its effects on the sets of social relations attached to various forms of sensory activity. (Gosden 2001, 165)

In this way objects have the capacity to re-channel human actions and perceptions of the world; and a recognition of this helps to overcome the prioritization of human over natural agency which may be limiting our understanding of materiality (Hallam & Hockey 2001, 116). Spyer likewise notes the power of objects 'to entrance, raise hopes, generate fears, evoke losses, and delight' (1998, 5). This emotive power is strongest in those things which may be deemed to hold an 'excess' of association, for example the personal effects of a deceased friend, partner or relative; or which 'by virtue of their insistent materiality and their capacity to transgress "orderly" systems of classification, become "other" in relation to the pliable domain of unthreatening everyday things' (Hallam & Hockey 2001, 117). Fetish objects provide a case in point — powerful constructions that seem to disrupt conventional theories of representation and the mind:matter, animate:inanimate dualities. To Pels, the fetish disrupts those theories that see everything as representation (an endless sequence of signifiers and signified)

since it provides a 'counterbalancing materiality' through its powerful presence, a presence that is too much to make the object 'a mere re-presentation of something else' (Pels 1998, 113):

> Fetishism says things can be seen to communicate their own messages. The fetish's materiality is not transcended by any voice foreign to it: To the fetishist, the thing's materiality itself is supposed to speak and act; its spirit is *of* matter. (Pels 1998, 94)

We should avoid the notion that human action and intention can always transcend materiality, and recognize how the materiality of things can disrupt and deflect human intentions. Objects can, unwittingly, carry forth their own projects.

Neolithic materialities

I would now like to take some of these issues further through a consideration of certain Neolithic materialities. The period is one that is frequently seen as marking an important series of social, material and ideological changes (Cauvin 2000; Thomas 1999; Whittle 1996), though the extent to which this holds true for all regions of Europe is open to debate (e.g. Zvelebil 1998). At the risk of generalization, however, a sense of commonality can be detected not just in a heightened interest in the symbolic potential of the material world (Hodder 1990; Cauvin 2000; Renfrew 2001), but, I would argue, also in the transformative nature of substances. This is seen in the development of ceramic technologies, plant cultivation, and in the Near East and Balkans with the use of new materials such as plaster and daub. It also extends to treatment of the human body following death. While by no means universal across Neolithic Europe and southwest Asia, extended mortuary practices were often employed which were designed to break down the human body in a structured manner. The specific details of these practices vary, involving post-burial skull removal in the PPNB of the Near East and Anatolia (Kuijt 2000; Rollefson 2000), and excarnation and disarticulation as a part of corporate burial in regions such as Britain and southern Scandinavia. Here, decay and disarticulation perhaps served as a means of releasing life-forces or vital energies and assisting in the transformation of people from corporeal entities into the material embodiment of ancestor spirits (Tilley 1996, 221–43; Thomas 1999, 127–51). Decay effected a radical reconfiguration of substance.

The human dead, however, were not alone in being subject to complex 'post-life' treatment. PPNB figurines were frequently decapitated in the same way as their human counterparts (Kuijt 2000; Rollefson 2000), and formal burials of pottery sherds, stone tools and animal bones are widely attested (Chapman 2000b; Thomas 1999, 62–88). As deliberately-buried selections of transformed materials, the latter are of particular interest (Plate 4.3). Such 'structured deposits' occur in association with occupation sites in the Balkans (Chapman 2000b), and, among other contexts, in pits and enclosure ditches in northwestern Europe. What is interesting is that so many of these materials

had undergone a degree of transformation through decay, weathering and attrition prior to burial: pot sherds display abraded break surfaces and animal bones signs of gnawing. Mixed with charcoal-rich soils, many of these deposits may represent the partial or wholesale burial of middens, perhaps undertaken at important temporal junctures, for example when occupation sites were formally abandoned (Pollard 2001). These acts of deposition have been variously interpreted in the context of reproducing culturally-specific schemes of symbolic order, as an aspect of social display, or a form of non-verbal symbolic communication (e.g. Chapman 2000b; Pollard 1995; Thomas 1999). The care often expended in the arrangement and placement of these deposits also alludes to the aesthetic qualities of their performance (Pollard 2001).

While it is possible to see the individual elements of these deposits as important in their own right, perhaps as symbols of domestic production, sharing and consumption, their transformed nature should not be ignored. Through slow accumulation in middens, partial decay, mixing and re-deposition, a matrix was created that may have been perceived as a new and potent substance in its own right, one that condensed the multiple identities of the makers and consumers of these erstwhile objects, their connections and energies. Drawing analogy from the work of Cornelia Parker, here original references were lost and new connections generated. Those connections could be reinforced through a process of re-assembly where similar or quite disparate materials were worked together. There are a number of recorded instances from the European Neolithic of objects, people and animals being 're-formed' following their disaggregation. Examples include paired cattle jaws at the Cerny enclosure of Balloy (Andersen 1997, fig. 257), and a partially articulated cattle carcass re-assembled in the ditch of the Kingston Deverill long barrow, Wiltshire (Harding & Gingell 1986). In other instances re-assembly involved combining transformed skeletal elements that originally belonged to separate individuals, or even different species. Several 'skeletons' interred in the chambered tombs of Penywyrlod and Pipton in the Black Mountains of South Wales were constructed using bones from different individuals (Wysocki & Whittle 2000, 598), while at the Windmill Hill enclosure, Wiltshire, one deposit included a human infant femur inserted into

4.3 *Transformed Matter*, midden material in the ditches of the Windmill Hill enclosure (after Whittle *et al.* 1999).

the shaft of an ox humerus (Whittle *et al.* 1999, 206). Though rarely worked with as much physicality as the latter, mixed human and animal bone groups are ubiquitous in enclosure ditch deposits of the period (Andersen 1997). It is necessary to ask what these deposits were considered to have become — stripped of their original connections by a process of defleshing and disarticulation, then re-assembled, were they still 'of people', 'of animals', a mixture of the two, or something ontologically quite different?

I would argue that this 'play' with materials, their transformation, re-contextualization and recombination, gave the potential to think of previously unimagined connections between things and so facilitated the creation of heterogeneous and hybrid objects. Perhaps here we have a context for comprehending those objects which seemingly embody a process of transmutation, such as *Körös* and *Linearbandkeramik* figurines that combine human, animal and object forms (e.g. Korek 1972, pls. 2–5), or the 'monstrous' two-headed PPNB plaster statues from 'Ain Ghazel, Jordan (Rollefson 2000). Engaging with the transformative qualities of materials allowed the making of the previously unimagined (Plate 4.4), and created a world that was understood as much through on-going processes as it was through fixed and immutable categories. As a final thought, was it this openness to the new and unexpected, created through a explorative material engagement, that made social and economic transformations such as domestication and the adoption of new productive technologies possible?

Conclusion

While providing important insights into the way in which material culture is actively constituted and embedded within human social life, a dominant concern with material symbolism and the 'meanings of things' has clouded other perspectives. Engaging with issues of materiality and embodiment will open a new intellectual landscape, allowing us to move beyond, yet still acknowledge the importance of, 'talk of abstract symbols, signs and signifiers' (Graves-Brown 2000, 4). The first stage is to recognize the difference between words and things. As Miller states:

> Artefacts are very different from words, and when we talk about the meaning of things we are primarily concerned with questions of 'being' rather than questions of 'reference'. Artefacts are a means by which we give form to, and come to an understanding of, ourselves, others, or abstractions … It is in this broad sense that their very materiality becomes problematic. (1994, 397)

4.4 *Recombined Matter*, a hybrid Körös figurine (after Korek 1972).

Like people, material things are processes, brought into being through production, embroiled in on-going social projects, and requiring attentive engagement. Their very materialness provides them with the capacity to redirect human intentions and engender reflection on the conditions and nature of being. This is where their real agency resides, because they cannot always be captured and contained (Pels 1998).

Here I have stressed the importance of understanding the transformative potential of materials. It is through processes of deliberate destruction, decay and transmutation that a heightened sense of materiality and material agency is developed, and the truly problematic nature of essentialism exposed. As ably demonstrated in the artworks of Andy Goldsworthy, Cornelia Parker and others, the breaking down of objects and substances frees them from the binding conventions of categorization, and allows their recombination in new and hybrid forms. Far from being imbued with negative qualities, the productive and generative potential of breakage and decay must be acknowledged. This has important implications for the way in which we approach the understanding of past materialities.

Acknowledgements

I would like to acknowledge the influence of the work of Lesley McFadyen and Mark Knight, for making me think more critically about materiality, fragmentation and assembly work, without implicating them in anything expressed here. Thanks are also due to Miranda Aldhouse-Green and Patty Baker for commenting on a draft of the paper.

Notes

1. Ruin, decay and loss were topics frequently meditated upon in early antiquarianism — from Browne's *Urne-Burial* (1658) to Colt Hoare on the sublime power of Stonehenge's romantic dilapidation (Robinson 2003, 116). The interest is in seemingly solid things that, with the passage of time, became unstable.
2. Ironically, this work soon took on new meaning as a *memorial* to students killed by National Guardsmen at Kent State during protests on 4 May 1970 (Wallis 1998, 32).
3. Archaeological metaphors are also implied. One snowball contained rusted iron objects gathered from fields and farms, the memory of 'hand and machine that have worked the land'; 'when it comes to the melt, they will appear as archaeological objects from a dig' (Goldsworthy 2001, 44).

References

Andersen, N., 1997. *Sarup*, vol. 1: *The Sarup Enclosures*. Moesgaard: Jutland Archaeological Society.

Appadurai, A. (ed.), 1986. *The Social Life of Things: Commodities in Cultural Perspective*. Cambridge: Cambridge University Press.

Argenti, N., 1999. Ephemeral monuments, memory and royal sempiternity in a Grassfields kingdom, in *The Art of Forgetting*, eds. A. Forty & S. Küchler. Oxford: Berg, 21–52.

Bloch, M. & J. Parry (eds.), 1982. *Death and the Regeneration of Life*. Cambridge: Cambridge University Press.

Bodrogi, T., 1987. New Ireland art in cultural context, in *Assemblage of Spirits: Idea and Image in New Ireland*, ed. L. Lincoln. New York (NY): George Braziller/Minneapolis Institute of Arts, 17–32.

Bradley, R., 1990. *The Passage of Arms: an Archaeological Analysis of Prehistoric Hoards and Votive Deposits*. Cambridge: Cambridge University Press.

Brett, G., 1996. The maybe, in *Avoided Object*, C. Parker. Cardiff: Chapter, 11–19.

Brown, N., 1995. Ardleigh reconsidered: Deverel-Rimbury pottery in Essex, in *'Unbaked Urns of Rudely Shape': Essays on British and Irish Pottery for Ian Longworth*, eds. I. Kinnes & G. Varndell. Oxford: Oxbow Books, 123–44.

Cameron, S., 1996. Foreword, in *Avoided Object*, C. Parker. Cardiff: Chapter, 5–6.

Cauvin, J., 2000. *The Birth of the Gods and the Origins of Agriculture*. Cambridge: Cambridge University Press.

Chapman, J., 2000a. *Fragmentation in Archaeology: People, Places and Broken Objects in the Prehistory of South-eastern Europe*. London: Routledge.

Chapman, J., 2000b. Pit-digging and structured deposition in the Neolithic and Copper Age of Central and Eastern Europe. *Proceedings of the Prehistoric Society* 66, 61–87.

Coote, J. & A. Shelton, 1992. Introduction, in *Anthropology, Art and Aesthetics*, eds. J. Coote & A. Shelton. Oxford: Clarendon Press, 1–11.

Edmonds, M., 1992. 'Their use is wholly unknown', in *Vessels for the Ancestors: Essays on the Neolithic of Britain and Ireland in Honour of Audrey Henshall*,

eds. N. Sharples & A. Sheridan. Edinburgh: Edinburgh University Press, 179–93.

Finnegan, R., 2002. *Communicating: the Multiple Modes of Human Interconnection*. London: Routledge.

Friedman, T., 1996. Stonewood, in *Wood*, A. Goldsworthy. London: Viking, 6–12.

Fuchs, R.H., 1986. *Richard Long*. London: Thames & Hudson.

Gell, A., 1996. Vogel's net: traps as artworks and artworks as traps. *Journal of Material Culture* 1(1), 15–38.

Gell, A., 1998. *Art and Agency: an Anthropological Theory*. Oxford: Oxford University Press.

Goldsworthy, A., 1999. *Arch*. London: Thames & Hudson.

Goldsworthy, A., 2000. *Time*. London: Thames & Hudson.

Goldsworthy, A., 2001. *Midsummer Snowballs*. London: Thames & Hudson.

Gosden, C., 2001. Making sense: archaeology and aesthetics. *World Archaeology* 33(2), 163–7.

Graves-Brown, P., 2000. Introduction, in *Matter, Materiality and Modern Culture*, ed. P. Graves-Brown. London: Routledge, 1–9.

Gunn, M., 1987. The transfer of Malagan ownership on Tabar, in *Assemblage of Spirits: Idea and Image in New Ireland*, ed. L. Lincoln. New York (NY): George Braziller/Minneapolis Institute of Arts, 74–83.

Hallam, E. & J. Hockey, 2001. *Death, Memory & Material Culture*. Oxford: Berg.

Harding, P. & C. Gingell, 1986. The excavation of two long barrows by F. de M. and H.F.W.L. Vatcher. *Wiltshire Archaeological and Natural History Magazine* 80, 7–22.

Hodder, I. (ed.), 1982. *Symbolic and Structural Archaeology*. Cambridge: Cambridge University Press.

Hodder, I., 1990. *The Domestication of Europe*. Oxford: Blackwell.

Hughes, G., 2000. *The Lockington Gold Hoard: an Early Bronze Age Barrow Cemetery at Lockington, Leicestershire*. Oxford: Oxbow Books.

Kastner, J. & B. Wallis (eds.), 1998. *Land and Environmental Art*. London: Phaidon.

Kopytoff, I., 1986. The cultural biography of things: commoditization as process, in *The Social Life of Things: Commodities in Cultural Perspective*, ed. A. Appadurai. Cambridge: Cambridge University Press, 64–91.

Korek, J., 1972. Katalog der ausgestellten Funde, in *Idole: Prähistorische Keramiken aus Ungarn*. Vienna: Verlag Naturhistorisches Museum, 31–51.

Küchler, S., 1992. Making skins: *Malangan* and the idiom of kinship in northern New Ireland, in *Anthropology, Art and Aesthetics*, eds. J. Coote & A. Shelton. Oxford: Clarendon Press, 94–112.

Küchler, S., 1993. Landscape as memory: the mapping of process and its representation in a Melanesian society, in *Landscape: Politics and Perspectives*, ed. B. Bender. Oxford: Berg, 85–106.

Küchler, S., 1997. Sacrificial economy and its objects: rethinking colonial collecting in Oceania. *Journal of Material Culture* 2(1), 39–60.

Kuijt, I., 2000. Keeping the peace: ritual, skull caching, and community integration in the Levantine Neolithic, in *Life in Neolithic Farming Communities: Social Organization, Identity, and Differentiation*, ed. I. Kuijt. New York (NY): Kluwer Academic/Plenum Publishers, 137–64.

Kwint, M., C. Breward & J. Aynsely (eds.), 1999. *Material Memories: Design and Evocation*. Oxford: Berg.

Larsson, L., 2000. The passage of axes: fire transformation of flint objects in the Neolithic of southern Sweden. *Antiquity* 74, 602–10.

Marshall, Y. & C. Gosden (eds.), 1999. *The Cultural Biography of Objects*. (= *World Archaeology* 31(2)).

Miller, D., 1994. Artefacts and the meaning of things, in *Companion Encyclopedia of Anthropology: Humanity, Culture and Social Life*, ed. T. Ingold. London: Routledge, 396–419.

Parker, C., 1996. *Avoided Object*. Cardiff: Chapter.

Payne, A., 1996. Neither from nor towards, in *Avoided Object*, C. Parker. Cardiff: Chapter, 39–50.

Pels, P., 1998. The spirit of matter: on fetish, rarity, fact, and fancy, in *Border Fetishisms: Material Objects in Unstable Spaces*, ed. P. Spyer. New York (NY): Routledge, 91–121.

Pollard, J., 1995. Inscribing space: formal deposition at the Later Neolithic monument of Woodhenge, Wiltshire. *Proceedings of the Prehistoric Society* 61, 137–56.

Pollard, J., 2001. The aesthetics of depositional practice. *World Archaeology* 33(2), 315–33.

Renfrew, C., 1997. Setting the scene: Stonehenge in the round, in *Science and Stonehenge*, eds. B. Cunliffe & C. Renfrew. Oxford: Oxford University Press (= *Proceedings of the British Academy* 92), 3–14.

Renfrew, C., 2001. Symbol before concept: material engagement and the early development of society, in *Archaeological Theory Today*, ed. I. Hodder. Cambridge: Polity Press, 122–40.

Renfrew, C., 2003. *Figuring It Out: the Parallel Visions of Artists and Archaeologists*. London: Thames & Hudson.

Renfrew, C. & C. Scarre (eds.), 1998. *Cognition and Material Culture: the Archaeology of Symbolic Storage*. (McDonald Institute Monographs.) Cambridge: McDonald Institute for Archaeological Research.

Robinson, D., 2003. 'A feast of reason and a flow of soul': the archaeological antiquarianism of Sir Richard Colt Hoare. *Wiltshire Archaeological and Natural History Magazine* 96, 111–28.

Rollefson, G.O., 2000. Ritual and social structure at Neolithic 'Ain Ghazal, in *Life in Neolithic Farming Communities: Social Organization, Identity, and Differentiation*, ed. I. Kuijt. New York (NY): Kluwer Academic/Plenum Publishers, 165–90.

Schiffer, M., 1976. *Behavioral Archaeology*. New York (NY): Academic Press.

Schiffer, M., 1987. *Formation Processes of the Archaeologi-*

cal Record. Albuquerque (NM): University of New Mexico Press.

Shelton, A., 1992. Predicates of aesthetic judgement: ontology and value in Huichol material representations, in *Anthropology, Art and Aesthetics*, eds. J. Coote & A. Shelton. Oxford: Clarendon Press, 209–44.

Skeates, R., 1995. Animate objects: a biography of prehistoric 'axe-amulets' in the central Mediterranean region. *Proceedings of the Prehistoric Society* 61, 279–301.

Spyer, P., 1998. Introduction, in *Border Fetishisms: Material Objects in Unstable Spaces*, ed. P. Spyer. New York (NY): Routledge, 1–11.

Strathern, M., 1988. *The Gender of the Gift.* Berkeley (CA): University of California Press.

Thomas, J., 1999. *Understanding the Neolithic.* London: Routledge.

Thomas, N., 1991. *Entangled Objects: Exchange, Material Culture, and Colonialism in the Pacific.* Cambridge (MA): Harvard University Press.

Tilley, C., 1990. Claude Lévi-Strauss: structuralism and beyond, in *Reading Material Culture*, ed. C. Tilley. Oxford: Blackwell, 3–81.

Tilley, C., 1996. *An Ethnography of the Neolithic: Early Prehistoric Societies in Southern Scandinavia.* Cambridge: Cambridge University Press.

Tilley, C., 1999. *Metaphor and Material Culture.* Oxford: Blackwell.

Wallis, B., 1998. Survey, in *Land and Environmental Art*, eds. J. Kastner & B. Wallis. London: Phaidon, 18–43.

Whittle, A., 1996. *Europe in the Neolithic: the Creation of New Worlds.* Cambridge: Cambridge University Press.

Whittle, A., J. Pollard & C. Grigson, 1999. *Harmony of Symbols: the Windmill Hill Causewayed Enclosure, Wiltshire.* Oxford: Oxbow Books.

Wood, P., 2002. *Conceptual Art.* London: Tate Publishing.

Woodward, A., 2002. Beads and beakers: heirlooms and relics in the British Early Bronze Age. *Antiquity* 76, 1040–47.

Wysocki, M. & A. Whittle, 2000. Diversity, lifestyles and rites: new biological and archaeological evidence from British earlier Neolithic mortuary assemblages. *Antiquity* 74, 591–601.

Zvelebil, M., 1998. What's in a name?: the Mesolithic, the Neolithic, and social change at the Mesolithic–Neolithic transition, in *Understanding the Neolithic of North-western Europe*, eds. M. Edmonds & C. Richards. Glasgow: Cruithne Press, 1–36.

Segsbury Project:
art from excavation

Simon Callery

This is an account of my direct experience of archaeological excavation in the chalk downland of southern England as a source for art making. It is also a record of the extent to which contact with the chalk bedrock changed my attitude to painting. Prior to this;

> Callery used to make drawings of the views from his balcony, but the building fragments now visible in his compositions — the angle of a roof, the edge of a wall, the line of a chimney or the curvature of an architrave — are not records of specific buildings or locations so much as ciphers; generalized evocations of the city's fabric. Architectural details play an integral part in structuring images whose function is more evocative than descriptive; in which a parallel is established between the language of architecture and the grammar of drawing. Lines may delineate forms, but they also function physically; as marks made in charcoal or pastel. Dribbles of paint evoke rain-soaked concrete; but they also make one conscious of the artist's actions — of paint trickled down canvas. (Sarah Kent in catalogue for 'Young British Artist's III'. Simon Callery, Simon English, Jenny Saville. The Saatchi Gallery, London, 1994.)

In July 1996 when I was offered the chance to work alongside archaeologists during the excavation of an Iron Age hill fort called Segsbury Camp on the Ridgeway in Oxfordshire I accepted. The idea was straightforward — to see how a painter of the urban landscape from London's East End would respond to a paradigm of English landscape. This experiment had meaning for me, as there was a hostile undercurrent towards landscape as a subject for contemporary painting from within the art world. I was not immune to this argument. I felt the need to question the established forms of practice and to reach my own conclusions. This was the opportunity to put the landscape content of my painting to the test. I wanted to understand to what extent this element of my work was an irrepressible trait of my character. I was interested to see if efforts to suppress it would go against the grain or if in fact it should be better understood and developed.

By spring 1996 I had begun to set about ridding the work of the illusion of depth associated with traditional landscape painting. I no longer wanted the paintings to represent architecture. I wanted them to be architectural in nature. The new large-scale works were pale and luminous. They were distinguished by an emphatic use of hundreds of horizontal lines that traversed the entire surface of the canvas. This use of line was an exaggeration and repetition of the horizon line found in the earlier cityscapes. I was

5.2 (opposite) *The Segsbury Project* (work in progress).

5.3 (opposite) *The Segsbury Project* overview.

concerned with slowing down the rate at which a viewer could absorb the information contained in a painting and line was important in controlling the pace of the work. Lines were coloured in order to set up a rhythm and to vary the way they communicated. Black lines recalled architects drawing. They stated their position in relation to one another in simple planar fact. Red lines moved the eye across the large canvasses at speed and green lines confronted the eye with a static light rather than causing the eye to move at all. Drawn horizontally they still encouraged a way of looking that drew the eye into a deep and receding space. As a result I felt that the paintings were refusing to give up an important component of the traditional of landscape painting. With this in mind I felt it was a good moment to leave the studio and to challenge my familiar working methods.

I had decided that I wanted to bring as little as possible in the way of my usual materials to Segsbury Camp. This was fortuitous as the dilemma I faced within a week of being there meant I had to reject almost all of my established methods. It became clear that I was not going to be able to make paintings. My painting practice, stressing the gradual accumulation of marks over an extended period, could not accommodate the sheer amounts of material and

data generated daily by the excavators. What I found here could only be absorbed into the painting by a change in attitude. I had little way of knowing that my experience of archaeological activity was to bring about a change not only to my attitude to art-making but also to its fundamental means of communicating.

An introduction to photographer Andrew Watson initiated a spontaneous discussion and a sharing of ideas that formed into a natural collaboration. Andrew Watson's long-term involvement in aerial landscape photography in the Oxfordshire area had developed beyond an interest in the picturesque. It was what lay under the surface that gave meaning to the form of the landscape.

We were not concerned with finds. Adopting a strategy borrowed from observing the process of excavation, we set out to communicate aspects of excavation entirely in a visual form. It was agreed that aesthetic decisions would be forced to make way to the demands of a complete photographic documentation of the 20×40 metre surface of Trench 1, Segsbury Camp, 1996. A medium format camera was mounted on a pole at a pre-determined height of 2.25 metres. The shutter was tripped by an air release. A complex series of spirit levels controlled the position of the camera to register the surface in 1.5 metre squares. A single plumb line located centre against a marked cord. Working as a team we were able to move across the trench at a given moment of excavation at relative speed.

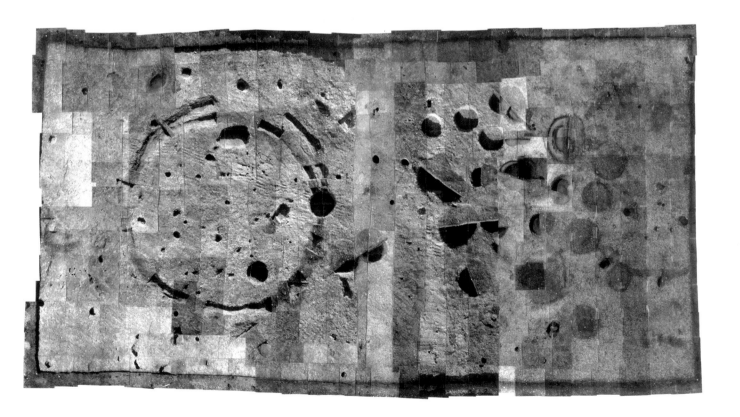

The resulting photographic work consists of 378 individual black and white images that form a complete overview of the trench. Each image was printed up at 60 cm square at a scale close to 2:1, by a darkroom technician whose normal work was urban aerial photography. The prints are housed in seven purpose-built plan chests each containing 27 drawers. There are two prints to a drawer. A viewer can move across the surface of the site sampling the highly detailed images and follow the archaeological features by opening consecutive drawers. The prints are ordered in the drawers according to the compass with the north end of the site in the top drawer of each chest. Opening the lower drawer takes you south with east to the left and west to the right. This interaction produces an urge to open ever-increasing numbers of drawers and to reach a conclusion about its contents based on visual contact with the chalk surface. It acts as a visual archive, a record of the entire surface and of the process of excavation.

5.4 The Segsbury Project plan chests.

The Segsbury Project plan chests were an immediate result of the collaboration. However, I was still ambitious to follow other clues that

concerned my painting's relationship with landscape. In quiet moments I was able to absorb the physical quality of the site and its relationship with the surrounding landscape. I became acutely aware of a sense of time made tangible and specific at an excavation.

A revelation came in the form of stratigraphy. I saw stratigraphy as a way of understanding time expressed as an axis of a vertical and a horizontal line. Finding stratigraphy to be a key principle of excavation backed up my assumption that line could be used to communicate a sense of time in a painting. It followed that a manipulation of the quality of the line could bring about a controlling factor to the quality of this communication. Back in the studio I began to make paintings that employed predominantly vertical line. This changed more than just the axis. It changed the way a viewer would respond to the work. The vertical line drew attention to the material painted surface of the canvas and blocked a reading of illusory deep space. Activating the surface in this way meant the paintings now demanded the attention of the body as well as the eye.

5.5 *The Segsbury Project.*

When I was invited back for the excavation of the Romano-British site of Alfred's Castle in 2000 I was far less apprehensive. I was eager to make a work that utilized the surface material of excavation. The photographic work was a mediated way of creating a response to surface but I wanted to see what would happen if I used the chalk itself. With the help of foundry technicians, I poured fine casting plaster in 1 × 2 metre sections directly onto a fully excavated trench opened across a Bronze Age ditch in the farmland adjoining the hill fort and left the sections to cure in the ground for two weeks. Prised away from the ground the plaster had captured the entire chalk surface rather than simply

taking the negative form of the 20 × 2 metre trench. Ranging from fine powdery loose to large and jagged pieces of bedrock. With the sections reassembled the completed work called 'Trench 10', has been tipped 90 degrees and exhibited leaning upright, supported from behind by a wooden structure. It is not unlike an enormous white painting weighing in at three tons.

To some extent this massively physical work was made to underline a point I had been quietly trying to make in painting. I felt that a major factor in understanding my relationship with the excavated landscape or the architecture of my habitual urban environment was enhanced through an act of measuring. This type of measuring did not involve the use of tools or instruments. I was the recording equipment and my senses were the registers. I wanted to know how I would respond to the stimulus of a given environment if I were able, by whatever means, to transform myself into some kind of unselfconscious sensory device. Data generated could then provide the clues or suggest the direction the work should move in.

In the landscape I could measure, position and relate to it only if I was responding with all my senses. This required me to be fully awake to the material qualities of this landscape. In terms of the work made with these factors in mind the scale of 'Trench 10' meant that its physical dimension was impossible to ignore. To walk in front of it is to be engaged in a constant act of measuring. What I had not expected was an awareness of another form of measuring. This is the expressive act of measuring ourselves on a time scale. It occurred to me that this was one of the defining experiences I had felt on the dig and an element I was seeking in the painting.

5.6 (opposite)
Trench 10 (detail).

5.7 Installation view of Segsbury Project at Dover Castle featuring Trench 10 and *The Segsbury Project*.

5.8 (over) *Trench 10.*

5.9 (previous page)
Trench 10 (detail).

5.10 Installation view at Dover Castle of archaeological context for Segsbury Project.

This way of thinking was now subject matter for the painting. With all the vernacular of depiction removed, the paintings had become an emphatic plane with no illusion of depth. They had crossed over from representation and were now factual and present. We can only project ourselves onto these paintings and measure our perceptions and our senses against them. With everything removed they offer a lean and stripped down physicality defined by specific proportion, luminosity and surface quality. They are intended to provide a slowed down, drawn out and extended perceptual experience. This experience is dependent solely on a response to the material nature of the work. This way of looking, or better, this way of sensing, leads to an engaged experience in which the viewer is no longer the passive recipient of the visual information contained in an artist's production. The dynamic is altered and

the viewer is active in an equation that is a reversal of the traditional flow between artwork and audience. The expressive end of this encounter is that the viewer, rather than the artwork or artist, becomes the subject of their perceptual process.

This was the fruit of my contact with the chalk surfaces of Segsbury Camp and Alfred's Castle. Quantifiable results are, for me, a sharpened awareness of the value of temporality as a defining experience of an artwork. I was able to realize that my intractable involvement with landscape lay in the influence of an 'unconscious apprehension' of it as material. I was now awake to landscape as multi-dimensional and no longer constrained by visual depiction. Working in such close proximity to material evidence from the past taught me how to make works that unfold in the present.

5.11 *Flake White Entasis.*

5.12 *Fabrik.*

5.13 (opposite)
Porch.

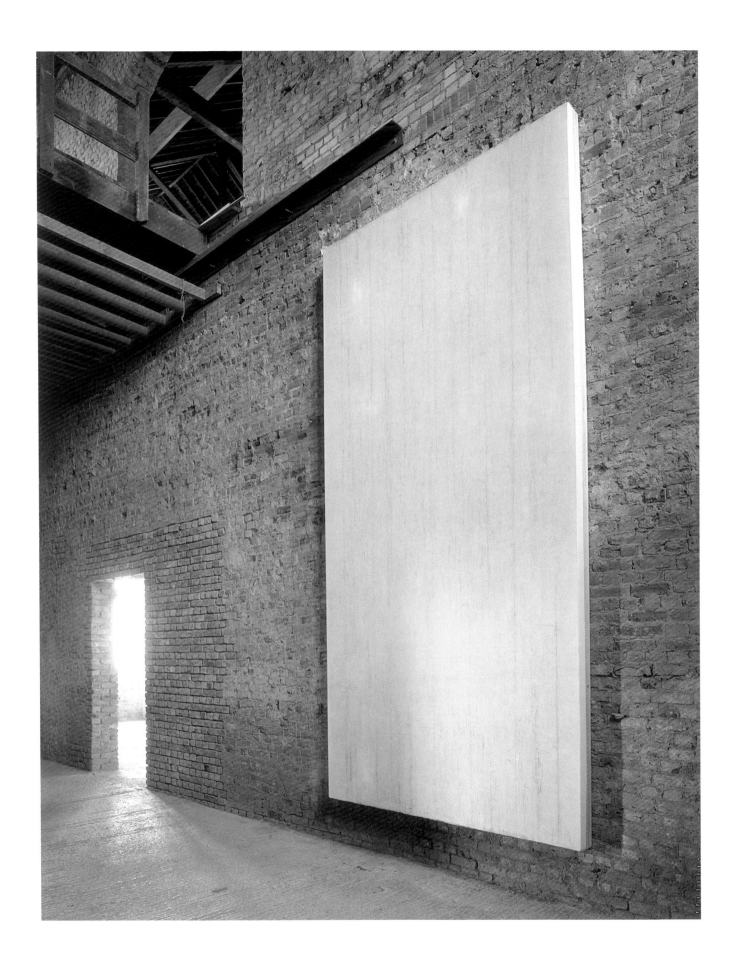

Acknowledgements

Paul Bonaventura, Senior Research Fellow at the University of Oxford, initiated and oversaw the project and put me in contact with the archaeologists at the outset. My contacts in archaeology were Dr Gary Lock from the Institute of Archaeology and Dr Chris Gosden from the Pitt-Rivers Museum, University of Oxford. The excavations at Segsbury Camp and Alfred's Castle are a part of the Hillforts of the Ridgeway Project.

Segsbury Project exhibition history:
Simon Callery: Segsbury Project (in association with Andrew Watson).
- The Great Barn, Great Coxwell, Faringdon, Oxfordshire (26–27 July 1997).
- Oxford University Museum of Natural History & Pitt-Rivers Museum, Oxford (22 September–2 November 1997).

Segsbury Project: Simon Callery.
- Officers' Mess, Dover Castle (1 April–1 August 2003).
- Storey Gallery, Lancaster (5 September–15 November 2003).

Additional information online at www.ruskin-sch.ox.ac.uk/lab.

References

Callery, S., 2003. *Segsbury Project: Simon Callery* (Fully illustrated publication featuring essays by art critic Michael Archer, novelist Tracy Chevalier and archaeologist David Miles.) London: English Heritage, The Henry Moore Foundation and the University of Oxford.

Kent, S., 1994. *Shark Infested Waters: the Saatchi Collection of British Art in the 90s*. London: Zwemmer.

Making space for monuments: notes on the representation of experience

Aaron Watson

... there are things that cannot be articulated, that are unavailable for discourse, which can be conveyed in a material way, but can never be given a precise word equivalent for (Antony Gormley, quoted in Hutchinson *et al.* 2000, 12).

My art is the essence of my experience, not a representation of it (Richard Long 1983).

In recent years, there has been considerable discussion concerning the ways in which archaeologists engage with the archaeological record. Studies of Neolithic monuments have increasingly emphasized the embodied experience of encounters with ancient buildings. These have included investigations into the visual relations between sites and features in the nearby landscape (Tilley 1994; Richards 1996; Watson 2001a), the significance of touch and texture (Cummings 2002; MacGregor 1999), the use of colour (Gage *et al.* 1999; Jones & MacGregor 2002) and the possible role of sound (Watson & Keating 1999; Watson 2001b). While such studies have encouraged archaeologists to interact with their material in new ways, the means by which these ideas can be communicated are not so well developed. This paper will consider whether the boundaries imposed by traditional ways of representing archaeological data and ideas might be constraining interpretations of the past.

Representing experience

Neolithic perceptions of the world are likely to have been rather different to our own. The archaeological record contains evidence which has an extraordinary potential for rich and varied interpretations of monuments, yet archaeologists rarely seem to question the impact of their traditions of representation. While research is beginning to consider the embodied experiences of light, sound and materiality, these ideas are often communicated in ways that have remained largely unchanged for decades.

6.1 The intensity of sound within Easter Aquorthies (right) contrasted against open ground (left). Sound amplitude is represented in increments of two decibels, with the brighter colours representing the greatest intensities (after Watson & Keating 1999, fig. 2).

Might this be directing archaeological interpretation in unrecognized ways?

The conventions by which monuments have been routinely recorded and published perpetuate a view of the past that is dependent upon two-dimensional imagery, black and white text, highly stylized illustrations and photographic plates. Expressed in this way, monuments from the past are rendered static and lifeless, devoid of sensory experience, movement, change and transition. This results in disembodied perspectives whose importance ultimately exceeds that of experiencing the monuments themselves. For example, might the categorization of monuments into groups such as 'henge' or 'causewayed enclosure' be perpetuated by a reliance upon the abstract overviews of two-dimensional plans? Such images emphasize features that may not be especially evident on the ground while, paradoxically, many elements fundamental to experience are not routinely integrated, including the movement of light and sound. Drawn plans objectify monuments by disconnecting them from their topographic setting, replacing landscapes with the margins of the page. This reinforces a way of seeing that separates 'artificial' sites from a wider 'natural' world, despite the possibility that these divisions may reflect entirely modern preconceptions.

Might there be rather more reflexive ways of representing monuments that encourage fresh interpretations that would not otherwise have been anticipated? There have been novel approaches to the study of prehistoric monuments such as visualizations of the relations between views and architecture (Cummings *et al.* 2002), the creation of narratives and installations in the landscape (Bender *et al.* 1997; Tilley *et al.* 2000), and the role of performance and theatre in creating new arenas for interpretation (Pearson & Shanks 2001). These approaches should not be treated as frivolous excursions

that, once completed, can be abandoned in favour of a return to the 'real' work of archaeology. Rather, they are concerned with trying to witness the archaeological record in lateral ways, potentially revealing pasts that were formerly unexpected and unseen. We do not know how people in prehistory perceived their world, but it seems critical to explore widely the multitude of possibilities permitted by the evidence rather than writing pasts that reflect our own prescribed boundaries. It is very much in this spirit of experimentation that these notes were put together.

Making space for sound

In recent years, there has been increasing interest in the role of sound in the use of monuments (Devereux 2001; Devereux & Jahn 1996; Watson & Keating 1999; 2000; Watson 2001b).

My own investigations began after an experience at the stone circle of Easter Aquorthies in northeast Scotland. While this circle is recognized for its use of coloured stones, the large recumbent block to one side of the circle also appeared to create echoes. A fieldwork methodology was devised to explore this by placing a sound source in the megalithic 'alcove' next to the recumbent and systematically measuring sound levels on a grid across the circle (Watson & Keating 1999, 326–7). Plate 6.1 is a plot of this data, showing how sounds generated in the vicinity of the recumbent are indeed reflected back into the centre of the circle.

While a scientific methodology informed the research at Easter Aquorthies, the representation of these effects is rather more problematic. Paradoxically, Plate 6.1 portrays dynamic sound effects in a way that is both fixed and silent, and it was necessary to supplement it with a written account:

> The recumbent block and its flanking stones seemed to project speech and other sounds across specific areas of the site, so that they could be heard easily in some areas, but were faint in others. Even with fairly quiet sounds, this echo noticeably fluctuated in intensity relative to the position of the listener. In addition, subtler reverberations appeared to originate from different places around the circle (Watson & Keating 1999, 326)

Even this description, however, is unable to reproduce the fundamental qualities of the experience of listening at the site itself. In part this is because sound can transgress the boundaries of sensory experience in ways that do not easily translate into words — it can be both heard by the ears and physically detected by the entire body as vibration. Indeed, some of the sounds that can be generated within some monuments using the voice or simple musical instruments induce intense sensations that are extraordinary, even uncomfortable, and can have an emotional impact upon the listener (Watson & Keating 1999; 2000; Watson 2001b). It is precisely those sound effects that are most dynamic that are most difficult to communicate.

One way in which it is possible to transgress these boundaries is by integrating sound within spoken papers. For instance, a presentation at the

1999 Theoretical Archaeology Group conference integrated photography, spoken text and a soundtrack (Watson & Was 1999). This did not aim to reconstruct a Neolithic experience, but was a contemporary composition of sound textures that attempted to reflect the intensity and power of sonic encounters. The audience was immersed within sounds that could be felt as well as heard, reproducing the vibrations, beats, subsonics and standing waves that had been identified during fieldwork at monuments like Maeshowe, the Ring of Brodgar and Stonehenge. A vocal narrative guided the listener, while photographic projections established a visual context. Some of the images were graphically manipulated to distort any familiarity with the places concerned (Plate 6.2), enhancing the sense of dislocation conveyed by unusual resonating sounds.

The archaeology of sound presents obvious difficulties in communication, but archaeologists often appear less aware of the boundaries that constrain other representations of embodied experience.

Making space for landscape

Stones from the sky

Tensions between objective and subjective perceptions were encountered during a study of Neolithic stone axe sources in Cumbria, northwest England. This project considered the possibility that the location of raw material sources on the Lake District mountains was determined by aesthetic qualities of the landscape, which were intrinsic to economic and technological considerations. Of central importance was the implementation of a methodology that could reveal aspects of Neolithic decision-making in relation to qualities of the mountain environment, especially height, exposure and steepness. Fieldwork was conducted along the sinuous 19 km long outcrop of rock from which axes were quarried, and the chi-squared significance test used to compare those locations with stone working against areas where there was no such evidence. This revealed a positive correlation between stone sources and those parts of the outcrop that were most spectacular and difficult to reach (Watson 1995).

While this relationship was statistically significant, the expression of landscape as a mathematical formula completely failed to communicate any sense of the places themselves. While I could use photography to capture some fieldwork experiences (Plate 6.3), this proved to be inadequate. In his critique, Michael Shanks notes that is misleading to treat archaeological photographs as 'transparent windows to what they are meant to represent' (1997). Indeed, I found my own images static and silent, failing to capture any sense of scale or materiality, bereft of any sense of being at the stone sources. Again, it seems that the kinds of information conventionally collected during fieldwork are sometimes unable to capture those elements that may be among the most critical to our understanding of Neolithic decision-making.

6.2 (opposite) A selection of imagery from an audio-visual presentation (after Watson & Was 1999).

6.3 The mountain environment near to the Cumbrian stone axe sources.

As a counterpoint to the rigidity of chi-squared tests and photography, I composed a further series of images, including Plate 6.4. These assisted with conceptualizing the subjective experiences that were central to the interpretation of the data, but could not themselves be reproduced in the final report. The working through of ideas in this way became just as much a part of the process as the planning the methodology and fieldwork recording. While Plate 6.4 shares some figurative similarities to photographs, its value lay in the potential to include more subjective qualities. The image depicts the

view near to a scatter of worked stone that was discovered during the project. The scene shows the mountaintop after snowfall, when the sense of liminality and contrast to the sheltered valleys beneath is at its most extreme. The different perspective of the height of the viewer is exaggerated in the curvature of the horizon, with the distant Irish Sea shining in the sunlight. Enmeshed within these figurative components are lines and shapes that represent a combination of my own engagement with the landscape as well as the changing light and the wind. In this way, the image is able to simultaneously represent the place I was investigating alongside more subjective and ephemeral qualities. This destabilizes any preconception of this landscape purely in terms of modern romantic or aesthetic values, capturing the contradiction between our culturally-determined preconceptions and the need to also be aware of strange and unfamiliar elements.

To me, the usefulness of pictures like this was that they permitted the representation of ideas that would have been difficult to express through words and photography alone. I was not especially concerned with the style or quality of the finished image, but rather with the *process* that was entailed both in its creation and my subsequent engagements with the image itself. For this reason, many similar compositions remained unfinished. Like the projects to which they relate, they are perpetually ongoing (Plate 6.5).

6.4 The view over a stone scatter, Bowfell, Cumbria (1995).

6.5 Stone axe sources and the elements, Scafell Pike, Cumbria (1995).

'Being in the Neolithic World: Cumbria'
Alongside imagery that directly integrates subjectivity, there may also be possibilities for combining images and words. While academic papers traditionally include a small number of images to supplement the text, there is also a potential to convey complex information with relatively few words. 'Being in the Neolithic World: Cumbria' (Plate 6.6) was an illustrated piece of

SKY (LOUGHRIGG)

SHIFTING WEATHER, CHANGING SEASONS. CLOUDS.
RAIN. SUN. MOON. STARS.

CIRCLES (SWINSIDE)

ALTERING THE LANDSCAPE, REARRANGING THE
WORLD. ENDURING MONUMENTS.

TIME (LONG MEG AND HER DAUGHTERS)

MIDWINTER SUNSET, MERGING STONE CIRCLE AND
SKY. SHADOW. LIGHT. TRANSITION.

MOUNTAIN (GREAT LANGDALE)

WHERE THE GROUND MEETS THE SKY. REMOTE.
DANGEROUS. ROCK. COLD.

AXES (SOURCE: LANGDALE)

SHAPING PIECES OF MOUNTAINS, SYMBOLS OF
POWER. STONES FROM THE SKY.

SPACE (LONG MEG AND HER DAUGHTERS)

ARENA FOR EXCHANGE OF SYMBOLS AND POWER.
PEOPLE. SOUNDS. BELIEFS.

VALLEY (CONISTON)

DWELLING. SHELTER. WATER. WOOD.
PATHWAYS BETWEEN PLACES.

PLACES (GREAT ASBY SCAR)

READING THE WORLD, WALKING A STORY. MYTHS.
ANCESTRAL PATHWAYS.

ART (LITTLE MEG)

IMPRINTING THE LANDSCAPE, CREATING MEANING
IN THE WORLD. COMMUNICATION.

SEA (SILECROFT)

CONNECTING AND SEPARATING EXOTIC LANDS.
JOURNEYS OVER WATER. DISTANT HORIZONS.

MEMORIES (IRISH ROCK ART)

IDEAS AND INFLUENCES FROM BEYOND THE SEA.
REMEMBERING DISTANT PLACES. ORIGINS.

COSMOS (MAYBURGH HENGE)

CIRCULAR LANDSCAPE, ENCLOSING STONES. CENTRE
OF THE WORLD. IDEAS. REVEALING. EXPANDING.

work commissioned by Penrith Museum and Art
Gallery as an alternative way to communicate ideas
arising from my research in the region (Watson 1994;
Watson 2000; Watson in press; Watson & Bradley in
press). The viewer was encouraged to negotiate their
own route through a mosaic of images and words,
enabling them to formulate their own connections
between a series of ideas in a way that would never
have been possible using conventional text.

It seems that there might be alternative ways of
representing information that could be integrated
within the process of researching and writing
archaeology. I will now consider how approaches
like these might be usefully integrated into detailed
reappraisals of specific monuments.

> I believe most photographers tend to think flat. The
> moment you look through the camera you become
> concerned with edges, and with composition. The
> vision of a photographer is framed: a rectangle with
> edges. The painter does not see things that way, he
> cares less about the edges of the picture. A painter's
> pictorial thinking is different; he accepts peripheral
> vision and includes it in the picture. It's possible in
> painting to present a vision that extends all the way
> around. (David Hockney 1982, 13)

Making space for monuments

In a recent discussion of the monuments of the
Avebury region in southern England, I wrote the
following description of the later Neolithic henge: 'In
Wessex this was an era of enormous henge
monuments, with Avebury being one of the largest of
its kind. Here, the earthwork is broken by four
entrances, and the interior contains pits and settings
of standing stones' (Watson 2001a, 297). In the
literature, this would often be accompanied by a photograph and plan
intended to convey additional information about the site (Plates 6.7 & 6.8).
This use of words and imagery, however, creates an especially linear
impression of Avebury. The henge is portrayed as unchanging and two-
dimensional, with no sense of chronological depth. Substantial features on the
ground are abstracted into cartographic symbols. Plans and maps in particular
lend themselves to the creation of fixed and immutable perceptions of
archaeological sites and landscapes; static, silent, familiar. They cement a
particular kind of expectation that implies a rigid and fixed phenomenon that
can clearly be defined, an artefact that can be 'visually and conceptually

6.6 *(opposite)*
Being in the
Neolithic World:
Cumbria (2002).

6.7 Avebury from
the southwest.

6.8 A plan of
Avebury (after
Watson 2001a,
fig. 2).

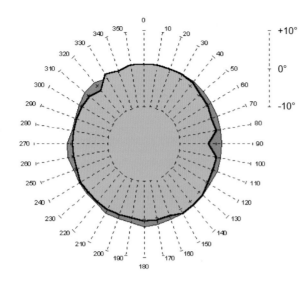

devoured' (Gillings & Pollard 1999).

Archaeologists are familiar with visualizing monuments in particular ways, and it is tempting to impart the same kinds of objectivity directly onto the sites themselves. Yet Avebury does not resemble Plate 6.8 when it is visited on the ground, and is very unlikely to have been seen in precisely that way by Neolithic people. While cartographic and photographic conventions might communicate a large amount of information, this is very different way of seeing to that of an observer within a monument. While conjuring the illusion of a monument in the archaeological mind, Plates 6.7 and 6.8 simultaneously deny the fundamental qualities of being there. Indeed, the modern visitor actually finds it rather difficult to appreciate the overall size and shape of Avebury when they are situated within its boundaries (Barrett 1994, 12).

In search of circular landscapes

Avebury was major case study within a broader investigation of the topographic settings of stone circles and henges across Britain (Watson 2000). This project was intended to test the premise that these monuments might have been conceived as *axis mundi* by Neolithic people, being constructed to create an illusion of centrality in the landscape and surrounded by hills and ridges (see Richards 1996; Bradley 1998, 122–5). A fieldwork methodology was devised to measure key aspects of the views from these sites — data which could subsequently be represented in schematic form (Plate 6.9). Images like these were designed to emphasize specific landscape features that appeared to be important in the situation of the monuments, namely the overall 'balance' between the skyline and dominant breaks of slope in the nearby terrain.

Visualizations were extremely useful to emphasize how the location of Avebury creates a specific kind of effect. Chalk ridges in the wider landscape appear to encircle the monument so that an observer within the henge perceives themselves to be at the centre of a circular space defined by both the monument and the wider topography. This was achieved by situating the earthwork so that an equilibrium existed between the foreground and skyline — a relationship which could not easily be achieved elsewhere in the local landscape. While there are wide views in most directions from the circle itself, control samples placed at systematic distances from the henge demonstrated that views become increasingly restricted by steeply sloping ground (Plate 6.10).

It was also possible to compare different monuments in the Avebury landscape in ways that would be very difficult to achieve using maps or

6.9 A schematic representation of the circular view from the North Inner Circle within Avebury. The angle of elevation to the skyline and distinctive breaks of slope in the nearby terrain were measured at 10 degree increments. This shows how the banks of Avebury (green) symmetrically frame the chalk ridges that rise beyond (red). Magnetic compass bearings are shown, with north at the top, and the vertical angle of view from –10 to +10 degrees indicated.

6.10 A schematic view from Avebury contrasted against control samples placed systematically in the wider landscape. Where the foreground terrain visibly merges with distant ground leading to the skyline a white triangle is indicated. To the west the foreground extended uninterrupted to the skyline, while to the north there was only a very restricted view of a break of slope.

NORTH
(CONTROL)

WEST
(CONTROL)

AVEBURY
(NORTH INNER CIRCLE)

EAST
(CONTROL)

SOUTH
(CONTROL)

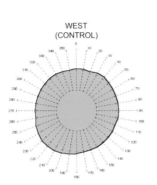
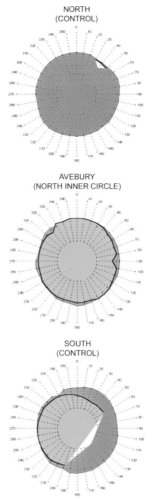
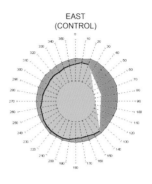

AVEBURY
(NORTH INNER CIRCLE)

THE SANCTUARY
(CENTRE)

SILBURY HILL
(PLATFORM CENTRE)

WEST KENNET AVENUE
(NEAR HENGE ENTRANCE)

WEST KENNET
LONG BARROW

ADAMS GRAVE
LONG BARROW

6.11 Schematic views from different monuments in the Avebury region.

photographs alone (Plate 6.11). Interestingly, these reflect how the views from within Avebury share qualities with those from the nearby sites of the Sanctuary and also the summit platform of Silbury Hill. They contrast entirely, however, with the Kennet Avenue and other earlier Neolithic long barrows nearby. This could be interpreted in terms of the relative ages of these monuments and changing concerns with landscape setting, but there are also other aspects which are less frequently discussed (see also Watson 2004). In particular, it is interesting to note that while the stone and timber circles of the Sanctuary are not enclosed by banks and ditches, the view from its centre is in many ways comparable to that from within the Avebury henge. By virtue of a carefully chosen location, the Sanctuary is surrounded by a river valley and distant chalk ridges that reproduce the sense of enclosure of an earthwork henge. Likewise, the view from the top of Silbury Hill combines similar elements despite being characterized by archaeologists as an entirely different kind of site. These observations raise some important questions regarding our definition of monuments. Might banks and ditches, hills and valleys have been interchangeable in the Neolithic? Should the Sanctuary be understood as a henge, an orchestration of natural features, or something else altogether?

> All of the theory about painting as a flat surface . . . it's a formalist theory. I know perfectly well that you can go through the surface, pierce the surface, so to speak, and there discover another world. There are all kinds of worlds, and the exploration and recording of them through painting interests me more. (David Hockney 1982, 12)

A multiplicity of Aveburys

It seems that alternative kinds of imagery might expand our perspectives and encourage new questions. A major limitation of schematic views, however, is that they are only useful when compared with one another. Rather like the acoustic map of Easter Aquorthies (Plate 6.1), they fail to communicate any sense of how these views can be experienced on the ground. It seems critical that we introduce some of the more transitory and subjective qualities of the monument alongside more conventional readings. Might there be alternative tellings of Avebury that challenge these modes of representation?

Avebury is stones that are textured.
Avebury is mist, rain, frost and fog.
Avebury is cold on a winter day.
Avebury is stones lit by moonlight.
Avebury is the sun and the stars.
Avebury is a flight of birds.
Avebury is echoes from stones.

These words give a voice to Avebury that more closely reflects aspects of my own encounters with the henge, and are constituted from memories of that place. They are fragments, emphasizing particular experiences while neglecting

others entirely. In contrast to conventional archaeological descriptions, this account appears ambiguous and partial. Yet if it is accepted that objective approaches to understanding places are problematic, then it might be important to emphasize the more subjective qualities of dwelling within monuments.

If we are to label Avebury as a stone circle, precisely what *are* stones, and *what* is a circle? We typically define stones as solid, geological aggregates of minerals, while a circle is a mathematical figure. It seems unlikely, however, that Neolithic people understood Avebury as either. Modern inferences draw upon abstract conceptions of geology and geometry that are unlikely to have been shared by people over four thousand years ago. Indeed, ethnography has emphasized how diverse social interpretations of materials and spaces can be (e.g. Taçon 1991).

Should we regard Avebury as one monument or a convergence of individual stones? Did the stones themselves constitute the monument, or did they define the space about them? We have certain expectations of the materiality of stone as solid, rigid and everlasting. Yet we do not know how Neolithic people understood sounds echoing from the stones at Avebury (Watson 2001a). Sound can change our expectations of materials — might stone itself be generating these sounds. Alternatively, the surface of a stone could be a permeable membrane (Plate 6.12) through which journeys might be made to other realms (Lewis-Williams & Dowson 1990).

If we look carefully, monuments and landscapes are constantly transforming in subtle ways. Should we understand Avebury as one place, or a constantly shifting agglomeration of changing sensations? There have been discussions about whether there are patterns in the stone shapes at Avebury (Smith 1965, 197), yet the perceived shape of a stone is also dependent upon the viewing angle of the observer (Plate 6.13). Stones are not only visual — they can also have audible, textural or other qualities. From a modern perspective, is it helpful for archaeologists to conceive of Avebury as a solid entity that is subjected to contrasting lights and weathers? We do not know how Neolithic people interpreted the changes in the appearance of Avebury during the course of a day. Was a stone in sunlight the same as one in shadow? Is Avebury the same place at midday as it is at midnight? Might Avebury actually be an ever-changing succession of substances and sensations — effectively a multitude of different places?

6.12 Transforming monolith, Ring of Brodgar (2002).

Plate 6.14 is one attempt to illustrate these ideas, drawing upon the technique of photomontage first creatively explored by David Hockney (1982; 1984) and subsequently by some archaeologists (Shanks 1992; Tilley *et al.* 2000). The images in Plate 6.14 represent a small fraction of a collection of over 300 photographs taken at Avebury during one afternoon in December 2002. This Avebury primarily exists on two scales. While each individual snapshot is itself representative of a single embodied experience in the landscape, the images can also be juxtaposed against one another. This can be manipulated to try and capture diverse experiences at many different scales, such as motion, enclosure, materiality, landscape, or texture and colour. While the image is a result of my entire afternoon at Avebury, it simultaneously conflates that time and space. Some of the images reflect early afternoon, others capture sunset. Some were taken in bright light, others during a rainstorm. This rather more effectively reveals my engagement with the place than the photograph in Plate 6.7, or the black and white plan in Plate 6.8. Indeed, the tensions between many of the photographs have taken on a life of their own and demand a continuous and reflexive dialogue. Unlike Plates 6.7 and 6.8 it is not static, having been arranged into a variety of different compositions over time, permitting an ongoing relationship between myself, the image and, ultimately, Avebury itself.

Just as this image can be rearranged in a potentially infinite number of ways, perhaps archaeologists should anticipate an indefinite number of Aveburys — places whose form and meaning is fuzzy and fluid. This creates a rather different space to traditional illustration, emphasizing the importance of dwelling *within* monuments rather than distancing ourselves from them (Ingold 2000). By moving beyond disembodied plans we might disclose a multiplicity of experiences, revealing unfamiliar and challenging Aveburys that are not easy to classify. Indeed, might we be neglecting such possibilities precisely because they are so difficult to represent?

Discussion: representation and interpretation

This is not a paper about art history, nor does it lay down new methodologies for field practice. Rather, it relates my own attempts to communicate ideas by

6.13 What shape is this stone?

6.14 *(opposite)* Photomontage of Avebury (2003).

Making space for monuments 93

integrating contrasting kinds of representation within archaeological research. The context for this has been the growing concern expressed by some archaeologists about the ways in which archaeology 'constructs' knowledge, and in particular the scientific stance that neatly subdivides subjective and objective: 'There seems to be presented a choice: write poems, novels, paint watercolours — subjective fictions; or do archaeology — concerned with the past itself. I want to deny that there is this simple choice' (Shanks 1992, 12).

Archaeologists should no longer be confident that there is a single 'true' past that will be revealed to them through ever more sophisticated studies of the archaeological record. Whenever archaeologists engage with the past they change it, not only through direct physical interventions such as excavation, but also through the ways in which that past is portrayed through writing, illustration and photography. While pursuing scientific ideals, these modes of representation are neither neutral or objective; even 'looking is not innocent' (Shanks 1992, 184). Archaeology is not simply a process of interpreting the material remains of past societies, but is fundamentally *a way of seeing the world*.

The history of archaeology is a history of how archaeologists have learnt to see the world. Perception and representation are intimately related for the simple reason that it is not possible to represent something which is invisible to the fieldworker: 'field archaeologists define themselves by looking at things, but what they are able to recognize will often depend on what they have seen before' (Bradley 1997, 71). In part, fieldwork practice reproduces some of the limitations of publication because it is principally concerned with collecting data that can be accommodated within the traditional printed report or archive. This raises some important questions concerning how traditions of fieldwork and representation perpetuate one another, and in particular how they may *exclude experiences of places or landscapes that do not fit within their constraints*. That is why it is important to try and go beyond conventional modes of representation. Alternative representations may not only permit archaeologists to see beyond modern preconceptions, but will also require different approaches to information recording in the field, potentially expanding archaeological vision. Traditional representation 'normalizes' prehistory, moulding the strangeness and unfamiliarity of the Neolithic into a comfortable format that denies the positive impact that such uncertainties and challenges might otherwise entail.

Conclusions

If archaeologists persist in creating a single modernist vision of sites and landscapes they deny the potential for multiple readings of the Neolithic. In order to widen understandings of how people in the Neolithic composed their world, it might first be necessary to create fluid and less clearly-defined spaces for people in the past to occupy. This is not to advocate, however, that archaeologists should abandon conventional modes of representation. Rather,

there is value in juxtaposing traditional representations against alternative tellings so as to acknowledge that embodied experience is subjective and that there can be no single 'correct' reading of the evidence. By remaining self-aware about the boundaries that exist in their dialogues with artefacts, places, and landscapes, archaeologists might begin to seriously challenge the modern preconceptions inherent within interpretations of the Neolithic. This is about making new conceptual spaces for monuments, spaces that might threaten conventions and be difficult to describe, but which ultimately enable archaeology to inhabit a less familiar past.

Acknowledgements

Many thanks to the symposium organizers both for their invitation and their hospitality during my stay in Cambridge. I am especially grateful to Richard Bradley, Chris Gosden, Mary Helms, Andy Jones, Susan Kus, Josh Pollard and Colin Renfrew for their constructive feedback and discussion.

References

Barrett, J., 1994. *Fragments from Antiquity*. Oxford: Blackwell.

Bender, B., S. Hamilton & C. Tilley, 1997. Leskernick: stone worlds; alternative narratives; nested landscapes. *Proceedings of the Prehistoric Society* 63, 147–78.

Bradley, R., 1997. 'To see is to have seen'. Craft traditions in archaeology, in *The Cultural Life of Images: Visual Representation in Archaeology*, ed. B.L. Molyneaux. London: Routledge, 62–72.

Bradley, R., 1998. *The Significance of Monuments*. London: Routledge.

Cummings, V., 2002. Experiencing texture and touch in the British Neolithic. *Oxford Journal of Archaeology* 21(3), 249–61.

Cummings, V., A. Jones & A. Watson, 2002. Divided places: phenomenology and asymmetry in the monuments of the Black Mountains, Southeast Wales. *Cambridge Archaeological Journal* 12(1), 57–70.

Devereux, P., 2001. *Stone Age Soundtracks*. London: Vega.

Devereux, P. & R. Jahn, 1996. Preliminary investigations and cognitive considerations of the acoustical resonances of selected archaeological sites. *Antiquity* 70, 665–6.

Gage, J., A. Jones, R. Bradley, K. Spence, E. Barber & P. Taçon, 1999. What meaning had colour in early societies? *Cambridge Archaeology Journal* 9(1), 109–26.

Gillings, M. & J. Pollard, 1999. Non-portable stone artefacts and contexts of meaning: the tale of the Grey Wether (www.museums.ncl.ac.uk/Avebury/stone4.htm). *World Archaeology* 31, 179–93.

Hockney, D., 1982. *Photographs*. London: Petersburg Press.

Hockney, D., 1984. *Cameraworks*. London: Thames & Hudson.

Hutchinson, J., E. Gombrich, L. Njatin & W. Mitchell, 2000. *Antony Gormley*. London: Phaidon.

Ingold, T., 2000. *The Perception of the Environment*. London: Routledge.

Jones, A. & G. MacGregor, 2002. *Colouring the Past: the Significance of Colour in Archaeological Research*. Oxford: Berg.

Lewis-Williams, J.D. & T. Dowson, 1990. Through the veil: San rock paintings and the rock face. *South African Archaeological Bulletin* 45, 5–16.

Long, R., 1983. *Touchstones*. Bristol: Arnolfini.

MacGregor, G., 1999. Making sense of the past in the present: a sensory analysis of carved stone balls. *World Archaeology* 31(2), 258–71.

Pearson, M. & M. Shanks, 2001. *Theatre/Archaeology*. London: Routledge.

Richards, C., 1996. Monuments as landscape: creating the centre of the world in late Neolithic Orkney, in *Interpretative Archaeology*, ed. C. Tilley. Oxford: Berg, 190–208.

Shanks, M., 1992. *Experiencing the Past*. London: Routledge.

Shanks, M., 1997. Photography and archaeology, in *The Cultural Life of Images: Visual Representation in Archaeology*, ed. B.L. Molyneaux. London: Routledge, 73–107.

Smith, I., 1965. *Windmill Hill and Avebury*. Oxford: Clarendon Press.

Taçon, P., 1991. The power of stone: symbolic aspects of stone use and tool development in western Arnhem Land, Australia. *Antiquity* 65, 192–207.

Tilley, C., 1994. *A Phenomenology of Landscape*. Oxford: Berg.

Tilley, C., S. Hamilton & B. Bender, 2000. Art and the re-presentation of the past. *Journal of the Royal Anthropological Institute* (N.S.) 6, 35–62.

Watson, A., 1994. Stones from the Sky: Monuments, Mountains and People in Neolithic Cumbria. Unpublished BA dissertation, University of Reading.

Watson, A., 1995. Investigating the distribution of Group VI debitage in the central Lake District. *Proceedings of the Prehistoric Society* 61, 661–2.

Watson, A., 2000. Encircled Space: the Experience of Stone Circles and Henges in the British Neolithic. Unpublished PhD thesis, University of Reading.

Watson, A., 2001a. Composing Avebury. *World Archaeology* 33(2), 296–314.

Watson, A., 2001b. The sounds of transformation: acoustics, monuments and ritual in the British Neolithic, in *The Archaeology of Shamanism,* ed. N. Price. London: Routledge, 178–92.

Watson, A., 2004. Monuments that made the world: performing the henge, in *Monuments and Material Culture: Papers on Neolithic and Bronze Age Britain in honour of Isobel Smith*, eds. R. Cleal & J. Pollard. East Knoyle: Hobnob Press.

Watson, A., in press. Fluid horizons, in *The Neolithic of the Irish Sea*, eds. V. Cummings & C. Fowler. Oxford: Oxbow.

Watson, A. & R. Bradley, in press. On the edge of England: Cumbria as a Neolithic region, in *Regional Diversity in the Neolithic of Britain and Ireland,* eds. G. Barclay & K. Brophy. Oxford: Oxbow.

Watson, A. & D. Keating, 1999. Architecture and sound: an acoustic analysis of megalithic monuments in prehistoric Britain. *Antiquity* 73, 325–36.

Watson, A. & D. Keating, 2000. The architecture of sound in Neolithic Orkney, in *Neolithic Orkney in its European Context*, ed. A. Ritchie. (McDonald Institute Monographs.) Cambridge: McDonald Institute for Archaeological Research, 259–63.

Watson, A. & J. Was, 1999. Monuments in Concert: a Journey through the Landscapes of Sound. Paper presented at the Theoretical Archaeology Group conference, Cardiff University.

The pot, the flint and the bone and *House Beautiful*

Anwen Cooper, Duncan Garrow, Mark Knight & Lesley McFadyen

The following collections of images were constructed using 'stills' cut from two performances originally created for the Muting Archaeology session at the European Association of Archaeologists conference, September 2000 in Lisbon. The aim of 'muting' archaeology was to explore innovative, multi-sensory forms of presentation, which moved beyond the traditonal verbal/textual forms of archaeological discourse to engage with material culture in different ways (Holtorf & Jones 2000). It is therefore ironic – though perhaps necessary – that they are represented here in a partly textual form.

The pot, the flint and the bone is a short animation lasting 3 minutes 5 seconds. The soundtrack — Geoff Love's version of the theme tune from 'The Good, the Bad and the Ugly' — sets the scene from the beginning. A tumbleweed bucket rolls across the road. A pair of gunslinger's eyes scan the skyline. The 'western archaeology' begins. The animation comments on the challenges of establishing dynamic narratives of the prehistoric past. The genre of the Spaghetti Western is used as a medium through which to tell tales of Neolithic lives, exploring the connections between the repetitive themes of the film genre and the repetitive practices of the British Neolithic (where pits were dug and filled with pottery, flint and bone). The burial of textual artefacts within a pit is an explicit portrayal of an archaeology without words. It is also a way of subverting any literal translation of 'material culture as text'. Importantly, during the making of the film, for the first time we were able to dig a 'Neolithic' pit for ourselves, rather than re-digging a feature which had originally been created thousands of years before.

7.1–7.3 *(over)* **The pot, the flint and the bone**.

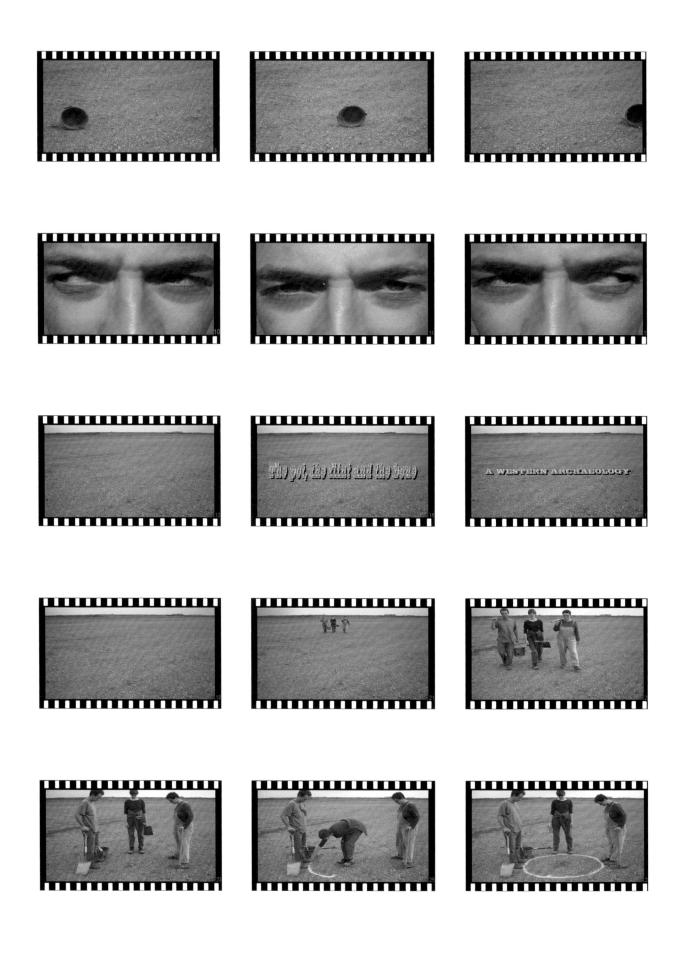

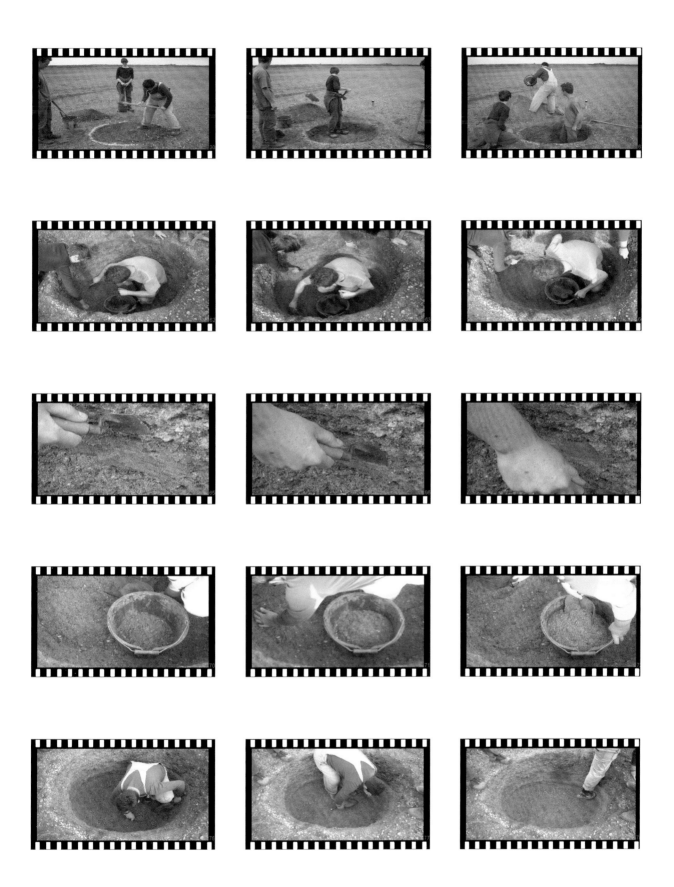

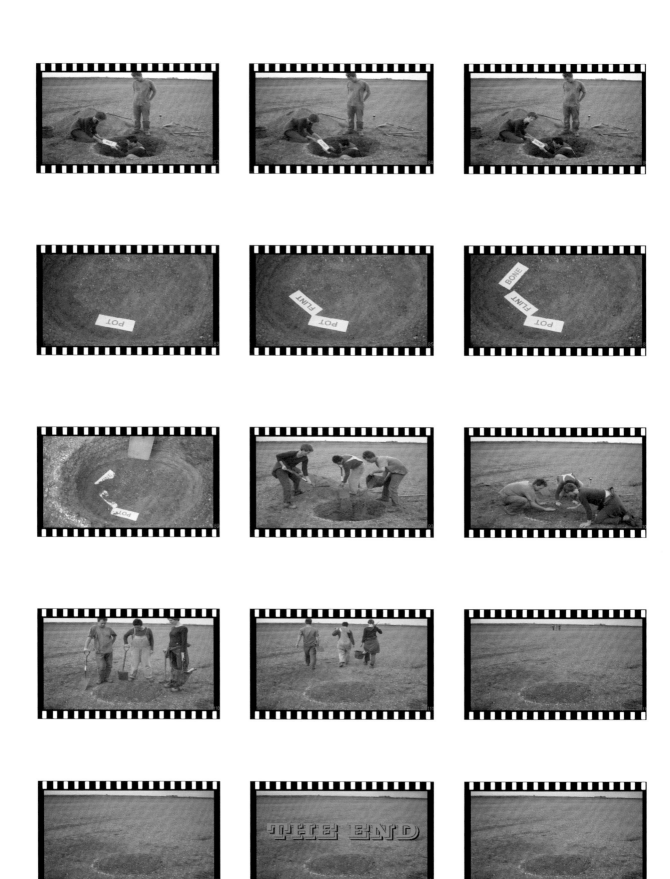

The pot, the flint and the bone

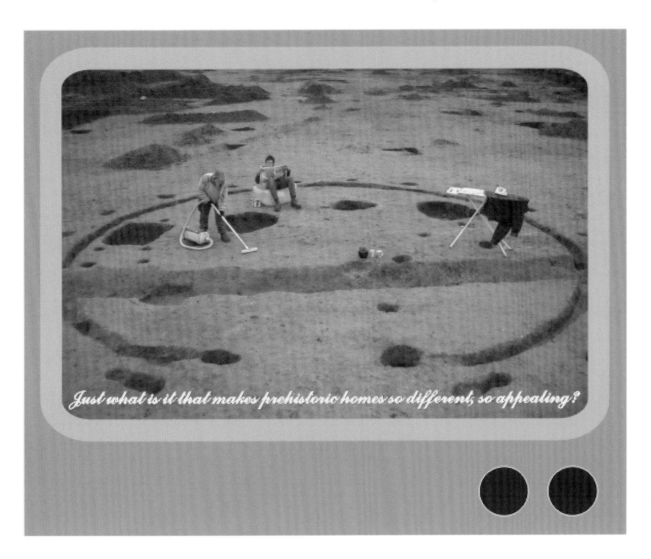

Just what is it that makes prehistoric homes so different, so appealing?

House Beautiful is a short animation lasting 2 minutes 42 seconds; the soundtrack is Astrud Gilberto's 'Take me to Aruanda'. The presentation plays with subverting the dominant 'domestic' ideology behind interpretations of the later Bronze Age. Images of a reconstructed first-millennium BC roundhouse are juxtaposed with idealized 1950s AD domestic scenes. An interplay, or mimicry, develops between 'reconstructions' and 'adverts', highlighting the incredibly stylized architectures, sexualities, genders and props that both sets of images build and are built upon. The comfortable scenes of Bronze Age 'family life' which we have become accustomed to in museum displays and text books seem suddenly artificial. There is nothing easily graspable when trying to understand how people lived their lives in the past. After posing the question 'just what is it that makes prehistoric homes so different, so appealing?' (after Richard Hamilton), the image reproduced in Plate 7.4 fills the screen.

7.4 *House Beautiful.*

Acknowledgements

We would like to thank Elizabeth DeMarrais, Chris Gosden and Colin Renfrew for their support and advice in turning animations into text, the staff at Flag Fen for allowing us to photograph their reconstructed roundhouse, as well as Beccy Scott and Dave Hall, the stars of *House Beautiful*.

References

Hamilton, R., 1956. *Just What is it that Makes Today's Homes so Different, so Appealing?* Collage, 26.0 × 23.5 cm. Kunsthalle, Tubingen.

Holtorf, C. & A. Jones, 2000. Saying Absolutely Nothing About Either the Past or Archaeology. Conference Session Abstract, 6th Annual Meeting of European Association of Archaeologists, Lisbon, Portugal.

Unearthing displacement: Surrealism and the 'archaeology' of Paul Nash

Christopher Evans

Forging a pedigree for the Brit-Art of the 1990s, in the Tate Modern Duchamp's *Fountain* — his renowned urinal of 1917 — is displayed as *the* pivotal masterpiece and, with it, Dada/Surrealism promoted as the great turning-point in the development of twentieth-century art. In effect, an arbitrary ready-made has usurped the position normally accredited to such modern classics as Picasso's *Les Demoiselles d'Avignon*. Together with Magritte's 'pipe/non-pipe' of *c.* 1928 (*Ceci n'est pas une pipe* - 'The Treacheries of the Image'), these are held to be amongst the crucial works of our age. Celebrated as ironic icons, for almost a century they have challenged the unique status of the artwork and the context of gallery display and image/object.

This paper is concerned with a little-noticed strand in the annals of art and archaeology — the interrelationship of archaeological source material and Surrealism, particularly in Britain in the 1930s and the work of Paul Nash. The root issues here are the interplay of context/displacement, materials and 'chaos', and behind this sits questions of archaeology's inevitable regionality as opposed to art's increasingly international arena — the local *vs* the worldly. It is appropriate to begin with Nash's 1938 description (remarkably enough published in *Country Life*) that accompanied photographs he had taken when visiting Wheeler's excavation of the War Cemetery at Maiden Castle in 1935 (Plate 8.1a):

> The summer excavations at Maiden Castle had disclosed many skeletons of the defenders of the hill fortress buried where they fell in their last fight against the Roman armies. So much, at least, I gathered from one of the party of diggers. *I was not particularly interested in the archaeological significance of the discovery. But the sense in its dramatic elements had, indeed, an awful beauty.* The sun beat down on the glinting white bones which were disposed in elegant clusters and sprays of blanched springs and branches. Or some seemed to be the nests of giant birds; the gleaming skulls like clutches of monstrous eggs. ('Unseen Landscapes', emphasis added; see also Causey 2000 for Nash's writings.)

We do not today experience this displacement. Through the sheer body of excavation data we have become familiar with digging up the dead and their

a

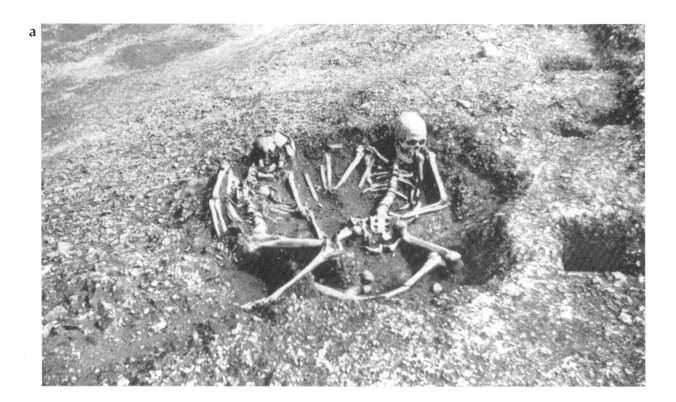

b

8.1a *The Last Defenders of Maiden Castle* (*c.* 1935) by Paul Nash.

8.1b *Found Objects Interpreted: Encounter of the Wild Horns* by Paul Nash, exhibited at the Redfern Gallery, London, 1937.

skulls neither strike us or the public at large as fabulous bird-eggs. It is this very different way of seeing the past — a sense of the shocking 'newness' of the ancient — that this paper explores (see Edmonds & Evans 1991 for further background).

Like so much in its over-arching inclusiveness, matters archaeological were an interest, albeit minor, of the Continental Surrealists. A vague

awareness of the discipline (or at least deep time) lurks in the long shadows of De Chirico's statue-strewn urban squares, Ernst's forests and the movement's many object assemblages. With its espousal of an anti-aesthetic and various modes of automatism, the notion that 'to find is to create' was central to both Dada and Surrealism. Archaeology was a source of found objects and, in many ways parallel with ethnographic primitivism (e.g. Goldwater 1986), was a source of inspiration as it provided messages from the 'night-mind' (Cooke 1991). Primitive art, particularly that of Oceania but also pre-Columbian pieces, was collected by the Surrealists and displayed in many of their major exhibitions; the appeal of ethnographic objects being in their potential for fetishistic and psychoanalytical association. (Sixteen Oceanic objects were lent by the Cambridge University Museum for the International Surrealist Exhibition held in London in 1936: Plate 8.2c; Ades 1978, 343 and Gathercole pers. comm.)

'Archéologie' and 'Ethnographie' were amongst the announced themes of *Documents*, Georges Batailles's extra-Surrealist magazine (1929–30: Plate 8.2a; Ades 1978, 228–49). It saw the publication of Paul Rivet's 'L'étude des civilisations materielles: ethnographie, archéologie, préhistoire', which compared the various methodologies of these disciplines (1929, no. 3), and there were articles concerning Japanese Neolithic figurines (1930, no. 1) and Stonehenge and other ritual circles (1930, no. 7). To the first issue Bataille himself contributed 'Le Cheval académique', comparing versions of the horse on Celtic coins and their classical sources. (Bataille had previously worked as numismatist in the Bibliothèque Nationale.) In the 1950s, the movement's domineering 'godfather', André Breton, himself took up the study of Gallic coins, finding in their chaotic designs a (national) 'Ancestor message' — a connection that had proven impossible with ethnographic works (Breton 1972; Cooke 1991, 138–9; also see Gell 1998, 242–51 concerning the representation of sequence/'dimension' in Duchamp's preparatory study for *The Large Glass* of 1913–25, *The Network of Stoppages* — effectively its 'archaeology').

Yet in the heyday of Surrealism archaeology was essentially only drawn upon as part of a wide array of 'otherness' and played but a minor part of the movement's broad pantheon of object-types. What interest there was in the subject was largely limited to museum pieces (i.e. not sites or excavation) and mock typologies, and personal/fictive museum assemblies were exhibited. Such was not the case in Britain where archaeological themes played a more prominent role in its home-spun Surrealism and it was the found object alone that was an abiding concern — in place of the mask and fetish was the gnarled tree, megaliths and other ancient monuments. This manifestation was inherently more sympathetic to its national landscape traditions and deep-rooted Romantic sensibilities (aside from Ernst, the natural landscape had little interest for Continental Surrealists). Nevertheless it was only through the impact of Surrealism that, for British Art in the 1930s, landscape could come to be viewed as something *found*.

a

DOCUMENTS

ARCHÉOLOGIE
BEAUX-ARTS
ETHNOGRAPHIE
VARIÉTÉS

1

Magazine illustré
paraissant dix fois par an

2ᵉ Année. — 1930

Georges BATAILLE. Le bas matérialisme et la gnose. — Marcel GRIAULE.
Légende illustrée de la reine de Saba. — Jacques BARON. Jacques Lipchitz.
— Jiujiro NAKAYA. Figurines néolithiques du Japon. — Robert DESNOS.
Pygmalion et le Sphinx.

Chronique par Georges Bataille, Arnaud Dandieu, Robert Desnos, Carl
Einstein, Marcel Griaule, Michel Leiris, Georges Henri Rivière.

Photographies de Jacques-André Boiffard.

PARIS. 106. B⁴ Saint-Germain (VI')

b

INTERNATIONAL SURREALIST BULLETIN
No. 4 ISSUED BY THE SURREALIST GROUP IN ENGLAND
PUBLIÉ PAR LE GROUPE SURRÉALISTE EN ANGLETERRE
BULLETIN INTERNATIONAL DU SURREALISME
PRICE ONE SHILLING SEPTEMBER 1936

THE INTERNATIONAL SURREALIST EXHIBITION

The International Surrealist Exhibition was held in London at the New Burlington Galleries from the 11th June to 4th July 1936.

The number of the exhibits, paintings, sculpture, objects and drawings was in the neighbourhood of 390, and there were 68 exhibitors, of whom 23 were English. In all, 14 nationalities were represented.

The English organizing committee were: Hugh Sykes Davies, David Gascoyne, Humphrey Jennings, Rupert Lee, Diana Brinton Lee, Henry

L'EXPOSITION INTERNATIONAL DU SURRÉALISME

L'Exposition Internationale du Surréalisme s'est tenue à Londres aux New Burlington Galleries du 11 Juin au 4 Juillet 1936.

Elle comprenait environ 390 tableaux, sculptures, objets, collages et dessins. Sur 68 exposants, 23 étaient anglais. 14 nations étaient représentées.

Le comité organisateur était composé, pour l'Angleterre, de Hugh Sykes Davies, David Cascoyne, Humphrey Jennings, Rupert Lee, Diana Brinton Lee, Henry Moore, Paul Nash, Roland Penrose, Herbert Read, assistés par

c

8.2a Title page of *Documents* (1930).

8.2b Title page, *International Surrealist Bulletin*, September 1936 (showing a Surrealist 'event' in front of the National Gallery, Trafalgar Square, London).

8.2c Reconstruction of the International Surrealist Exhibition, London, 1936 (as re-staged in the 1978 Hayward Gallery exhibition; note the display of ethnographic pieces, left).

Equivalence and chance

The English organizing committee for the 1936 International Surrealist Exhibition in London included Herbert Read, Roland Penrose, Paul Nash and Henry Moore, and the latter artists all contributed work to it. In an effort to introduce Surrealism to the English-speaking world, Breton writing in the periodical, *The Quarter*, in 1932 sought to establish an English tradition for the movement based on the wit and word-play of Synge, Swift and Lewis Carroll (and also Gothic novelists). Both Read in his *Surrealism* of 1936 and later Nash expanded upon the movement's 'native' ancestors to include mystics and Romantics (e.g. Blake, Wordsworth and Coleridge), thereby embracing a landscape tradition wherein Romantic empathy embodied and animated the countryside. It is arguably this legacy and national rural traditions that produced the dilemma of English Surrealism; prone to ready landscape symbolism, from the outset this stifled the urbane intellectualism of Continental Surrealism.

It is only really in the 1930s that archaeological monuments featured in mainstream English art. Becoming icons of the countryside, chalk-cut figures, stone-circles and barrows began to dot the landscapes of Nash, Moore, Piper, Webb, Ward and Ravilious. This growing interest in 'things archaeological' related, in part, to the subject presenting a professional public face, a trend best exemplified by Wheeler's much-reported excavations at Maiden Castle in the 1930s and the often-reprinted popular archaeological syntheses which began to be regularly published (see Hudson 1981, 99–116 and Evans 1989b, 442–4). At this time, a new cultural 'home-land' was being forged. A number of historical, social and economic factors underlie this development: the impact of the First World War, the decline of empire and, primarily, the growth of leisure and recreational pursuits through shorter working hours and paid holidays. Public and private means of transportation were to bring escape to the countryside from what was by then essentially an urban and industrial society:

> Hiking and rambling boomed, particularly in the 1930's, when they combined a cult of healthy athleticism with the deep-seated fondness for the countryside which operated powerfully in British culture. The 'rediscovery of the countryside' was already well under way before 1914, but between the wars it rose into a passion, aided no doubt by the increasing availability of cars, motor-cycles and bicycles, and the readiness of large numbers of people of all classes to don strong shoes, shorts and ruck-sack in the quest for rural peace and tranquillity (Stevenson 1984, 392).

The establishment of the Council for the Preservation of Rural England in 1926, the Youth Hostel Association (1930), the Federation of Ramblers' Associations (1936) and the passing of the Green Belts Acts in 1938 all attest to a growing appreciation of the countryside and the popularity of rural pursuits (Stevenson 1984, 393–4; Yorke 1988, 74).

The sense of the countryside as a place of escape pervades much of the landscape art of the 1920s and early 1930s. The cottage set amid rolling hills

and neat fields was a sanctuary from burgeoning cities, the 'vulgarity' of the modern masses and memories of the war. Emphasizing pattern, in the gentle rhythms of the downland and the playful geometries of ploughed fields or hedgerows the homely qualities of an orderly countryside were conveyed. It is into this thoroughly domesticated landscape that archaeological motifs were introduced, and prehistoric monuments were a major component of the many County Guidebooks that then entered publication (Nash himself producing the *Dorset Shell Guide* of 1936). It equally tells of the growing popularity of archaeology that the first of Shell-Mex BP 'professions' posters was the Ellis' *Antiquaries Prefer Shell* in 1934 (see Jeffrey 1984, ill. 57; the series was alphabetical, nevertheless 'architects' could equally have initiated it). In 1931 the Company commissioned two advertisements showing Stonehenge, one by Edward Bawden and, the other, a lithographic poster by E. McKnight Kauffer (by the early 1930s Stonehenge was receiving more than 15,000 visitors in a peak month: Chippindale 1983, 195, ills. 168 & 170).

Having variously, and often repeatedly, sketched, painted and photographed Avebury, Silbury Hill, the Cerne Abbas Giant, and Maiden Castle in the 1930s, in many respects Paul Nash is the seminal figure in this study (see Causey 1980 and Cardinal 1989 on Nash generally). Certainly he is the first major twentieth-century British artist to seriously explore and draw upon archaeological sources. His interest in the subject is epitomized in *Found Objects Interpreted: Encounter of the Wild Horns* that he exhibited at the Redfern Gallery, London in 1937 (Plate 8.1b). Drawn from his own 'strange store' of collected items, it is entirely an archaeological ensemble and consists of a Neolithic antler pick and cattle horncore set on a Roman tile. While devoid of style, typical of Nash (as opposed to the much more arbitrary character of, for example, Duchamp's ready-mades) its arrangement is aesthetically balanced. Its found objects are effectively interpreted by their evocative entitlement, and the juxtaposition of the two 'horns' (horncore and pick) conveys a sense of conflict, 'presences' and implied meaning.

Nash's sense of landscape, concerned as it was with the character of specific environs and their objects, was entirely personal. His treatment of monuments was far from topographic; they are not just signatures of locality, instead their role lay in their contribution to the 'personality of a place' — the *genius loci*. Nash, for instance, first painted the tree-crowned earthworks of the Wittenham Clumps, the twin hills of Sinodun, near Wallingford, Berkshire (one, the site of an Iron Age hillfort), while still in his early 20s. A key place in the artist's private geography, the hill-tops became a recurrent landmark in his work. It appeared, for example, as a formalized motif in such late works as *Landscape of the Summer Solstice* and *Landscape of the Vernal Equinox* (1943) and, in fact, at the time of his death in 1946 he was still working on a large study of the 'Clumps'.

The symbolic implications of Nash's megalithic period in the mid 1930s has been the source of much speculation (e.g. Wingfield Digby 1955, 147–72

and Eates 1973, 57–9). Certainly the 'stones' struck Nash in such a way so as to re-direct his art. When he sketched one of the Rollright Stones in 1923 the site made little impression, whereas the impact of his visit to Avebury a decade later was clearly profound. He wrote of this encounter in the *Unit One* volume published in 1934:

> Last summer I walked in a field near Avebury where two rough monoliths stand up, sixteen feet high, miraculously patterned with black and orange lichen, remnants of the avenue of stones which led to the Great Circle. A mile away, a green pyramid casts a gigantic shadow. In the hedge at hand, the white trumpet of a convoluvulus turns from its spiral stem, following the sun. *In my art I would solve such an equation* (emphasis added).

It is the last sentence that seems to be the key to Nash's megalithic works. In relationship to this experience, the direct equation he hit upon was the introduction of a mythic serpent stretching up from the hedge toward the sun before the stones of the Kennett Avenue in his watercolour, *Landscape of the Megaliths*, of 1937. Nash was not concerned with the literal representation of the monument, but the discovery of their conceptual equivalents. In *Cloud and Two Stones* (1934) and other related paintings, rocks and flint nodules command the foreground of the paintings and, therefore, assume the scale of Avebury's standing stones; in the *Equivalent for the Megaliths* (1935) geometric forms and a gridded plane are substituted. Set against a stylized landscape background, the abstract solids seem displaced, as if stuck onto the field in much the same way that the tennis ball and gnarled tree trunk float above the land in *Event on the Downs* of the same year. This sense of unease is further enhanced by the split horizon and dual landscape perspective he employed in some of the 'stone' paintings. Not all of these works are entirely successful, but in his search for conceptual substitutes he managed to prise monuments out of their docile settings and imbued them with the power to disquiet.

Christopher Neve has remarked upon the sense of 'dumb brightness' and 'concealment' that pervades Nash's landscapes. Writing that the artist was able to hint at what lay beneath their debris-littered surfaces, he directly compares Nash's work itself to a kind of archaeology and his method to that of a water diviner or ley-line hunter (1990, 3, 9–10). Nash's attitude towards the practice of archaeology seems to have been somewhat ambivalent. Despite owning a copy of William Stukley's antiquarian studies, his knowledge and appreciation of the subject itself was apparently limited. In a letter of 1927, for example, he proclaimed that anybody within the vicinity of Stonehenge 'airing archiological [sic] small talk should be fined five shillings and hustled into the highway with the utmost ignominy conceivable'. As his above-cited comments concerning Maiden Castle suggest, Nash placed little value on the academic significance of archaeological findings nor was he particularly concerned with the context of excavated remains (Bertram 1955, 237; see also Yorke 1988, 60).

Yet archaeological subject matter evidently appealed to the two main

strands in Nash's work — the modernist and Surrealist. The depiction of megaliths and earthworks were means by which abstract quasi-architectural elements could be introduced into landscape, but in them the hand of 'man' was blurred. Time, in other words, masked intention. Through arbitrary association and coincidence, archaeology also provided grist for 'landscapes of chance'. The contours of earthworks could frame or pattern landscapes and excavations produce startling *new* images and unique objects.

Nash's black and white photographs are also of interest, not least because their subject matter is closely parallel with that of his paintings. After an initial phase of hard-edge structural/architectural composition and travel documentation, in 1934 he shot a series of poised, highly abstract still-lifes composed of found objects consisting of small 'pure' solids (wooden blocks, tennis balls) and natural objects (bark, flint nodules, fossils and stones: see Causey 1973, pls. 27–31, 36, 38). Like miniature stage-sets, in them one finds models for the *Equivalent for the Megaliths*. At that time Nash also shot a series of evocative wood studies: *Lon-gom-pa* and *Marsh Personage* — that suggest totems or bog effigies. (The latter piece was exhibited in the International Surrealist Exhibition and thereafter hung as a personal totem in the artist's studio: Eates 1973, xii, 61).

Shortly thereafter Nash turned from formal abstraction and returned to the portrayal of subtly rhythmic landscapes. In his photographs of that time he emphasized the pattern of dry-stone walls, seashores and plough furrows. It is during this period that he also began to photograph archaeological subjects. In *c.* 1935 he undertook the series showing the hillfort at Maiden Castle, two years later the White Horse at Uffington (Plate 8.3a), and in 1942 he returned to photograph Avebury. In many respects the readily identifiable picture of the double inhumation from Maiden Castle is unrepresentative of his archaeological work. He generally took his pictures of monuments from a low angle, raising or obliterating the horizon so that it is the rhythmic solidity of the hillfort's massive ramparts or the abstract angular distortion of the chalk-cut Horse that was revealed.

In the late 1930s Eric Ravilious actually developed a minor specialization in the depiction of chalk-cut figures, his best-known being the Westbury Horse as seen through the window of a railway carriage in *Train Landscape* of *c.* 1939. The oblique perspective of the Uffington Horse in his 1939 watercolour, *The Vale of the White Horse* (Plate 8.3b), suggests that Ravilious was aware of Nash's photographs and his 1938 arguments concerning the subject (Binyon 1983, 109). His chosen subject matter disappeared in that year when, with the outbreak of war, the chalk hill figures were covered in scrub less they serve as navigation markers for enemy aircraft (Neve 1990, 18–19, ills. 5, 6).

John Piper had the closest ties to archaeology of any major British artist of the twentieth century. In 1949 he published a paper in the *Architectural Review* outlining historical representations of Stonehenge; he designed the

dust-jacket for T.D. Kendrick's *British Antiquity* (1950) and donated a pen & wash study of the dolmen at Pentre Ifan to Piggott's 1978 Festschrift, *To Illustrate the Monuments*. (In 1981, he contributed a stained glass window to Devizes Museums depicting a number of the region's archaeological icons.) A member of the Wiltshire Archaeology Society in his youth, in 1937 Piper presented the results of aerial photographic site surveys to the arts community in *Axis* ('A Quarterly Review of Contemporary Abstract Painting & Sculpture'). His references in that piece indicate that he was familiar with current archaeological literature and the article included recent images of Beacon Hill, White Sheet and the Uffington Horse. In a startling double-page spread composition, below Stukeley's engraving of Silbury Hill he juxtaposed a vertical photograph of the monument which had distinct echoes in a composition by Juan Miro on the facing page (Plate 8.4). In the accompanying text Piper stressed the absence of any horizon in these aerial images and their emphasis upon plan, and proclaimed their 'great beauty' in the light of their 'un-art-conscious' purpose (see Causey 1977 concerning the role of the horizon in landscape and Land Art).

a
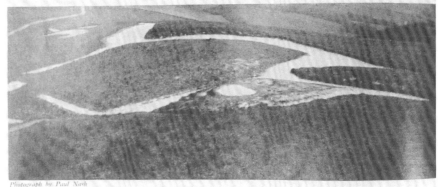

UNSEEN LANDSCAPES
By PAUL NASH

LANDSCAPE OF THE WHITE HORSE, BERKSHIRE DOWNS
Seen from close to, the "horse" becomes indecipherable, but the fusion of natural and artificial design asserts itself

b
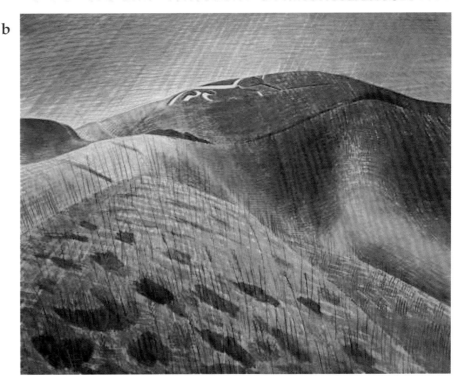

8.3a Paul Nash's low-angle photograph of the Uffington Horse in 'Unseen landscapes' article, *Country Life*, 1938.

8.3b *The Vale of the White Horse* (1939) by Eric Ravilious, watercolour.

Piper was to produce numerous megalithic images over his career (see Ingrams & Piper 1983 and Levinson 1987). Picturesquely set — he never aspired to Surrealism — he announced the need for landscape context in another essay of 1937, 'Lost, a Valuable Object':

> . . . And now where are we: Where is the subject, or the object, or the subject or sub-object, or whatever it is your fancy to call it? In oblivion still? One thing is certain about all activities since cubism: artists everywhere have done their best

to find something to replace the object that cubism destroyed. They have visited museums, and skidded back through the centuries, across whole continents and civilizations in their search. They have been frantic and calm by turns. They have adopted simple means, and very complicated ones. They have gone a long way in space as well as time. In this country, for instance, we find Paul Nash identifying all nature with a Bronze Age standing stone, and Ben Nicholson even assisting at world-creation. Henry Moore has landed us back in the stomach of pre-history, while Paul Nash, again, leaves us with the bare sea-washed bones of it. Abroad, we find Arp also in pre-history's midriffs; Mondrain charting the seas of pre-creation; Helion constructing complex object-symbols, new yet age-old, part-game and part-worship; and Miro rocketing among the stars and comets. It all seems to me an attempt to return to the object, not escape from it.

In spite of these varied activities there is one striking similarity of the surrealist and the abstract painter to the object: *they both have an absolute horror of it in its proper context.* The one thing neither of them would dream of painting is a tree standing in a field. For the tree standing in the field has practically no meaning at the moment for the painter. It is an ideal: not a reality.

But the object must grow again, must reappear as the 'country' that aspires painting.

In this we see an ethos of neo-Romanticism that was to become a hallmark of Piper's work and other contemporaries such as David Jones. Having turned from abstraction at this time (see Jenkins *et al.* 2003 for this period), Piper's megaliths are darkly atmospheric and their appreciation is entirely a matter of taste. However, when working as a war artist he did produce one archaeological-inspired image that is extraordinary (Jenkins 2000, fig. 8). The pen and watercolour, *Shelter Experiments near Woburn, Bedfordshire* of 1944 shows a circle of box-like military shelters that consciously evokes stone circle settings. Its impact entirely relates to a Nash-like sense of 'equivalence'; it is forcefully disquieting in its resonance of the prehistoric in the modern precisely because it is not 'the ancient' that is portrayed.

Behind the various artistic revelations of a 'wild downland' and monument empathy must sit two interrelated strands of landscape appreciation. On the one hand are notions of a generic *homeland nationalism*. Unlike, for example, in Australia or the Americas where there is a disjuncture between the distant past and much of their present-day inhabitants, in Europe appeal to monuments will carry the tinge of ancestral roots with 'our land'. In this context, strategies of visual displacement or the appeal of 'wild otherness' will invariably only reflect different facets of the 'homeland self'. More specifically, on the other hand, the celebration of downland-scapes appealed to a sense of *chalkland mysticism*. Combining ancient lore and various druidical musings of early antiquarians, during the later nineteenth–early twentieth centuries this 'bare bones' landscape came to be seen as a repository of ancient myth and the mystical 'soul' of the nation, which found diverse expression in the novels of Hardy and J.C. Powys (e.g. *Maiden Castle*, 1937) or even in the creed of the Kibbo Kift (Hargrave 1927). This, of course, was itself fostered by the sheer scale of the region's monuments (e.g. Stonehenge, Avebury, Silbury and

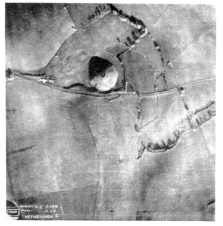

Silbury Hill, Avebury, Wiltshire. (Top) After Wm. Stukeley, 1723. (Bottom) Air photo (Crown copyright reserved). Opposite : Painting by JOAN MIRO

Maiden Castle) and coincided with British archaeology's own Wessex-oriented focus that was prevalent until at least the 1970s.

The foremost archaeological exponent of this chalkland ethos was, of course, Heywood Summer, whose ornate illustrations of Wessex's monuments (and also his own small excavations) so strongly bear the imprint of the Arts and Crafts movement. Summer was a major influence upon Piggott, particularly for his graphic style, as the ornate lettering that was to accompany his own fieldwork illustrations and that of a generation of field archaeologists bears witness (see Piggott 1965 and Edmonds & Evans 1991 for further discussion, and also R. Bradley 1997 concerning archaeological 'seeing'). Despite the 'prettiness' of much Summer's work, as portrayed by Nash and others the rolling 'tree-less' contours of the downlands had the potential to convey a wilder and more elemental Britain (and abstract nature) than the picturesque glades favoured by eighteenth- and nineteenth-century Romantics.

It would be stretching matters to further eke out archaeologically-inspired artists of the period. Nevertheless it is clear that there was significant interaction between artists and archaeologists during the 1930s. To paraphrase the title of one of Nash's own paintings, this essentially comes down to 'a chance encounter on the Downs'. Nash had become acquainted with Piggott and Keiller whilst staying at Avebury; this was furthered by his

8.4 Double-page illustration in Piper's 'Prehistory from the air' article in *Axis*, 1937.

work with John Betjeman on the Shell County Guides (by writing *Dorset* he certainly became re-acquainted with Wheeler, and apparently they knew each other at University: Wheeler 1955, 30), and to this must be added Piper with his archaeological connections. Arguably, this was the most influential art/ archaeology network since that of John Soane, John Britton, Colt Hoare and Turner a century before (Evans 1994; 2000). While sharing interests in landscape (and monuments), the discipline's interaction with the arts seems to have been relatively one-sided and the new visualization of the past during the 1930s had no obvious impact on the practice of archaeology itself. As outlined in other papers in this volume, it is really only over the last two decades that archaeology has begun to update its interrelationship with the contemporary visual arts and experiment with its own representation (see also e.g. Shanks 1992 and Bender *et al.* 1997).

Context and displacement

The 1930s clearly saw a creative vitality in the relationship between archaeology and the arts in Britain, and trends in the visual arts can also be traced in literature (Evans 1989a). In part, this was a product of the broader exposure and practice of archaeology, allowing it to provide grist for artistic inspiration. Yet, though excavation drew attention to major sites and there were close ties between archaeologists and artists, it was not 'deep' archaeological context that was sought. The vagaries of subtle interpretation or artefact typologies held little interest, but rather it was the evocative quality of excavation/monumental imagery that provided inspiration. In fact, the naming of archaeological phenomena itself — be it *The Avenue* at Avebury or Maiden Castle's *War Cemetery* — seems to have promoted association and this has parallels in, for example, the entitlement of Nash's own works.

The impact of Surrealist (and abstraction) tenets were crucial in this appreciation, as they encouraged disjuncture with the familiar. It was the ability of archaeology to reveal the *hidden*, whether found artefacts or the rhythms of 'horizon-less' earthworks seen from the air, that provided inspiration. This changed during the years of the Second World War as the Surrealist movement ran out of impetus generally and art was called to serve the nation. Nash was to depict Messerschmidts looming over Silbury Hill; once 'other', the monument now became a symbol of defence of the ancient homeland (see however Nash's 1945 'Aerial Flowers' and Gruffudd 1991 concerning the aviation art of the 'RAF Pastoral'). Increasingly, at least until the Land Art of the 1960s, monuments became a vehicle of sentimental neo-Romantic sympathies. Admittedly acknowledging a wilder Britain, they were still very much rooted in the 'home-landscape' and lay at a far cry from the internationalism of urbane Surrealist 'play'.

Ultimately Nash's landscape vision was to prove too personal and idiosyncratic for broad popular appeal and during the later 1930s his stature was out-stripped by that of Henry Moore (ejected from the Surrealist

movement in 1947 'for making sacerdotal ornaments': F. Bradley 1997, 60). Drawing inspiration from monumental sculptural forms of the ancient world and ethnography, Moore's abstraction — and the greater appeal of 'universalizing' figurative art — became more in tune with the tastes of modern post-war Britain, where clean abstraction and neo-Romanticism simultaneously held sway (see Moore writing in the *Listener* in 1941 concerning his sources in the light of the wartime closure of the British Museum.)

In the light of on-site artistic experiments today and shared interests with the arts concerning key questions of representation, the historiographic relevance of this study is obvious. Sitting centrally behind this is the issue of the depiction of a 'new past': is it still possible and can this impulse be maintained? It here that the relationship to materiality is particularly relevant concerning questions of context, content and 'play'. The great icons of Dada/Surrealism — Duchamp's urinal and Magritte's pipe — portray artefacts of mass-production. (Just as Warhol's later soup cans, the object depicted is commonplace, and its ready flat-style rendering is itself a product of advertizing; akin to silk-screening, Magritte also reproduced numerous versions of the same pieces.) The value of the work lies not in its artistic labour or 'style', but the context/de-contextualization of the banal in gallery space. Their impact is primarily ironic and relates to situation. Concerning the role of archaeologically-inspired art, it is surely relevant *vis-a-vis* Surrealist predecessors that it is largely in museum-inspired collection activities and mock typologies that a tradition of irony persists (e.g. Paolozzi and Dion: see Ades 1985; Coles & Dion 1999; Renfrew 2003, 84–94). Certainly there is little sense of this in 'painterly' traditions and landscape constructions. Whether it is Goldsworthy's snowballs or Long's stonework or David Nash's tree pieces, the assembly of 'raw' materials — be it stone, ice, clay or wood (and paint) — gets in the way and becomes embodied in the object/image itself, which conspires against erudite play. In reference to issues of 'newness', it could be argued that the work of these artists has roots in the 'found' landscape works of the 1930s. That, however, is surely not the point. Considering art from an archaeologically-informed perspective, *the new cannot be all* and perhaps, in the end, it can only be very specific or short-lived and can probably never exist in an artistic context alone but need also relate to broader world-view changes.

However awkward in style, a number of Nash's megalithic works are still striking visualizations of the past. It is surely not accidental that Richard Bradley illustrated the cover of his 1993 Rhind Lecture Series volume, *Altering the Earth*, with Nash's *Landscape of the Megaliths* of 1937 and Julian Thomas similarly chose Nash's *Equivalent for the Megaliths* for his *Re-thinking the Neolithic* of 1991. Sixty years on these remain powerfully disturbing works, more so than the most of the 'assembled' monuments of recent Land Art. Seemingly devoid of atmosphere and rendered in a flat painterly style, Nash's

megaliths are still deeply 'unfamiliar'. This is, of course, why they have been selected to announce these volumes, archaeology now being keenly concerned with *unfamiliar pasts* (especially as regards issues of monumentality). Much of the power of Nash's images relate to their situation — at the cusp of the modernist project and 'the traditional'. We are, of course, now beyond that point and when regularly bombarded with the new it risks becoming commonplace. Yet issues of 'ways of seeing' the past still confronts us and, in this capacity, these earlier attempts to depict (and displace) 'the ancient' continue to inform our viewing.

Acknowledgements & Appenda

Apart from the generic inspiration of the Cambridge conference, this paper has variously benefited from discussions with, and the comments of, Richard Bradley, Peter Gathercole (who supplied Fig. 8.2c), Mark Knight and Colin Renfrew — and, too, a long-shared discourse with Mark Edmonds and Marie-Louise Stig Sørensen.

This paper was first drafted arising from researches relating to the 1991 Kettle's Yard exhibition, *Excavating the Present* (Edmonds & Evans 1991) and was completed before my attention was drawn to Smiles's two recent papers concerned with its theme (2002 and 2003).

References

Ades, D., 1978. *Dada and Surrealism Reviewed.* London: Arts Council of Great Britain.

Ades, D., 1985. Paolozzi, surrealism and ethnography, in *Lost Magic Kingdoms and Six Paper Moons from Nahuatl: an Exhibition at the Museum of Mankind: Eduardo Paolozzi.* London: British Museum Publications, 61–6.

Bender, B., S. Hamilton & C. Tilley, 1997. Leskernick: stone worlds; alternative narratives; nested landscapes. *Proceedings of the Prehistoric Society* 63, 147–78.

Bertram, A., 1955. *Paul Nash: the Portrait of an Artist.* London: Faber and Faber.

Binyon, H., 1983. *Eric Ravilious: Memoir of an Artist.* London: Lutterworth Press.

Bradley, F., 1997. *Surrealism.* London: Tate Gallery.

Bradley, R., 1993. *Altering the Earth: the Origins of Monuments in Britain and Continental Europe* (The Rhind Lectures 1991–92). (Monograph Series 8.) Edinburgh: Society of Antiquaries of Scotland.

Bradley, R., 1997. 'To see is to have seen': craft traditions in British field archaeology, in *The Cultural Life of Images: Visual Representation in Archaeology*, ed. B.L. Molyneaux. London: Routledge, 62–72.

Breton, A., 1972. The presence of the Gaul [1955], in *Surrealism and Painting.* New York (NY): Icon Editions.

Cardinal, R., 1989. *The Landscape Vision of Paul Nash.* London: Reaktion.

Causey, A., 1973. *Paul Nash's Photographs.* London: Tate Gallery.

Causey, A., 1977. Space and time in British land art. *Studio International* 193, 122–30.

Causey, A., 1980. *Paul Nash.* Oxford: Clarendon Press.

Causey, A., 2000. *Paul Nash: Writings on Art.* Oxford: Oxford University Press.

Chippindale, C., 1983. *Stonehenge Complete.* London: Thames and Hudson.

Coles, A. & M. Dion (ed.), 1999. *Mark Dion: Archaeology.* London: Black Dog Publishing.

Cooke, L., 1991. The resurgence of the night-mind: primitivist revival in recent art, in *The Myth of Primitivism*, ed. S. Hiller. London: Routledge, 137–57.

Eates, M., 1973. *Paul Nash: the Master of the Image.* London: John Murray.

Edmonds, M. & C. Evans, 1991. The place of the past: art and archaeology in Britain, in *Excavating the Present* (2). Kettle's Yard, Cambridge. (Exhibition catalogue).

Evans, C., 1989a. Digging with the pen. *Archaeological Review from Cambridge* 8, 185–211.

Evans, C., 1989b. Archaeology and modern times: Bersu's Woodbury 1938/39. *Antiquity* 63, 436–50.

Evans, C., 1994. Natural wonders and national monuments: a meditation on the fate of the Tolmen. *Antiquity* 68, 200–208.

Evans, C., 2000. Megalithic follies: Soane's 'Druidic remains' and the display of monuments. *Journal of Material Culture* 5, 347–66.

Gell, A., 1998. *Art and Agency: an Anthropological Theory.* Oxford: Clarendon Press.

Goldwater, R., 1986. *Primitivism in Modern Art.* Cambridge (MA): Belknap Press.

Gruffudd, D., 1991. Reach for the sky: the air and English cultural nationalism. *Landscape Research* 16, 19–24.

Hargrave, J., 1927. *The Confession of the Kibbo Kift.* Tonbridge, Kent: William Maclellan. [Reprinted 1979 by Embryo Books.]

Hiller, S. (ed.), 1991. *The Myth of Primitivism: Perspectives on Art.* London: Routledge.

Hudson, K., 1981. *A Social History of Archaeology.* London: Macmillan.

Ingrams, R. & J. Piper, 1983. *Piper's Places.* London: Chatto & Windus.

Jeffrey, I., 1984. *The British Landscape 1920–1950.* London: Thames & Hudson.

Jenkins, D.F., 2000. *John Piper: the Forties.* London: Imperial War Museum.

Jenkins, D.F., F. Spalding & D. Shawe-Taylor, 2003. *Abstraction on the Beach: John Piper in the 1930s.* London: Merrell.

Levinson, O. (ed.), 1987. *John Piper: the Complete Graphic Works.* London: Faber and Faber.

Moore, H., 1941. On primitive art. *The Listener* 25, 598–9.

Nash, P., 1937. The life of the inanimate object. *Country Life* 82, 496–7.

Nash, P., 1938. Unseen landscapes. *Country Life* 83, 526–7.

Nash, P., 1945. Aerial flowers. *Counterpoint* 1.

Nash, P., 1949. *Outline.* London: Faber & Faber.

Neve, C., 1990. *Unquiet Landscape: Place and Ideas in Twentieth-century English Painting.* London: Faber & Faber.

Piggott, S., 1965. Archaeological draughtsmanship: principles and practice (pt I). *Antiquity* 39, 165–76.

Piper, J., 1937a. Prehistory from the air. *Axis* 8, 3–8.

Piper, J., 1937b. Lost, a valuable object, in *The Painter's Object*, ed. M. Evans. London: Gerald Howe, 69–73.

Piper, J., 1949. Stonehenge. *Architectural Review* 106, 177–82.

Renfrew, C., 2003. *Figuring it Out: the Parallel Visions of Artists and Archaeologists.* London: Thames & Hudson.

Shanks, M., 1992. *Experiencing the Past: On the Character of Archaeology.* London: Routledge.

Smiles, S., 2002. Equivalents for the megaliths: prehistory and English culture, 1920–50, in *The Geographies of Englishness: Landscape and the National Past 1880–1940*, eds. D.P. Corbett, Y. Holt & F. Russell. London: Yale University Press, 199–223.

Smiles, S., 2003. Ancient country: Nash and prehistory, in *Paul Nash: Modern Artist, Ancient Landscape*, ed. J. Montagu. London: Tate Publishing, 31–7.

Stevenson, J., 1984. *British Society 1914–45.* Harmondsworth: Penguin.

Thomas, J., 1991. *Rethinking the Neolithic.* Cambridge: Cambridge University Press.

Wheeler, Sir M., 1955. *Still Digging: Interleaves from an Antiquary's Notebook.* London: Michael Joseph.

Wingfield Digby, 1955. *Meaning and Symbol in Three Modern Artists.* London: Faber and Faber.

Yorke, M., 1988. *The Spirit Of Place.* London: Constable.

Art of war:
engaging the contested object

Nicholas J. Saunders

Materiality, conflict, art

War is the transformation of matter through the agency of destruction, and industrialized war creates and destroys on a larger scale than at any time in human history. Modern war has an unprecedented capacity to make, unmake, and re-make matter, individuals, cities, and nations. The vast quantities of material culture produced during twentieth-century conflicts, and the extremes of human behaviours that it embodies and provokes, suggests that the study of conflict-related materialities is a vital if hitherto under-acknowledged and un-theorized area of archaeological and anthropological investigation.

The materialities of conflict — from bullet to battlefield — are produced by human action rather than natural processes. They occupy a dynamic point of interplay between animate and inanimate worlds, inviting us to look beyond the physical and consider the hybrid, constantly re-negotiated relationships between objects and people (Attfield 2000, 1). Like any artefacts, they embody a diversity — but perhaps a unique intensity — of individual, social, and cultural ideas and experiences. Their analysis reveals the social origin of artefact variability, and the fact that simultaneously they are part of, and constitute the physical world. This world structures perceptions, constraining or unleashing ideas and emotions by the people who live within it in ways that draw together materiality, spirituality, politics and emotion, and link the living and the dead in an ever changing relationship between past and present.

We are all immersed in the material medium, our constant intimacy with the endlessly varied objects that surround us probably being the most distinctive and significant feature of human life (Schiffer 1999, 2,4). In wartime, this medium is constituted more powerfully than at any other time. Nowhere other than in war are people's lives more powerfully determined by their relationship to the objects that represent them, and through which they come to know and define themselves (see Hoskins 1998, 195).

The First World War was the world's first global industrialized conflict. It was recognized at the time as a war of *matériel*, or *materialschlacht* — which fact alone invites an approach focused on the study of material culture.

Nevertheless, since 1914, studies of the Great War (and indeed most other twentieth-century wars) have been the domain of military, economic, social, cultural, and political historians. The two disciplines whose focus is on material culture — archaeology and anthropology — have, with but few recent exceptions (Schofield *et al.* 2002; Saunders 2003a; in prep.), ignored the materialities of industrialized conflict and the capacity of material objects to act as a bridge between mental and physical worlds (Miller 1987, 99). Much needed multi-disciplinary studies of industrialized conflict may be considered as one of the many 'archaeologies of the contemporary past' (Buchli & Lucas 2001).

Illustrating the complexities of meaning between various kinds of matter and their relationships with human beings in war is a remark by the creator of that testament to monumentality on the First World War's Western Front — the eponymous 'Hindenburg Line'. Commenting in 1918 on the allied advance towards this formidable defence, Hindenburg

> . . . bemoaned that the British 'bombard our front not only with a drum-fire of shells, but also with a drum-fire of printed paper. Besides bombs which kill the body, they drop from the air leaflets which are intended to kill the soul'. (Fyfe 1919, 399)

As a contribution to still emerging multi-disciplinary approaches to modern conflict, I will examine a unique kind of war-related materiality that stands on the boundary between art and archaeology and is mediated by an anthropological focus on material culture. It is known, somewhat misleadingly, as 'trench art' — 3-D objects made from re-cycled war matériel and other materials by soldiers and civilians affected by conflict and its aftermath. In its varied shapes and kinds, trench art displays a conceptual coherence that encompasses diverse forms and contexts — a prime example of how art objects represent 'the visible knot which ties together an invisible skein of relations, fanning out into social space and social time' (Gell 1998, 62). A working definition, published and explored elsewhere (Saunders 2000a; 2001a; 2003a), is that trench art may be considered

> any item made by soldiers, prisoners of war, and civilians, from war matériel directly, or any other material, as long as it and they are associated temporally and/or spatially with armed conflict or its consequences.

In this essay, I use the concept of trench art as a model for exploring and understanding the relationships between people and war mediated by 3-D art. The variety and intensity of human experiences and emotions which are sealed within the trench-art object makes its study a kind of archaeology, the excavating of (often long-forgotten) personal lives — the reconstruction of personhood through the study of its scattered objectifications. The variety of meanings that characterize these objects envelops them in larger social projects. They move through symbolic as well as geographical space, intersecting cultural ideas, historical events, and personal lives as well as academic disciplines. As they move, they create liasons between people,

places, and experiences, and punctuate the textual dimension of memory. They also bring to light long-forgotten and sometimes unexpected aspects of the conflict that gave them birth.

The visceral nature of the trench art item as personalized memory object is illustrated by the case of 'talismanic bullets'. Shortly after the First World War began, German newspapers reported that the dowager Grand Duchess of Baden visited several military hospitals and presented the wounded with the bullets that had been taken out of their bodies and set in silver mountings. Not long after, the German jewellery industry '. . . turned to this new field of activity . . .' (IGW 1914–15, 153). In these instances, life and death experiences were embodied in previously lethal objects transformed into talismanic somatic art — bodily adornment that represented a symbolic re-ordering of personhood. Buying into this re-ordering process with money rather than wounding was achieved through commercialization — a separate process that incorporated the wider public in the war effort through acts of visual display. The investigation of these objects intersects many issues that concern art history, archaeology and anthropology. Trench-art pieces are objectifications of the self, symbolizing loss and mourning (Maas & Dietrich 1994; Saunders 2003b); are poignantly associated with memory and landscape (Saunders 2001b); and with issues of heritage and museum displays that increasingly emphasize the common soldier's and civilian's experience of war (Thierry 2001). Trench-art objects are associated also with pilgrimage and tourism — particularly as regards their symbolic status as souvenirs (Richardson 1996). In addition, they are a prime example of recyclia (Saunders 2000b; Cerny & Seriff 1996).

War into art

Art history has either ignored trench art *per se*, or ignored an object's trench-art status. For the First World War, 'war art' has hitherto referred almost exclusively either to paintings (Cork 1994; Silver 1989), or, more broadly, post-war commemorative monuments (Boorman 1988). Even at the time, the war was seen by many artists as a valueless and formless experience which could not be rendered by the conventions of the day (Hynes 1990, 108; Nash 1998, 29–30). Paintings and memorials represented war from a distance, connecting through impressions, and possessing little or no sensuous or tactile immediacy. By contrast, trench-art objects were a distinctive and 'attention-grabbing' kind of artistic endeavour that often incorporated the agents of death, mutilation, and destruction directly.

Hitherto, a discussion of trench art has been avoided by art historians in part because, in their view, it displays an unsophisticated interpretation of western art's aesthetic principles. Trench art has suffered from what Freedburg (1991, xxi) calls art history's suppression of the evidence for the power of images and an embarassment at the so-called primitive (artistic) behaviour of Western societies. More positive is Gell's (1998, 6) thesis of an action-centred

approach to art, which stresses agency, and sees in the inscribed decoration of an object an aspect not only of that object's function (as opposed to mere 'beautification'), but also the social project embodied by the decoration as it attaches the maker to the artefact he is inscribing (Gell 1998, 74).

The match between Gell's approach and trench art would appear well made. Apart from the visual attractiveness and often technical virtuosity of individual pieces, trench art can be seen as representing the intense relationships between human beings and artefacts during and after war. The qualities attached to these objects can evoke love, hate, fear, and grief, as well as boredom, inventiveness, and commercial advantage. In other words, trench art is a 3-D embodiment of the complex relationships between human beings and the things they make, use, and recycle — in the physical, spiritual, and metaphorical worlds they construct and inhabit.

Many trench-art objects occupy a point of tension on the boundary between traditionalism and modernism in art. Trench art often widens this boundary to a kind of No Man's Land within which its shapes and designs hover betwixt-and-between, caught in transition, at the point at which pre-1914 art becomes post-1914 art. This creative hybridity in (often lethal) liminal space is marked by the contradictions inherent in the objects themselves — where their raw material is the definitive product of modern industrialized manufacture, yet their subsequent decoration, shaping, and sometimes function, hark back to a pre-1914 world now destroyed by these same objects. Artillery shells covered with art nouveau's romantic and floral designs exemplify this in a powerful and ironic way (Plates 9.1 & 9.2).

Art nouveau's origins lay in the nineteenth-century reaction against the impersonal uniformity of industrial production — i.e. the processes which underwrote the nature of the First World War as a conflict of matériel. Artillery shells represented the epitome of such processes — the ultimate in de-personalization, both literally and figuratively. The covering of the spent shell case with art nouveau motifs re-personalized the object both at the individual level, and symbolically, at a cultural level that saw a peculiarly anachronistic (and short-lived) triumph of art nouveau's original intent.

9.1 Two First World War French 75 mm artillery shells decorated with art nouveau floral motifs. The brass square held between them originally held a clock and the lower strut is made of two carved bullets.

Yet, the strange conglomerations of shells, bullets, brass and aluminium were modernism embodied. They influenced the avant-garde, and arguably foreshadowed at least the spirit of post-war Art Deco — one of whose famous names, the glassmaker Rene Lalique, had served on a panel of specialists judging trench art in a wartime exhibition in Paris (EAG 1915). The church at Martigny-Courpierre is an Art Deco creation built on the old Chemin des Dames battlefield — its new forms and materials partaking of the aestheticization of the reclaimed battlefield.

As Hynes (1990, 195) observed, 'a Modernist method that before the war had seemed violent and distorting was seen to be realistic on the Western Front. Modernism had not changed, but reality had'. Although he was talking about painting and drawing, Hyne's comments fit 3-D trench art equally well, as do those of Booth (1996, 6), 'the Great War was experienced by soldiers as strangely modernist and that modernism itself is strangely haunted by the Great War'.

Many kinds and categories of trench art can be seen as a materialization of widely held post-war attitudes that articulated notions of dislocation and fragmentation. The war was seen as a 'gap' in history (Hynes 1990, xi, 116), time itself ruptured by a conflict which shattered not only human bodies, families and relationships, but wider European notions of society, civilization, art, and scientific progress as well (Silver 1989, 1–2, 8; Booth 1996).

Many examples of metal trench art embodied the confusions of war as ambiguous weapons transformed into ambiguous art, each object retaining visual cues to the former lives of its constituent parts. Previously unacknowledged is its role in the development of the art of the avant-garde, particularly Cubism and Dadaism. The link between these lies in the debate on the representation of space and reality — a debate that found reality on the battlefields and in the minds of soldiers and civilians of the Great War.

Many artists not only refused to let the war prevent them from working but also practised their art with war matériel. To date, artists' work in this genre has been regarded almost exclusively as but part of their early oeuvre, eliding their status as trench art produced by already (or subsequently) famous artists. Partly as a consequence, the influence of these early works on their makers and consumers has also been unacknowledged. The presence in countless European homes of souvenirs of battlefield debris and/or trench art memory objects for the bereaved, is an important but uninvestigated topic. In their ornamenting of domestic space, such objects familiarized, perhaps predisposed a wider public to industrialized military shapes and materials during the post-war era.

Many famous artists made 3-D trench art during the war — and many others appear to have been influenced in some way by it. Max Beckman produced a mural in a soldiers' delousing house — one of tens of thousands of such endeavours along the Western Front. Paul Klee painted on scraps of the linen covering of crashed aeroplanes, as did Erich Heckel on the side of an army tent. Henri Gaudier-Brzeska 'souvenired' an enemy soldier's Mauser rifle and wrote to his father in 1914

> I'm not at all bored in the trenches. I am doing some little pieces of sculpture. A few days ago I did a small maternity statue out of the butt-end of a German rifle, it's magnificent walnut wood, and I managed to cut it quite successfully with an ordinary knife (quoted in Ede 1931, 268).

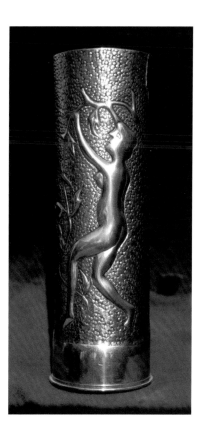

9.2 First World War artillery shell-case vase depicting a nude woman and floral motif in art nouveau style. Erotic imagery was rare in such pieces.

André Derain also extemporized with trench debris; abandoned artillery shell cases revived his pre-war interest in sculpture and he made several mask-like heads from this sinister beaten metal (Coray 1994, 58–60; Cork 1994, 61). Yet, while Cork's art-historical perspective leads him to regard Derain's trench-art shell cases as evidence of this prolific and inventive artist's neglect of his abilities during wartime, he ignores the wider and deeper significance of trench art *per se*, and its role in mediating (and representing) the multi-sensorial dimensions of war for Derain the soldier and man.

Apart from Freedberg's comments above, the refusal of art history to engage with trench art as multi-dimensional memory objects which affected artistic sensibilities is also due partly to the rarity of textual evidence making such links explicit, and partly to the sheer intellectual weight and (commercially valuable) quantity of these artists' subsequent work. Yet, while the influence of the war on Fernand Léger's work is generally well documented, it is never conceptualized anthropologically in terms of materiality. This despite Léger's own admission that 'It was in the trenches that I really seized the reality of objects' (quoted in Cork 1994, 86).

For Léger, the war brought new experiences of reality that centred around the machines of war and appeared almost alchemical in their effect on his sensibilities. As Léger himself says

> I left Paris in a period of abstraction, of pictorial liberation . . . I was dazzled by the breechblock of a 75mm gun opened in the sun, the magic of light on polished metal . . . taught me more for my artistic evolution than all the museums in the world (F. Léger, quoted in Schmalenbach 1991, 18).

9.3 *The Card Game/ The Card Party* (1917) by Fernand Léger.

Many trench-art objects recall Léger's belief that Cubism was particularly

appropriate to portray life in the trenches, as in his 1917 painting *The Card Party* (Silver 1989, 79, fig. 44) (Plate 9.3). While the mechanistic appearance of the soldiers in this painting has been commented upon (Cork 1994, 164), the dominance of cylindrical shapes that recall artillery shells (a favourite trench-art item) has not. In some ways, this painting is a re-working of his earlier 1915 piece *The Card Players*, which was painted on the recycled lid of a wooden shell-crate. This fact alone brings it within the orbit of trench art, as does the linking of object and place via Léger's inscribing it with the location it was painted. As with so many other similarly trench-art pieces, inscribing toponomy made the *The Card Players* a memory object.

More generally, Cubism's capacity to marry modern form with wartime subjects through the agency of destruction could equally well be applied to some kinds of trench art. Both are characterized by the fragmentation of figures and objects, and both flatten as they destroy (see Barrett 2000, 141). The associations are suggestive — in one sense, metal trench art is three-dimensional Cubism, and Cubist paintings verge on two-dimensional representations of metal trench art.

More traditional artists also found ways of incorporating the experiences and emotions of industrialized war into their work. Wyndham Lewis's 1918 *Officer and Signallers* (Plate 6.4), although produced as a pen, ink, crayon and watercolour on paper, nevertheless intersects with sensibilities similar to those apparent in 3-D metal trench art. The human figures look like the same polished brass as artillery shell cases. Simultaneously they appear as shiny anthropomorphic trench-art sculptures, as robots, and as metal men. There appears to be no distinction between humans and matériel. This recalls

9.4 *Officer and Signallers* (1918) by Percy Wyndham Lewis, in which the figures appear almost as 3-D polished-brass trench-art sculptures.

Kandinsky's (1977, 18) ideas concerning abstraction in which the human being is an object like any other. Intentional or not, Lewis's imagery conjures the ambiguous metaphors of industrialized war — where men and matériel are interchangeable, where men make the objects of war and are re-made by them, and where wider notions of men of metal are linked to ideas of men as machines — either as robots in their entirety, or in part as war-maimed men fitted with artificial (prosthetic) limbs.

The artistic appreciation of trench art was as ambiguous during the First World War as after. Conflicting attitudes towards war matériel re-worked and re-presented as souvenirs and memorabilia elicited popular descriptions of these objects as kitsch, trivia, and as beautiful, ugly, emotional, and patriotic items (Mosse 1990, 126–7). The cheapening over-familiarity that appears an inherent quality of kitsch was, in part, and ironically, a product of the same nineteenth-century industrialized replicative manufacture which created the First World War as a war of matériel.

Stewart's (1993, 167–8) view, that the '. . . kitsch object offers a saturation of materiality . . . [so that] . . . materiality is ironic', seems appropriate to many kinds of 3-D war art. The assertion that such objects are not apprehended on the level of the individual biography but rather the collective identity, and that such items are souvenirs of an era not a self (Stewart 1993), is more problematic. Today, First World War trench art can evoke the period 1914–39, but during that time such objects served also as highly personalized biographical objects. Etching a design onto a shell may over-materialize the object and produce kitsch, yet it is this design that personalizes the otherwise anonymous object by inscribing evidence of life, culture, and agency. In the study of trench art, the terms 'cheap junk', 'cherished memory object', and 'historic item' overlap in ways that are full of cultural insights yet often difficult to disentangle.

The labelling of such objects as a trivialization of war (Mosse 1990, 126) obscures more than it reveals by regarding all such objects as the same — an assumption which classification would seem to undermine (Saunders 2000a; 2003a). Trench-art objects are less a trivialization of war than its miniaturization, 'whose reduction in scale . . . skews the time and space relations of the everyday lifeworld' (Stewart 1993, 65).

In wartime France, public events displayed a positive attitude toward such objects — one that distinguished the French (and their Allies) from the Germans both during and after the war. In the dark days of 1915, there were two exhibitions that included trench art at the *Salles du Jeu de Paume des Tuileries* in Paris (Plate 9.5). The first, *L'Exposition National des Oeuvres des Artistes* (ENOA 1915), had a committee of judges which boasted such luminaries as Renoir, Rodin and Lalique; the second was *L'Exposition de l'Art a la Guerre* (EAG 1915). While doubtless used for propaganda, money-raising, and the boosting of morale, such exhibitions had other significant dimensions.

By bringing the trench war into the metropolis — the world capital of

culture — these exhibitions served if not to civilize the war at least to show the ingenuity of the soldiers and how they had not been barbarized by conflict. Making sometimes beautiful, if more often ingenious objects for social use and cultural display, trench art was part of the 'art of war', a graphic demonstration of how the shapes and forms of civilization could dominate those of war through artistic transformation. The exhibition was a public display and reification of these civilized virtues and sensibilities.

A less grand, though equally significant exhibition of soldier-made trench art appeared in the showroom of the Parisian jeweller *La Gerbe d'Or* throughout the war. Here, ambiguity and irony mingled in equal parts, as the company's regular catalogues made explicit that the money raised from the sale of these items would go directly to the soldiers themselves — each piece bearing the name and address of its maker (Warin 2001, 37–8). Buying these objects was presented both as a patriotic duty and the acquisition of a useful item — 'une nouvelle manifestation de l'esprit et de l'ingéniosité de nos braves poilus' (Warin 2001, 37–8).

The Armistice of 11 November 1918 changed the nature of Great War trench art and its display. Objects once made by soldiers and war-zone civilians were now made almost exclusively by refugees returning to their ruined towns and villages. Objects that previously were ambiguous art became memory objects of an event no longer ongoing but retreating in time and whose purchase no longer possessed a patriotic dimension. Public display became private, and any notion of such objects as art was subverted by the temporal shift from war to peace — a view that endured until the late 1990s.

A century of 3-D conflict art

One of the defining characteristics of trench art is its capacity to embody human experiences of, and reactions to, the unique circumstances of the conflict that gives birth to it. The Second World War differed from 1914–18 in being a war of movement not entrenchment, and in being considerably more civilianized. Both developments shaped experiences and their representations in material culture.

One example is the home-front bomb damage and civilian casualties caused by the Blitz in London and elsewhere. Materializing this technological development is a beautifully carved Masonic gavel, made of oak from the roof of London's Guildhall destroyed by the Luftwaffe on 29 December 1940 (Dennis

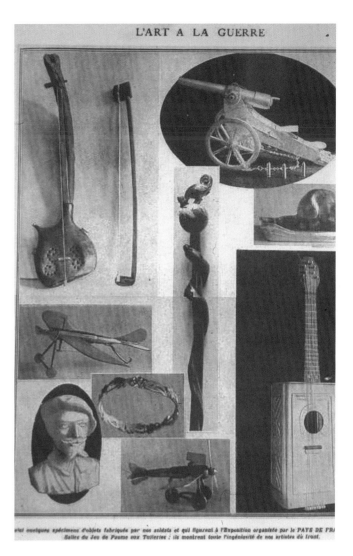

9.5 First World War trench art exhibited at the Salles du Jeu de Paume, Tuileries, in Paris in 1915 organized by the magazine *Le Pays de France*. Items include a walking stick, chalk carving, miniature monoplane, musical instruments and bracelet.

& Saunders 2003, 40). More telling are the 'Victory Bells', whose inscriptions recorded they were 'Cast with metal from German aircraft shot down over Britain 1939–45', and that embodied the imminently anachronistic Allied alliance in their decorative profiles of Churchill, Roosevelt, and Stalin (Plate 9.6).

Equally significant is the case of Finnish soldiers who represented their experiences of modern war in an age-old folk-art tradition. The archaic Finnish word *puhdetyö* originally referred to 'handiwork done by lamplight to while away the time'. It was soon applied to the multitude of wooden objects made by soldiers, finding visual and symbolic expression in photographs sent home from the front that showed soldiers in 'a popular martial pose . . . with knife and wood — rather than a rifle — in hand, surrounded by shavings, as if caught in the act of creation' (Steffa 1981, 154).

More recently, in Sarajevo after 1995, traditional Muslim metalworkers began using shell cases and bullet cartridges fired at them by Bosnian Serbs. Although designs and motifs are said to be spontaneous creations, there seems little doubt that they draw on an older artistic tradition, incorporating designs derived from the 'Bosnian Style' which flourished during the period of the Bosnian Banate and Bosnian Kingdom of the late fourteenth and early fifteenth centuries (Wenzel 1999, 159–62, 211 fig. 3b; Saunders & Wenzel in prep.). The most frequent images are Sarajevo's nineteenth-century neo-Gothic Christian cathedral, the early sixteenth-century Gazi Husrev Beg mosque, and the mid-sixteenth century Ottoman bridge at Mostar (Plate 9.7). These instantly recognizable motifs make for attractive souvenirs, yet their makers describe them as an artistic statement of peace, religious tolerance, and cultural and political reconciliation. As with many makers of such objects, Sarajevo metalsmiths are eloquent in their descriptions. In the words of one master metalsmith

> . . . a man should make objects which last ten times longer than his own life [for by so doing] he leaves [the world] a part of himself (Nasir H. Jabučar, pers. comm. 2000).

9.6 'Victory Bell' depicting Stalin. These items were cast from the aluminium debris of German aircraft shot down over Britain during the Second World War.

9.7 Distinctive 'Black and Gold' style artillery shell case from the 1992–5 Bosnian War. Made by a Muslim metalsmith maimed during the conflict it depicts Sarajevo's nineteenth-century neo-Gothic Christian cathedral.

Concluding comments

Trench art remains a volatile concept, not a stable corpus of conflict-specific art objects. It is a visceral exemplar of the art of war, and as such elicits the range of human responses to its varied forms. Trench art items are narratives of war inscribed on objects, and equally vocal as those inscribed on paper. Their tactile and durable qualities, and the freewheeling and imaginative engagement they demand of the observer serves to create constantly renegotiated meanings for post-war generations.

Trench art's capacity for transformation reveals it as a deeply ambiguous kind of matter. Regarded variously as junk, kitsch, art, or treasured memory object, trench-art items occupy a point of overlap between art history, archaeology and anthropology. The fragmented qualities and valuations that such objects can possess across time symbolize the tensions and confusions of a world created by industrialized war. Arguably more than any other kind of cultural matter associated with conflict, such objects provide opportunities for exploring the ways in which the dead and the living find proximity via materialities and places (Hallam & Hockey 2001, 6).

References

Attfield, J., 2000. *Wild Things: the Material Culture of Everyday Life*. Oxford: Berg.

Barrett, M., 2000. The Great War and post-modern memory. *New Formations* 41, 138–57.

Boorman, D., 1988. *At the Going Down of the Sun: British First World War Memorials*. York: Sessions.

Booth, A., 1996. *Postcards from the Trenches: Negotiating the Space between Modernism and the First World War*. Oxford: Oxford University Press.

Buchli, V. & G. Lucas (eds.), 2001. *Archaeologies of the Contemporary Past*. London: Routledge.

Cerny, C. & S. Seriff (eds.), 1996. *Recycled Re.Seen: Folk Art from the Global Scrap Heap*. New York (NY): Harry N. Abrams and Museum of New Mexico.

Coray, P., 1994. *André Derain, Sculpteur*. Milan: Electa.

Cork, R., 1994. *A Bitter Truth: Avant-Garde Art and the Great War*. New Haven (CT): Yale University Press.

Dennis, M.J.R. & N.J. Saunders, 2003. *Craft and Conflict: Masonic Trench Art and Military Memorabilia*. London: Savannah.

EAG, 1915. *Catalogue Général de L'Exposition de L'Art à la Guerre*. Salles du Jeu de Paume, Tuileries, Paris, October 20–November 30, 1915. Organized by 'Le Pays de France'.

Ede, H., 1931. *Savage Messiah*. New York (NY): The Literary Guild.

ENOA, 1915. *Exposition Nationale des Oeuvres des Artistes tués a l'ennemi, Bléssés, Prisonniers, et aux Armées*. Catalogue to Exhibition, Salles du Jeu de Paume, Tuileries, Paris, May 20–July 20, 1915. Organized by 'La Triennale'.

Freedburg, D., 1991. *The Power of Images: Studies in the History and Theory of Response*. Chicago (IL): University of Chicago Press.

Fyfe, H., 1919. British propaganda and how it helped the final victory, in *The Great War: the Standard History of the World-Wide Conflict*, vol. 11, eds. H.W. Wilson & J.A. Hammerton. London: The Amalgamated Press Limited, 393–402.

Gell, A., 1998. *Art and Agency*. Oxford: Blackwell.

Hallam, J. & J. Hockey, 2001. *Death, Memory and Material Culture*. Oxford: Berg.

Hoskins, J., 1998. *Biographical Objects*. London: Routledge.

Hynes, S., 1990. *A War Imagined: the First World War and English Culture*. London: The Bodley Head.

IGW, 1914–15. *Illustrierte Geschichte des Weltkrieges*, vol. 3. Stuttgart.

Kandinsky, W., 1977. *Concerning the Spiritual in Art*. New York (NY): Dover Publications.

Maas, B. & G. Dietrich, 1994. *Lebenszeichen: Schmuck aus Notzeiten*. Cologne: Museum für Angewandte Kunst.

Miller, D.M., 1987. *Material Culture and Mass Consumption*. Oxford: Blackwell.

Mosse, G.L., 1990. *Fallen Soldiers: Reshaping the Memory of the World Wars*. Oxford: Oxford University Press.

Nash, P., 1998. Letter by Paul Nash, Official War Artist, 18th November 1918, in *In Flanders Fields Museum, Cloth Hall, Market Square, Ieper: Eye Witness Accounts of the Great War: Guide to Quotations*. Ieper: Province of West Flanders.

Richardson, M., 1996. Mute witness: material culture in the context of war. *The Poppy and the Owl* 19, 31–8.

Saunders, N.J., 2000a. Bodies of metal, shells of memory: 'trench art' and the Great War re-cycled. *Journal of Material Culture* 5(1), 43–67.

Saunders, N.J., 2000b. Trench art: the recyclia of war, in *Transformations: the Art of Recycling*, eds. J. Coote, C. Morton & J. Nicholson. Oxford: Pitt-Rivers Museum, 64–7.

Saunders, N.J., 2001a. *Trench Art: a Brief History and Guide, 1914–1939*. Barnsley: Leo Cooper.

Saunders, N.J., 2001b. Matter and memory in the landscapes of conflict: the Western Front 1914–1999, in *Contested Landscapes: Movement, Exile and Place*, eds. B. Bender & M. Winer. Oxford: Berg, 37–53.

Saunders, N.J., 2003a. *Trench Art: Materialities and Memories of War*. Oxford: Berg.

Saunders, N.J., 2003b. Crucifix, Calvary, and cross: materiality and spirituality in Great War landscapes. *World Archaeology* 35(1), 7–21.

Saunders, N.J. (ed.), in prep. *Matters of Conflict: Anthropology and the First World War*. London: Routledge.

Saunders, N.J. & M. Wenzel, in prep. *Fighting with Style: Trench Art, Ethnicity, and War in Sarajevo*.

Schiffer, M., 1999. *The Material Life of Human Beings*. London: Routledge.

Schmalenbach, W., 1991. *Fernand Léger*. London: Thames and Hudson.

Schofield, J., W.G. Johnson & C. Beck (eds.), 2002. *Matériel Culture: the Archaeology of 20th Century Conflict*. London: Routledge.

Silver, K.E., 1989. *Esprit de Corps: Art of the Parisian Avante-garde and the First World War, 1914–25*. London: Thames and Hudson.

Steffa, L., 1981. *Muisto Syväriltä: Sota-ajan puhdetyöt: Finnish Trench Art*. Helsinki: Otava.

Stewart, S., 1993. *On Longing: Narratives of the Miniature, the Gigantic, the Souvenir, the Collection*. Durham (NC): Duke University Press.

Thierry, J.-P. (ed.), 2001. *Petites Histoires de la Grande Guerre: Les Objets insolites de L'Historial*. Péronne: Historial de la Grande Guerre.

Warin, P., 2001. *Artisanat de tranchée et briquets de Poilus de la guerre 14–18*. Louvier: Ysec Editions.

Wenzel, M., 1999. *Bosanski Stil Na Stećcima I Metalu/Bosnian Style on Tombstones and Metal*. Sarajevo: Sarajevo Publishing.

Art as process

Antony Gormley

Colin Renfrew: Antony Gormley, is, as you know, one of the sculptors who has returned to the body as a central theme in contemporary art. I think it is much better that he tells us himself what he thinks, without further introduction.

Antony Gormley: I haven't prepared a written paper.* My paper is in some way contained in my work which I will show to you as slides, which is a very different thing from experiencing them physically. I am suffering a little from 'Future Shock' because this is a bit like what I imagine might happen several hundred years hence, when the things that I have made are being interpreted. But at the same time, I'd love to use the combined brain power in this room to think about what I have done within the context of archaeology and material culture.

So far as I am concerned art is not a noun: it's a verb, it's a process. These objects that I'll be showing you are the fall-out, as it were, from a way of thinking physically. And that's what I do, as my daily activity. It is a daily practice.

Now, I'm going to show you some slides that were actually taken just last Wednesday, in De Panne which is on the coast of Belgium, where Ostend meets France (Plates 10.1–10.7).

So here we are: Wednesday afternoon, at about four o'clock. The sun was setting. It looks like a peaceful beach scene, but that beach is actually occupied by a mixture of living and iron bodies. These are a hundred works that are made of solid cast iron;

* This paper is the edited transcript of the talk, illustrated with slides, which Antony Gormley gave at the Symposium and of the discussion which followed. A short list of publications pertaining to Antony Gormley's work is added at the end of the paper.

10.1–10.4 *Another Place* , De Panne, Belgium.

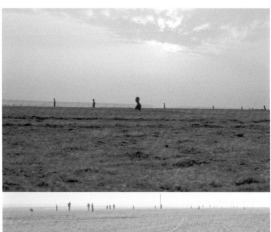

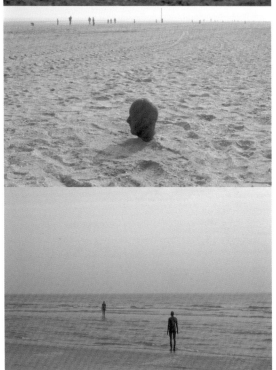

they weigh about 700 kilos each and the tops of the heads describe a perfect plane. They are absolutely horizontal, and mediate between the built world and the chaotic world of nature. I am very interested in this tide line. This is the third time this work has been shown and in every context, it changes. Here, because of the Belgian coastal regulations and the nature of that coast, the slope of the beach was such that I was not able to install it as it had been made originally, which was an extent of two and a half kilometres long by a kilometre deep out towards the horizon. They had to be in a line. There are 17 different body forms that are moulded directly from my body at different periods of breathing, from the fully inflated chest, to fully exhaled, fully relaxed, so a sort of mediation between a very tense and very relaxed body. And they all face precisely north in this installation. They effectively face the horizon, but in this installation, we turned them slightly. But anyway, the effect of the coastal regulations and the coast itself has meant that rather than it being a kilometre deep towards the horizon, it is actually at the widest point no more than a hundred metres. People walk up and down along that tide line between the domestic world and the natural and that is where the works are found.

The works have arrived here, having been in Norway, where they were in a very different circumstance (Plate 10.8). But they have aged. Sculpture has to do with time, with making interventions in lived time with geological or mineral time.

We know from Merlin Donald's work that consciousness exists within a fourteen-second frame: that is the window of the present through which we experience things. Sculpture has an extraordinary ability to intervene in that window. In many senses, these are memories of real moments that have been taken out of time. This is a real body in a real position, that is a 'frozen moment' of 'stopped' time, and these still moments, when placed in this liminal position between tide and the time of daily life have a peculiar kind of action. They are like a lever on both time and space. And (in the context of this learned gathering) the references to archaeology are very clear. These are industrially-created fossils that have been inserted within the existing world in such a way that the permanence and *assumed* dynamics of that world are in some way undermined. So this leads to something else that is important: we have to think about where the value is in these objects — evidently *not* intrinsic. It is evidently in the way in which they *unsettle* the state of things. I

10.5–10.7 *Another Place*, De Panne, Belgium.

like this. I like the fact that we've got the bouncy castle and old conventions die hard in Belgium, so they still have bathing huts, which they still wheel out into the sea so that the modesty of ladies and others should not be offended. And I like very much the fact that these still bodies are inserted into this dialogue between the modern apartment block and the Victorian bathing machine and at times are completely invisible within the daily life of that space, which is a space (well, when the weather isn't filthy) of fun and games. I quite like the insertion of questions about mortality — questions about where we come from and where we are going, that are inserted into this playground. This slide (Plate 10.6) attempts to show that we are dealing (and this is something that you will understand better than me) with a layer that is artificial, but nevertheless deals with what is apparent and what is implied, leading to some things being more implied than others. Obviously as the tide comes in, a second process of covering and revelation takes place.

The original inspiration for this work was that I was invited to do a work for the Happag Halle in Cuxhaven which was a place from where, at the end of the Weimar Republic and during the rise of National Socialism, many left Germany for the States. The work is called *Another Place* which I think has a wide resonance, not only in relation to the desire for emigration, but the desire for somewhere else where things are different. When that notion is made physical and then placed within an existing world it changes the place.

This is the same work (Plate 10.8) as it was shown in Norway, in a very different circumstance where the tide is insufficient for the pieces to get fully submerged.

The art of the twentieth century in some senses has aspired to the condition of the museum — the specialized, both intellectual and physical environment, in which cultural artefacts can be understood and

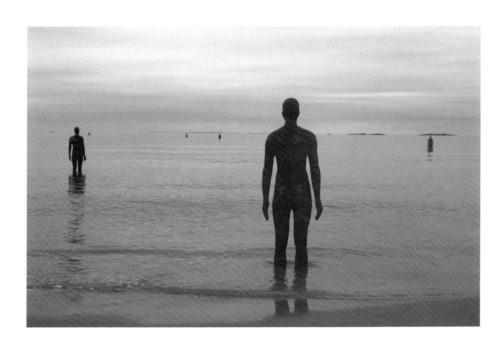

10.8 *Another Place*, Norway.

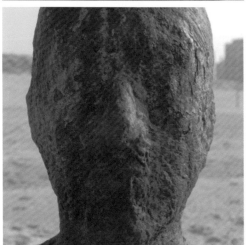

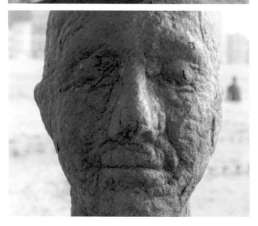

10.9–10.11
Another Place,
Norway, showing
how the iron has
spalled over time.

contextualized. I am very interested in breaking that model. I think that the objects that I make, make much more sense when placed either in the elemental world or ideally, as in this installation, somewhere in between, in a place of dialogue, between the elemental world and the domesticated world. I want to introduce, I suppose, a sense of uncertainty. Is it humorous? Is it an obstacle? Maybe it can be both. I am not making a representation of something — these are not representational in the traditional sense — they are indexical. Nor are they representational of landscape in the traditional way, even though they refer back, to the 'Rückfigur' that you might find in a Caspar David Friedrich, for example. But what they do is, hopefully, allow one to use the real world as a zone of imagination, wonder and questioning. This is pertinent to some of the papers that I've read and that I've listened to today in this Symposium.

Sculpture has always been an attempt to leave some inscription about human experience on the face of an indifferent universe. We have heard a paper about megaliths and the uncertainty about whether their material was chosen simply because it was around, or whether it had intrinsic qualities. I think the fact is that sculpture has always been attracted to stone because stone endures, and endures longer than we do. Having said that these works are made of a relatively permanent material but are placed provisionally in contexts where the meaning, the upshot of this intervention, this infection of a context, is provisional. They themselves change, and I love that. I love the fact that as a result of standing in the sea in Norway, which it did for about 14 months, the effect of saline penetration into the iron and then temperatures of minus 50 degrees or so, spalls the surface off (Plates 10.9–10.11). And each of these works in different ways — it begins to evoke different feelings about mortality, portraiture and metonymy that is intrinsic to my project: posing the question about what is the most viable subject for sculpture by using my own subjectivity as the sculptural subject.

I try to make the shortest possible bridge between something called 'art' and something called 'life' by making an impression of my own body in three dimensions, similar to a photographic negative, except that this is a three-dimensional mould. I do that not because my body is anything special, but it is the only bit of the material world that I happen to inhabit and therefore can work on from the inside, avoiding the problem of appearances. I am very aware as I speak to you now that where I am is behind my face; my face and my body in some way belong more to you than they do to me, and vice versa. I am interested in bearing witness to what it feels like to be alive the other side of appearances. In many senses, the processes that are involved in stripping that surface away, that

surface of appearance, portraiture I think allows for the second premise of my work: which is, that this is a materialization of the space that a body once occupied, some body, a particular body, an individual and subjectively-experienced body, but (and this is the other side of the proposition) could be anybody's. So there is a sense in which I am trying to de-monumentalize, de-heroicize, de-idealize, the normal position of the 'statue' that is our inheritance in the Western tradition, by making in a way, a radical statement about subjectivity but at the same time, demanding an equally empathic inhabitation of that space.

This idea prevails in this work, called an *Insider* (Plate 10.12). It has one-third of the volume of a bodyform, again taken from me, but it has been derived entirely by a measured reduction. You can imagine maybe from the earlier slide that after a sculpture has been in the sea for two hundred years it might look a bit like this.

This is one of those bodyforms being made (Plate 10.13). It's industrial. It takes us about three and a half seconds to go from void to object, from nothing to something. It's a pyroclastic moment and has all sorts of resonances with Pompeii. Origination is important: one is taking a moment of lived time and objectifying it in a very cataclysmic moment. This is heavy industry! Maybe the domestication of natural cataclysms is the basis of industry. And this is probably familiar to you too — here we have a lost body, or a lost Gormley (as somebody said), and here we have found something like him that has to be revealed from the matrix of the

10.12 *Insider V* by Antony Gormley.

10.13 Casting *Critical Mass* at Hargreaves Foundry, Halifax.

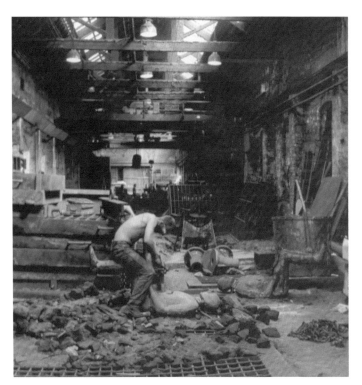

sand (Plate 10.14). I love these places — my studio is more like a hospital. The works that end up in these places are in a way at the end of the industrial story. There were 65 foundries in Halifax, and there is now only one, and this is it. I am very aware that this is the end of the exploitation of the Second Law of Thermodynamics: the industrial age in terms of the evolution of Western life. I want to take the potential of this moment and move from the fragility of the studio practice to the determinism of an industrial process while it is still possible.

I guess I just wanted to say something about where in the end these objects belong. Well, the fact is that they don't belong anywhere — they are lost objects that come from a found subject. That is very purposefully said, because I think what I have tried to do is re-attach to the central purpose of sculpture, something that was lost when we stumbled across the found object: self-consciousness and feeling. If you look at a great deal of the sculpture of the twentieth century, you will find formal devices that are more about structure and less about affect: so here are a couple of these lost objects (Plate 10.15). I'm probably a bit jealous of you archaeologists — you know where your stuff is, it's in the ground, and even if you can't find it, you know where to look for it. We don't have that certainty. So *where* these objects belong is uncertain. But I like that uncertainty, and I think what I want to do is invite you to share that uncertainty about where these lost objects belong. They no longer can, as

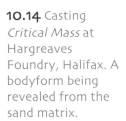

10.14 Casting *Critical Mass* at Hargreaves Foundry, Halifax. A bodyform being revealed from the sand matrix.

10.15 *Critical Mass* by Antony Gormley.

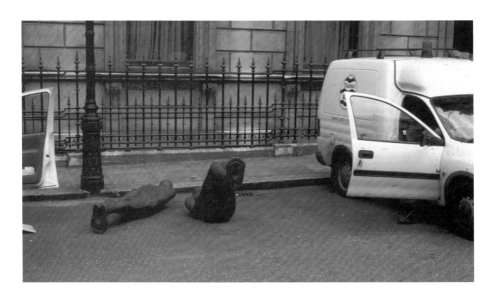

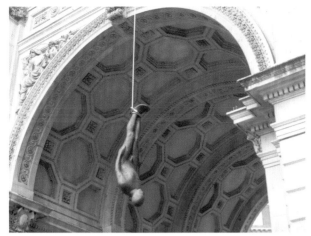
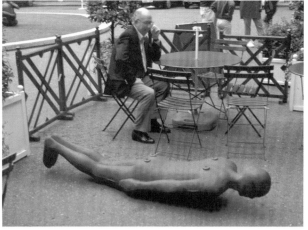
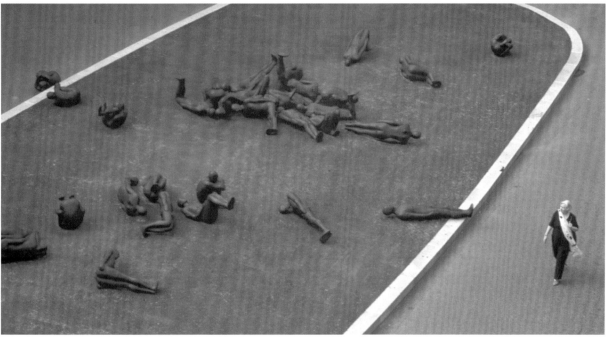

Colin Renfrew has very eloquently pointed out, exist in the niche, on a plinth, where there is a determined understanding about the mutual place of the viewer and this object of implied virtue. This is the courtyard of the Royal Academy in London (Plates 10.16–10.18) — it's amazing that I got away with it. In the structure of the work, there is an acknowledgement of the Ascent of Man; I've tried to re-do human evolution so you start with this foetal form which then becomes conscious, and he goes from there, to a kneeling position via a sitting position to an enthroned seated position — to the position of supplication to standing and finally looking above the horizon. There are twelve positions here which are a basic lexicon of the positions of the body which have then been jumbled and let fall. Some of the positions change radically when loosed from their 'normal' orientation. The kneeling one becomes an arch of hysteria; the mourning body form becomes an acrobat doing a shoulder stand. There is no determined demonstration of either an evolutionary or syntactical relationship between one body posture and

10.16–10.18
Critical Mass, Royal Academy, London.

another. They have simply been tipped out of the back of a lorry, literally, well, 46 of them, and the other 14 are suspended from the façade of the Learned Societies (the inheritance of enlightenment and the eighteenth century) and in front of statues of Michelangelo, Leonardo, Sir Joshua himself, on the façade of Burlington House. They were everywhere. *Where* does the significance of this infection of an otherwise perfectly self-possessed environment begin?

So here is a standing stone (Plate 10.19). I took this about 35 years ago. It is one of the Rollright Stones. So what is a standing stone? For me, a standing stone is the Ur-sculpture — it's a bit of the material world that was lying around doing nothing in particular, and then somebody comes along and decides to stand it up and it becomes a marker in space, a marker in time: a measure against which human life and consciousness registers itself. I still

aspire in sculpture to the condition of the standing stone. This is a tumulus (Plate 10.20) that has been incorporated into a golf course, but there is something fantastic about this. I could have shown you a picture of Silbury Hill but this is better: the immanent in the ordinary.

I just wanted now to show you a little bit of the history of my thinking. This image is taken at the Slade (Plate 10.21) and it was a very early experiment where I was simply trying to find a tree inside the tree. (I then discovered that Giuseppe Penone had been doing something similar.) So this is about a 40-year-old birch tree that has been cut back to the core, revealing the early sapling, the tree within. The idea that you can unpeel things, whether unpeeling the surface of the earth, or unpeeling the skin of the tree, was very much part of my early thinking in sculpture. This is called *Full Bowl* (Plates 10.22 & 10.23) and it is simply a bowl that has become the matrix for another bowl, and another bowl and so on. These are lead bowls, beaten one inside the other; they are a model. They look a bit like the Ptolemaic models of the passage of planetary bodies. But there are Taoist ideas here about empty cores and empty conditions: about skins and the way the condition of one thing can become the birth chamber of another.

I played with that idea in other works — this is a work from the late 1970s or early

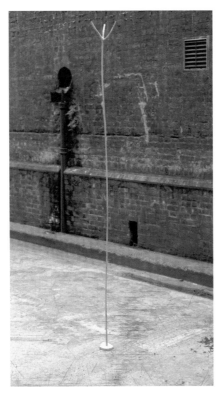

10.19 Rollright Stone.

10.20 Tumulus.

10.21 *Third Tree* by Antony Gormley.

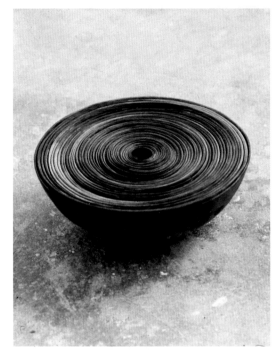

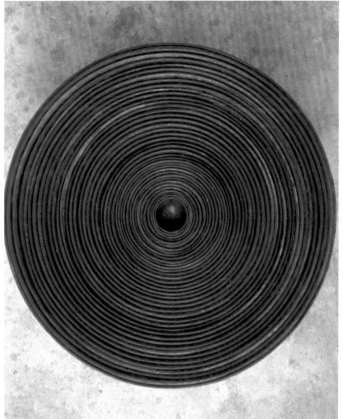

1980s, called *Natural Selection* (Plate 10.24) which has 24 objects in it, twelve of which are man-made and twelve of which are natural. It simply takes the notion of a morphological progression but subverts it by an alternate current, as it were. The real objects are in there, much to the dismay of the Whitechapel Art Gallery which sent me a telegram after the exhibition had been up for about four days, saying 'Your help urgently needed. Fruits and vegetables exploding'. The melon, that was the first to go: it was very smelly — they were worried about botulism. I don't want to be pedantic, but this was a very early attempt to deal with object reference — a kind of unpicking of the relationship between subject and referent by conjoining them. There is a relationship between a reliquary and this work. This is the container of an actual object but the box conforms to the shape of its content precisely. What I like is that in remaking the skin of something becomes an invitation to reimagine it — so it is a *re*-presentation not a representation, a very different way of refiguring the world traditionally exercised, through virtuosity and the skills of drawing and manipulation.

10.22–10.23 *Full Bowl* by Antony Gormley.

10.24 *Natural Selection* by Antony Gormley.

This was my first really completed work, which became a model for future work (Plate 10.25). This was the beginning of the 'body works', and is called *Room*. This is a set of my clothing, a shirt, and a vest and a pullover, pants, trousers, socks and shoes. The shoes were rather good — Church Brothers'. They were all cut into about five or six millimetre strips, peeled in a spiral like an orange. All the clothes were left in their same relations, one to the other, and stopped where the clothing stopped at the neck, but then expanded to an enclosure of about 20 foot square. A *re*-presentation again of the space of life, taking as it were the intimate container of clothing and extending it to the second, architecture.

This is *Bed*, it was looking rather fresh (in spite of the mould) in this early slide: this (Plate 10.26) is 600 loaves of Mother's Pride, out of which I ate my own volume over about a four-month period — I have never been able to eat Mother's Pride again.... The idea here is that somehow that if sculpture was about trying to get mind back into matter, the process of eating is itself a sculptural activity going the other way. I wanted to use, as it were, this 'staff of life' to leave an impression of the 'mortal process'. To make it I had a big drawing with all the layers marked on it and I knew exactly how much of this I was going to have to eat on any one day.

Now you might understand why earlier I asked a question about

10.25 *Room* by Antony Gormley.

Gavrinis. This is called *Heavy Stone* (Plate 10.27). Michelangelo's thesis was 'inside a block of stone is something desperate to get out, and it is the job of the sculptor to reveal it'. I'm more interested in this question — How can you use the inertia, the silent stillness, of a simple lump of rock to express the human experience of lifting it? Here we have this naturally-produced stone (this isn't a glacial erratic but I have used them — in fact there is a series of eight outside the British Library), clasped by a body carries the outline of my hands and arms, carved in a single line so a moment of contact is carried by the object.

This is a typical afternoon at the studio (Plate 10.28). I don't do much you see: I just hang around while other people cover me in plaster — but *why?* I go back to what I said at the beginning. This is so far as I am concerned the shortest route between something called life and something called art. If you are interested in somehow bearing witness to existence, use your own. Through making these spaces that tell you and the rest of the world where you were once, maybe something will be revealed.

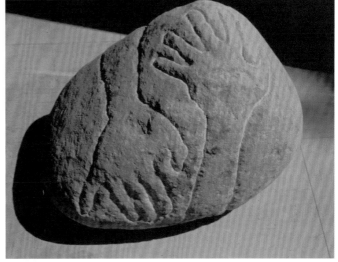

10.26 *Bed* by Antony Gormley.

10.27 *Heavy Stone* by Antony Gormley.

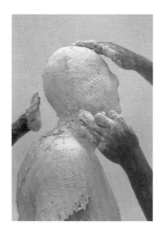

10.28 A typical day in the studio. Antony Gormley being covered in plaster.

This is an early work where — I was wondering — can you replace a human space in space at large and allow it to become evocative? The problem about my work is that, until recently, when it has exploded and I am beginning to use other people's bodies, I think people have seen it very much as a continuation of the statue. To that degree I have failed.

These are boxes, (Plate 10.29) three lead boxes in three positions, with certain orifices opened. 'Sea' in the middle has its eyes open and looks at the horizon. 'Air' on the right has its nostrils open and 'Land' on the left has its earholes open (the ear is sort of cocked). I was trying to link a sense with a posture and a posture with an element, in such a way that you could take these three void cases and put them in an interior space and you would still (similar to raising a shell to your ear) somehow get a sense of an elemental connection. These become vehicles for a connection between the body and the elements.

This is another case. These lead body cases have the same relationship to the body as a violin case has to a violin. They are empty boxes like architecture which has been brought to the most intimate realm. This is called *Learning to See* (Plate 10.30); it's the first work where I got good enough beating the lead technically to actually make the dome of the eye within the orbits. These are not casts, they are beaten, lead sheets over the original

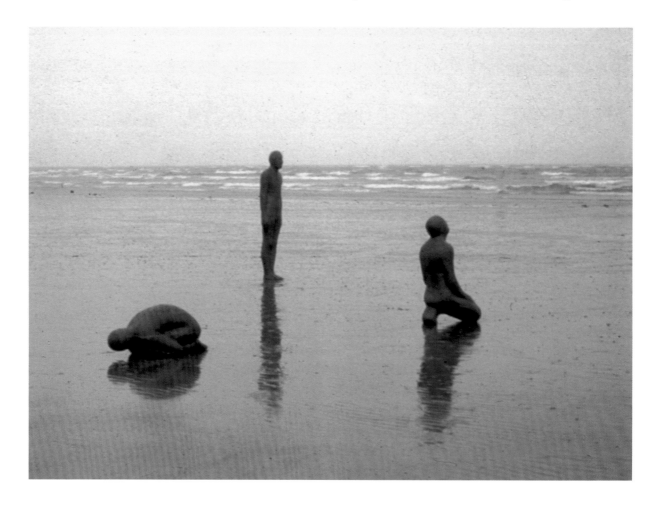

plaster mould which has been strengthened with fibreglass. Here, for the first time, you get an indication of the eyes: the subject of the work being whatever that space is that we can all enter and all of us inhabit when we close our eyes but are still conscious perhaps, with this piece that space becomes more apparent.

Sense is a concrete block (Plate 10.31) that contains the impression of my body pushing against its extremities with the brain left out — you can look into that void. This has everything to do with the Laetoli footprints, everything to do with another trace, the ochre handprint left on the wall of Pech Merle — perhaps the most evocative thing that a human being can leave for another is this indication of where he or she once was and we can imaginatively also be.

It's a kind of compression of architecture into a block — into a mass.

This is another way of doing the same thing — this is the same thing but inverted into architecture, where we walk into the volume of a room, and as it were, see these absent spaces. It is called *Learning to Think* (Plate 10.32).

Here is a really architectural piece, it really is 'reduced architecture' — a functional real building (if you felt like living like this) but made for one man. Here is the head space, here is body space, ears, mouth, genitals. This is in the middle of Australia: it's called *A Room for the Great Australian Desert* (Plate 10.33) a minimal habitation in a maximal expansion of space: there is a 360° horizon. The work is for imaginative inhabitation. It's not far from the nuclear testing site.

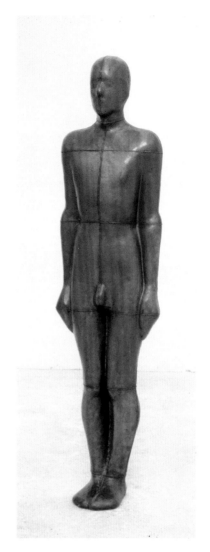

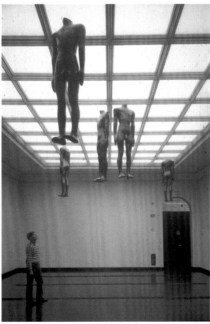

10.29 (opposite) *Land, Sea* and *Air II* by Antony Gormley.

10.30 (above) *Learning to See* by Antony Gormley.

10.31 (far left) *Sense* by Antony Gormley.

10.32 (left) *Learning to Think* by Antony Gormley.

Art as process 143

The idea of 'room' was then expanded to this work which will be seen for the first time in this country next month — it is called *Allotment* (Plate 10.34). This is 300 inhabitants of a small town called Malmö in southern Sweden who were very carefully measured. They were invited to stand in a steel box and their vital statistics were taken. Those intimate details were then translated into this bunker modernist architecture and the whole made into a virtual city in which there are two avenues, four cross streets and twenty blocks of about fifteen rooms each.

We'll finish with this work, *Field for the British Isles* that I am very proud to have shown at the British Museum recently (Plate 10.35). This goes back to the tumulus — the idea that the earth has memory, that we, the conscious layer of material on this planet somehow look on the earth with memory: the spirit of the ancestors; and potential: the spirit of the unborn also suggests by making us the subject of the earth's gaze, that we are responsible for it and for making the future. This is another version of the same work made in Mexico (Plate 10.36). I've just made the largest version of this in China, which opened last week in Guanzhou.

Questions

John Clark: Did you see the Aztec exhibition at the Royal Academy? One thing the Aztecs did was to skin a guy alive and have somebody else dance around in that skin. You can see the statues wearing that skin.

AG: What's he called? –Xipe Totec: I love that idea. In some way, that's a materialization of my entire project.

Steven Mithen: Thanks very much for your talk. I was very much struck by one of the first things that you said when you talked about your De Panne installation. You said that this acts as a mediation between the human world and the natural world — in fact you said between the built world and the chaotic natural world — and that struck me, because received opinion I would have thought is that we have got a chaotic built world and a natural world full of natural rhythm. I was wondering quite why you expressed it that way?

AG: I like very much that you have turned the thing on its head and certainly, in these unsettled times, the idea that human beings make anything but chaos is a pertinent point. I do like that Heideggerian notion that the earth is what we inherit and the world is what we make out of it. What I like about that cliff-like group of apartments in De Panne (anywhere else, like the outskirts of

10.33 *A Room for the Great Australian Desert* by Antony Gormley.

Moscow or St Petersberg, it would be prison-like social housing but because it is Belgium it is luxury flats) is the idea that this is a structured world that faces the elemental one with a steady stare. Maybe you are right that it is an unfortunate dialectic to continue but beaches interest me because I think they are places where there is a lot of regression going on, where we are trying to find our way back to a 'natural state'. Actually, I am looking forward to the first storm that hits that beach, and what happens to those works when there are four or five metre high waves crashing into them. That is perhaps what I mean about the dialogue; that what architecture expresses is to do with stability, the whole thing that Colin criticized Merlin Donald for missing out. This represents the sedentism of the twentieth century, being faced with the timeless and provisional. What did you think? I regret not showing more slides of people with their icecreams and their dogs having a wee: all of the things that actually went on. It's very natural for people to want to play with the work and I quite enjoy that. When we first showed it in Cuxhaven — it was originally made in Cuxhaven at the mouth of the Elbe, which is a very different circumstance altogether where the sea goes out and in over seven kilometres, a very deep field — the morning following the first night after this installation was completed, seven of the figures had ties on, three of them condoms — there was a nice wish to subvert them.

Steven Mithen: Since we spoke the other day, I have been haunted by the Keith Arnatt self-burials. That work frightened and terrified me. You have to have that clay and box — the idea of wanting to become buried underground

10.34 *Allotment* by Antony Gormley.

— living bodies – it's frightening thing to me.

AG: I go in for a lot of self-burial in the process of being moulded because I think it is quite intriguing, that voluntary loss of freedom. I hadn't realized what the effect was going to be of this work in Belgium. In Cuxhaven, it was very romantic and an *invitation au voyage*. It was the measure of the time and tide as this repeated human form led you to the horizon. In De Panne it is something much more troubling, therefore probably more interesting, troubling questions about mortality and freedom in a zone of play. In Cuxhaven, it was more about being in the picture that you are invited to look at.

Manuel Arroyo-Kalin: I like very much what you just said about the perspective of contrasting that experience with how we think of archaeology (quite apart from the works themselves). I think that when we discuss materiality, we are fixated on a set of concepts — the purposes of objects, the form of objects and in the last twenty years, the meaning of objects. I think these lead to questions of people as end-users — who *uses* the object and who *produces* the object? I find it very provoking, that for example, you present your own work as not a form of signifying the world, but also a form of exploring the world — a form of materially exploring the world. And if I get you correctly, not just by positing symbols but by positing indexes of ideas and consciousness.

AG: It is much more to do with spaces and places than it is with objects and symbols *per se*. That is why I started with asking — can we consider art less as a dialogue with objects than as a process in which the objects are fallout, a kind of evidence, or symptom? Somebody invited me to put this same work on the ice shelf in Antarctica and I thought that was a pretty good idea. It didn't worry me that nobody was going to see it apart from a few penguins, because I like the idea that this was another context where the work could do something different. In the end, I decided it was ever so slightly decadent, even though somebody was going to pay for it who felt that this was

10.35 *Field for the British Isles* by Antony Gormley.

important for Antarctica, for some reason. But I liked the fact that some of these works might end up in museums, others might equally well end up on the seabed. But I also worry about that. I said to Olav, who was head of the Norwegian Antarctic Survey Team, 'What about the iron?'. He laughed at me, and said 'Antony, do you not realize that below the Antarctic Ice Cap, every year some astronomical amount of iron oxide goes into the sea?'. It was a joke to him that somehow this little bit of material that I happened to think of as being my responsibility, that this was going to make any difference to the level of residual deposits in the sea.

Chris Evans: Just wondering, in terms of the end of the process, to what degree you see these as artefacts. For example, the *Field for the British Isles* figures, now you have made another version of it — so do they remain as an artefact of itself? Or the bronze figures — do you recast your figures afterwards, or are they all destined for someone?

AG: I think they are all destined for an uncertain passage in time and space, and in a way, that isn't my problem. I use words like 'infection'. I went to China with an idea, and in the end, 500 people helped to realize that idea. The work isn't mine. I take responsibility for initiating it. The work is there: we made 192,000 pieces. There are 3731 blue boxes of them, and we didn't even use all of them in the first display. Now, what should we do with them? The Japanese want to show the piece. That's great but I think they should go back to China. Everyone wanted to know what was going to happen to them and I said 'Well, China has a very long history of how to deal with objects like these', and it seemed natural to return them to China and decide whether to bury them or not.

Kristian Kristiansen: I was just wondering who owns 100 bodies? I mean they are travelling round, and you are arranging and re-arranging them and you live with them, to some extent and there is a continuing relationship.

AG: Yes, I do own them, and it is extraordinary that I do own them because most of these big ones have been paid for by others. The hundred pieces that are in De Panne were paid for by the Cultural Ministry of Schleswig Holstein

10.36 *Field for the British Isles* by Antony Gormley.

in 1997. *Critical Mass* a piece that was in the Royal Academy forecourt, was paid for by the City of Vienna. *Critical Mass* is now going to be exhibited in a Jesuit College in Graz. But yes, they are mine, but I'm not running around after them, worrying about what happens to them. It's a good question — should I be engineering a Gavrinis-type tumulus for them?

Kristian Kristiansen: You have a different relationship to the little figures in China?

AG: I'm not very possessive about these things. In broad terms, I'm a cultural worker who works in substance — you and your colleagues probably work in ideas that are attached to objects. I think that in both cases, the fruit of both our labours is offered back to the world to be reassessed, reprocessed and recontextualized. I think that is what human culture is about: picking things up, turning them around, giving them thoughts, and then passing them on to somebody else. I mean, passing them on maybe with these added inscriptions or material additions, attached, which might stay attached for a certain amount of time, or not. Things are very fluid.

I think the great joy about art of the late twentieth century has been the way in which signifiers have been loosened, and I would say that the job of the viewer has become as important as the job of the maker. The emergence of new value comes by making objects as places of exchange, that don't have fixed roles. I don't know whether this destroys your discipline because I know a lot of the time you spend attempting to define what the specific purpose of this artefact was, and how it was used and how it carries the sense of the culture which gave rise to it. I admire this in the discipline of archaeology. But I also admire the way that objects can communicate directly over vast areas of time. You can pick something up — I had that experience of picking up those tiny little unfired clay figures from Tel el-Amarna in the British Museum and just feeling the way they sat in the hand as they had done in the hands of the maker. It was a quite remarkable sense of shaking somebody's hand over vast eras of time — it was more the sense of contact that grabbed me rather decoding function.

Carl Knappett: Picking up on the idea that archaeologists and perhaps artists have objects and are trying to understand the imprints. You talked about imprints or indexes. But lots of the imprints and indexes we have in archaeology are partial. Lots of the indexes we think of generally are quite partial as well, like a footprint or a fingerprint or smoke for fire. They are partial and in a part to whole relationship, I suppose. But a lot of your figures are whole to whole. It is rather a whole space that's built rather than just handprints or whatever. I just wondered if you could elaborate a bit on the difference.

AG: Yes, I like the line of your questioning metonymy: parts for wholes. I

have been in interested in the body in pieces, but never as a totality — but recently I have been concerned with how that singleton connects: the one in the all: the 'I' in the 'we'. Colin has questioned quite seriously the level of socialization in the work. Why is it that you have taken as it were the idea of the individuated total body, which evidently has dangers of conveying solitude? For the first twenty years of my practice, I held on to the idea that there was no reason to speak for others, and that the only morally justifiable bearing witness was to bear witness to your own existence. I have *now*, since making *Field*, I have now tried to. And that came out of a crisis, in a way, of having borne too much witness to my own existence. *Field* was the result of saying: 'Look, can I open the door to this place called art and can we make collectively, taking the earth that lies beneath our feet and touching it in this way, can we make a reservoir that in some way is collectively engendered but also is an evocation of the collective body?' I think that was what it was — and in the end, I tried with *Critical Mass* and with *Another Place*, the first two series of slides that I showed, I tried, by multiplying my own body to give a kind of illusion of the collective. I've stopped that now.

The piece that I am in the middle of making at the moment up in Gateshead at the Baltic — I invited 250 people to come and have a total body mould taken of them standing in a relaxed and comfortable position — I was amazed when over a thousand people applied for that. This is another attempt to take the total body that in itself is only partial in terms of the collective which gives it a context. This is the other revolution in the work; from the singular body to the multiple, from my own to others. I've also lost the skin, and I haven't shown you any slides of that, but the work has essentially exploded. And since the making of the solid masses which themselves followed the body case works which were all voids, all of the new works are random matrices. So they are open, they are completely transparent — they are made out of lengths of steel. And the idea of this collective body is expressed in *Domain Field*, which is the work I am in the middle of making for the Baltic, by the fact that these random matrices of stainless steel elements, collectively fill this room with this energy field that you could read as a total system (Gormley & Renfrew 2004, 26–7). Then, as you walk in, they resolve into individuals. The youngest is Oscar who is two and a half, and the oldest is a woman of 85. My idea is that the body unconsciously carries an attitude — the body is the language before language. It carries within it *posture:* an attitude to life which is derived both from genetic hardwiring and the experience of life. *Domain Field* is an attempt to remove the subtle body from the physical body, so that you get an evocation of presence, or, if you were religious, you could call it soul, but anyway, a kind of a dematerialized body that nevertheless carries the attitude of that body to life.

Richard Bradley: You were talking about the way in which your work can be recontextualized, the way in which it can be interpreted. Do you ever feel you

want to set a limit on those interpretations, that people are engaging in interpretations that are so distant from your own conception that you actually disapprove of them, or is it completely free?

AG: No, I think it is very important that once the thing is made, that it does its job, which is to float free. What I say to people is that whatever you think or feel is the subject of the work. You may say that is a complete betrayal of your responsibility as originator of these objects in the world, and I would say to the contrary. I did try and write down a definition of what sculpture is: 'the conceptual use of physical materials and processes to provoke feeling and thought'. Now, that is a bit of a mouthful, isn't it? I have tried to formulate concise and focused strategies that give rise to the work, which I believe are the most concise and focused that I am able. But how those objects, the outcome of those processes are registered by the culture as a whole, cannot be my job. I would never, ever want to determine it.

Elizabeth Brumfiel: I was really interested in the fact that you constructed your 'collected works' using hundreds or even thousands of other people, and to an archaeologist, that sounds a lot like monument building. So I am wondering if these projects have done either one of two things? One, to engender social relations among the people who participated, or else to transform them in a different way. As the finished work provokes — does participating in the work provoke?

AG: Absolutely. That's a brilliant question and absolutely right. Even in the Amazon, in Porto Veilho where we made a *Field*, it was a dysfunctional community, in fact it could not be called a community at all. It was a sort of Favella, in which there was drug warfare going on. The invitation to participate in the project (and I've always made certain that there was an excellent cook and really good food) for many the motivation was simply that they were going to be fed. But in making the work, there was a brief constitution of a formal community and that has been a most powerful and moving part of the process. It certainly happened in China but in a way you couldn't predict. The ritualized side of total body casting, which is itself in a way a rite of passage and represents quite a serious challenge to anyone who hasn't done it before, has resulted in the most incredibly powerful cohesiveness in the individuals that have come forward. It's very moving, the accounts that have both been left on the side of the moulding booths and that have come through on the internet. (You can go to the site - it's http://www.balticmill.com). Both in *Field* and in *Domain Field* — it's not only the representation of a collective body but the forming of one, and that has been very powerful. Who makes art? Who can feel represented in art? Where can art be found? Can it be shared? Is it necessary that it has to be interpreted? These are some of the questions that concern me. Art is normally written

about by those responsible for the museum, the art gallery and the private collection. The culture has failed us if the art of our time cannot be collectively owned, collectively understood or collectively enjoyed: that it should be something that belongs to us and is for us. This may be wishful thinking — I can see that in many senses this is happening that the works of Damien Hirst and Rachael Whiteread and others are fulfilling this function. But the art world is a very self-serving and somewhat isolated part of the world at large. I suppose I look at the cultures that many of you are studying and looking at, and wonder whether this word 'art' isn't itself a bit of a problem. I wonder whether the forms in which life expresses itself naturally in material culture, aren't the things that are the most valuable, and this idea that a monetary value is to be placed on these cultural objects that are only valuable because they need interpretation and have a rarity built into them from scratch, and that they all aspire to an institutional validation which worries me.

Relevant Publications

Gormley, A., 1996. *Body and Light and Other Drawings 1990–6*. London: Jay Jopling.

Gormley, A., 2001. *Some of the Facts*. St Ives: Tate.

Gormely, A., 2002a. *Antony Gormley* (exhibition catalogue). Compostela: Xunta de Galicia, Centro Galego de Arte Contemporaneo.

Gormley, A., 2002b. *Workbooks 1977–92*. Compostela: Xunta de Galicia, Centro Galego de Arte Contemporaneo.

Gormley, A., 2003. *Domain Field*. Newcastle: Baltic Exchange.

Gormley, A. & C. Renfrew, 2004. A meeting of minds: art and archaeology, in *Material Engagements: Studies in Honour of Colin Renfrew*. (McDonald Institute Monographs.) Cambridge: McDonald Institute for Archaeological Research, 9–29.

Hutchinson, J., E.H. Gombrich & L.B. Njatin, 1995. *Antony Gormley*. 2nd edition. London: Phaidon.

Moszynska, A., 2002. *Antony Gormley Drawings*. London: British Museum.

Renfrew, C., 2002. Antony Gormley: making contact. *British Museum Magazine* 44 (autumn), 16–19.

Riley, R. (ed.), 2003. *Asian Field: Antony Gormley*. London: British Council.

Schmidt, H.-W. (ed.), 1999. *Antony Gormley: a Conversation with Klaus Theweleit and Monika Theweleit -Kubale*. Kiel: Kerber Verlag.

Contemporary Western art and archaeology

Steven Mithen

Many artists have been influenced by prehistoric monuments and other aspects of the archaeological record. Chris Evans (this volume) has provided a detailed study of how the British surrealists of the 1930s, especially Paul Nash, responded to stone circles, chalk-cut figures, and standing monuments. He shows how an understanding of their art requires an appreciation of developments in archaeological thought and excavation, and how these contributed to changing views of the British countryside. There is evidently a great deal more that needs to be explored on this specific topic, and more generally on how archaeology has influenced artists working in different traditions, times and places. The converse also requires examination: how art has influenced archaeologists, and how it could potentially do more so in this regard. Renfrew's *Figuring it Out*, is the first book to explicitly address this topic with regard to contemporary Western art, exploring the 'parallel visions of artists and archaeologists' (Renfrew 2003). His article within this volume summarizes many of the ideas presented in *Figuring it Out*, while those by Gosden, Pollard and Watson provide further commentaries on the relationship between art and archaeology. In this contribution I review some of their arguments, agreeing with and developing some of their key points. But I conclude on a note of caution about what I believe to be essential differences between the practice of art and archaeology. My contribution must be placed into the context of how art and archaeology have been interwoven in my own career.

A brief personal reflection

In 1979 I began a degree course at the Slade School of Fine Art with the intention of becoming a sculptor. That was an ambition I had harboured for many years. It did not materialize. I left the Slade after less than a year, and soon found myself working on a dig in Winchester, and then at the Bronze Age site of Douglasmuir, near Arbroath, Scotland. That was my first contact with archaeology; realizing that one could study this subject at University I enrolled for a BA at Sheffield University and have been involved in archaeology ever since. Although my interest in art continued, it has only been with the publication of Colin Renfrew's *Figuring it Out* and the

conference in Cambridge from which this volume has derived, that I have seriously reflected upon whether my own experiences of making art and my (limited) knowledge of contemporary art, have had any impact on my own practice of archaeology and how I believe we can study the past.

While at the Slade I was interested in issues of transformation, destruction, ambiguity and truth. Indeed these themes of work had underlain the work that formed the portfolio of studies I submitted as application to the Slade. I had made several woodcarvings of figures and then either buried them so they rotted away in an unknown place, or burnt them to a charred stub (Plate 11.3). I had also made a series of 'black boxes' which carried labels describing the small sculptures that were contained within — whether the sculptures were actually present or not nobody knew, except for me (Plate 11.1). And even I can no longer remember. Similarly I produced 'paintings' which were then covered by white card just leaving the title that described the hidden painting (if indeed there was a painting); I then produced paintings in which both the image and the title were hidden (if either of them had ever existed).

When I think about such work with the hindsight provided by two decades of studying, teaching and researching in archaeology, the themes contained within such work are evidently resonant with those of prehistory. Archaeologists find the remnants of things that have been buried and decayed; they are often burnt; when archaeologists embark upon an excavation they are unsure of what they might find; quite often this is entirely different from what had been expected from the surface exposures; sometimes there is nothing at all below the ground.

While at the Slade I was profoundly influenced by three artists and their work was instrumental to my own decision to quit (for descriptions of the artists to whom I refer here and elsewhere in my text, I recommend Gresty 1984 and Causey 1998). I often visited the Rothko Room at the Tate. But it was an artwork that one had to pass by on the way to that room that began to haunt me — and still does. This was the photographic record of Keith Arnatt's *Self-Burial*, undertaken in 1969 (Plate 11.4). Nine photographs recorded the gradual disappearance of the artist into the ground. There was, of course, a resonance here with my own inclination to hide things into boxes and the irony of creating works of art that were not visible. In Arnatt's case, however, it was the artist himself who disappeared. Quite why I was so drawn to this

11.1 *Black Box* (1978) by Steven Mithen.

photographic series I remain unsure. Hindsight enables me to see that it has a profound connection with prehistoric archaeology, as in that discipline we deal with people whose remains lie buried below the ground. Nothing states the challenge that archaeologists take upon themselves in starker terms than the first image in the series — Arnatt standing upright upon the ground so that we can see him as a person — and the last image — the surface of the ground below which he is now buried. I suspect, however, that my attention was drawn to 'self burial' because it served as a warning to those who let their own lives become so overwhelmed by art so that their identity becomes entirely subsumed within it.

The second artist(s) by whom I was heavily influenced was Gilbert & George. Having met at St Martin's Art College in 1967, this pair entirely eroded the distinction between 'art' and 'non-art' simply by assuming that their whole lives were a work of art. In this regard they willingly and intentionally engaged in the 'self-burial' within their art that Arnatt had seemed to be warning against. The distinction between 'art' and 'non-art' had been challenged long before by Duchamp in terms of his ready-mades. Gilbert & George's accomplishment was to take this one step further by removing the 'art context', i.e. the gallery, in which Duchamp's found objects had been placed. I had little interest in the specifics of Gilbert & George's life/art; indeed their only art-work/act that I have ever found appealing is their *Singing Sculpture* of 1969 (in which with bronzed faces, white gloves and walking sticks they repeatedly sung Flanagan's and Allan's music hall song 'Underneath the Arches' for eight hours at a time: Plate 11.2). The idea of this art-work (I have not seen it performed) appealed simply because it amused; I found their other activities uninteresting and unmemorable, while their more recent work involving bodily excreta and graffiti I find completely repellent. What attracted me to Gilbert & George in 1979 was simply their demonstration that the boundary between art and life was far more fluid than I had previously assumed.

Richard Long was the third and most significant artist that I encountered in 1979. I saw an exhibition of his photographs and then acquired two slim booklets of these, one entitled *The North Woods*, arising from his Whitechapel

11.2 *The Singing Sculpture* by Gilbert & George.

11.3 *Burning Figure* (1978) by Steven Mithen.

Gallery exhibition of 1977, and the other *Rivers and Stones* arising from an exhibition held in Cornwall in 1978. The photographs were snapshot records of walks that Long had undertaken, often including the subtle alterations he had made to the landscapes he had passed through. Some of the captions contained text describing the activities he had performed or things that he had seen. There is a clear link with Gilbert & George as the boundary between art and non-art is entirely absent within such work, and also with Arnatt as Long is concerned with the landscape and with nature.

I have little understanding of why I find much of Long's work so appealing — not all of it, as I am largely unmoved by his mud-hand prints and gallery installations. As someone who had always enjoyed walking in wild landscapes, including some of those featured in Long's booklets such as

11.4 *Self-Burial* (1969) by Keith Arnatt.

Dartmoor, it may be because his work provides the means to connect this aspect of my life with my interest in art. There is, of course, the compelling manner in which he draws attention to the natural world and materials, to the sheer enjoyment of walking and arranging rocks and sticks. Discovering his work was profoundly important to me, and continues to be so — I still have those two slim booklets on the shelf I reserve for my most treasured items. As a student at the Slade I initially began some pale imitations of Long's work — photographic records of walks through London parks (e.g. a photograph of the ground immediately below my feet every 100 paces). But these were unsatisfactory. Sometime during 1980 I decided to leave the Slade. With the (probably false) *post-hoc* rationalization of hindsight I would explain this as a consequence of the warning from Arnatt of how one's identity can become engulfed by art, the demonstration by Gilbert & George that one does not need the label of 'art' for one's work, and the sheer brilliance of Richard Long — having seen some of his work there seemed to be nothing left for me to do.

Making subtle and reversible changes to the landscape

In 1984 I arrived in Cambridge to undertake a PhD in archaeology and had the pleasure of my first interview with Colin Renfrew in the office of the Disney Professor. I was understandably astonished to see that sitting on the filing cabinet there was a photograph of one of Richard Long's pieces — I think it was a stone line in the Himalayas (see Plate 2.2). I had already been aware of Renfrew's interest in contemporary art as a few days before I had cycled through pouring rain to attend a talk by an artist at Kettle's Yard Gallery. I arrived late and the talk had begun. I then proceeded to disturb everyone by removing my waterproofs with unavoidable rustles and felt that my hoped for Cambridge career was fatally blemished before it had begun when I noticed that one of those who looked understandably annoyed was Colin Renfrew.

As explained in *Figuring it Out*, Colin Renfrew is also a devotee of Richard Long and eloquently describes how he has been influenced as an archaeologist. Writing about his work on Neolithic burial mounds, Renfrew explains that 'Through Long's work I see these prehistoric monuments more clearly as works of deliberation, and as assertions of the intention that the presence of their makers should be seen, known, accepted . . . and remembered' (Renfrew 2003, 38). Renfrew goes on to explain how via Long's work he feels better able to appreciate the sheer physical and mental sensations that are invoked in him by such monuments, and perhaps also in those who lived in prehistory.

I suspect Richard Long's work has this impact on many archaeologists. But to me this is of less importance that two other ways his work has influenced my own archaeological thought and practice. The first concerns excavation. I find there is a resonance between many of the constructions that Long leaves in the landscape and that of an abandoned and back-filled trench.

Long's constructions are subtle and often geometric — lines or circles of stones and sticks. The geometry is evidently imposed by a human hand but is temporary; over time it will be lost by the action of wind and rain, by frost and the processes of decay. Eventually there will be no evidence that a man-made construction had ever been present. It is strangely similar with a trench, especially if, like me, one chooses to excavate in wild landscapes similar to those with which Long engages. Once back-filled, a geometric pattern is still evident as the sods of turf leave the

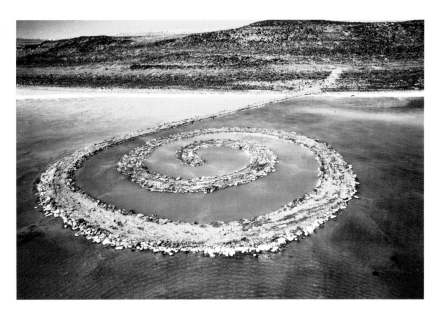

trench outline and the rectangular shape of each sod is perceptible. But as time passes, the sods knit together, new grass grows and eventually the trace of the trench will disappear, either entirely or to leave a form that might have been formed by nature alone. I was especially struck by this a few days after the Cambridge conference when visiting the site of Bolsay Farm on the Isle of Islay. One of my own trenches had been rather poorly back-filled at that site in August 1992, leaving an unfortunate scar in the field of pasture. But in April 2003 there was no trace of it at all — the Hebridean sun, wind and rain, grazing sheep and cattle, earthworms and processes of plant growth and decay had removed the unnatural geometry, just as Richard Long invites the elements to do to his own constructions.

One might argue that all Land Art (or Earth Art) has this resonance with archaeology. Certainly one could compare the *Spiral Jetty* of Robert Smithson (Plate 11.5) or the *Double Negative* of Michael Heizer with either the great monuments produced during prehistoric times or the large-scale excavations that some archaeologists have undertaken. But neither have the same impact on my own thought as the smaller and more subtle work of Richard Long, perhaps because I feel that archaeologists have an obligation to leave behind a minimal sign of their presence.

The significance of walking

Long's work has a second resonance with the discipline of archaeology, at least with how I undertake it. This is the significance it attaches to walking. Many of Long's engagements with the world are specifically about walking, epitomized by his 1967 *A Line Made by Walking* (which was literally that, made within an English meadow). Other pieces are described by maps and have titles that explicitly refer to walking, such as 'a hundred mile walk along a straight line in Japan', illustrated by a misty photograph of woodland in *The North Woods*. In one of his few recorded statements about the significance of

11.5 *Spiral Jetty* (April 1970) by Robert Smithson.

walking Long has explained that the walk is a 'mark laid upon thousands of other layers of human and geographic history on the surface of the land' (cited in Gresty 1984), a view which prehistorians will readily understand. But prehistorians also place their own significance on walking. Those dealing with human evolution are placing ever greater importance on the origin of bipedalism as the precursor to the evolution of a large brain, creative intelligence and language. Walking is quite literally what made us human. And walking is essential to the practice of archaeology, as this is a key means by which artefacts and sites are discovered.

Those archaeologists who study prehistoric hunter-gatherers have a particular concern with walking because of the highly mobile nature of that way of life and hence the need to adopt a landscape approach to archaeological fieldwork. Whether by systematic field walking or visiting caves, raised beaches and other likely features of site location, walking is an essential archaeological technique. But it is also far more than this because it can provide an insight into hunter-gatherer lives that cannot be gained by any other means. Even though there may have been substantial changes in vegetation, landform and climate, the distances between contemporary settlements and the type of topography that has to be covered often remain similar to those experienced by prehistoric hunter-gatherers. Walking the landscape, just as Mesolithic and Palaeolithic people had to do, is an essential means of enabling one to think cogently about those past lives.

The precise significance of such walking for a final archaeological report is unclear. During the eight years that I undertook survey and excavation for Mesolithic sites in the Southern Hebrides I spent a great deal of time walking the landscape, sometimes visiting specific localities, sometimes walking between specific sites, but often simply as a means to gain a better appreciation of the landscape. Whether or not this improved the final report, I remain unsure. But I felt it essential to record the significance that walking in the Hebrides had for me in the final chapter of that report:

> if we are to gain insight into the Mesolithic experience the key is not to sit still
> but to be mobile. The key is to leave the sites, to get walking . . . Do that and
> one can begin to engage with the Mesolithic experience, engage in a more
> profound manner than one can by studying any number of lithic reports,
> pollen diagrams and site plans (Mithen 2000, 632).

The fact that this is possible relies on a belief that all humans share not only a common physiology but also perceptual and cognitive features; if one denies this then any hope of engaging with the experience of past people is entirely lost. This is, of course, the inherent contradiction of post-modernist archaeologists who believe that all is relative but also wish to write about human experience in the past under-cover of a phenomenological approach.

I have recently tried to use the process of walking as a means to help write prehistory. When I embarked upon writing *After the Ice* (Mithen 2003), a history of the world between 20,000–5000 BC, the text was initially little more

than a description of one site after another; it was a long and rather dull compendium of archaeological excavations. Even translating some of those descriptions into imaginative reconstructions of living settlements was insufficient. But when I experimented with sending an imaginary traveller walking (and sometimes canoeing) between those settlements, I found the text became more compelling to write and to read, especially for those who are not academics by profession. In this case walking is used as a literary device to provide a narrative for what would otherwise by a catalogue of archaeological sites. It is also used to stress the centrality of walking to early prehistoric life and to archaeological practice (see especially Mithen 2003, 116). I think that Richard Long's work is telling us just the same but on a much larger scale: appreciate walking and one appreciates what it is to be a human being.

Unlearning

Walking can be as much about unlearning as learning; we think we understand a landscape but as we walk through it we shed our preconceptions and acquire the type of knowledge that can only come from a direct engagement with the natural world. This, of course, is precisely what we cannot do with the prehistoric past — our minds are full of preconceptions built up by our experience of the modern world that can never be entirely shed. Good archaeologists attempt to do so, or at least to become more aware of their own biases, by adopting explicit procedures that reduce the extent of unintended subjectivity when interpreting archaeological remains. The techniques of archaeological science also contribute as they continue to provide new levels of detail about past lives, things which we had previously just to guess about.

Art, especially much of contemporary art, provides a further means by which we can unlearn and become more effective archaeologists. Chris Gosden expressed this very effectively at the Cambridge meeting: 'The attempt to appreciate the sensory worlds of others, distant in time and place, necessitates an unlearning: that we subject to scrutiny our sensory education of which the prejudice towards vision is only one part'. A classic example of this is how we interpret art itself, the art made in prehistory, and especially the painted caves of Ice Age France and Spain.

Although the specific interpretations of the paintings within Lascaux, Altamira and other cases have varied from 'art for art's sake' to 'hunting magic', 'fertility magic', 'information storage' and the like, all of these have focused on the finished image itself, implicitly assuming that the caves were equivalents to art galleries. Sometimes this became explicit, such as when the painted ceiling at Altamira was called the 'Sistine Chapel of Prehistory'. The presence of walls with many super-imposed paintings led some to question the notion of the 'art gallery' viewpoint, acknowledging that the performance of making the image may have been of more significance that the image itself. But this was marginalized in the face of claims by Leroi-Gourhan of cultural

rules regarding how specific types of animals and abstract images had to be placed in specific parts of the caves (rather like artworks in a medieval cathedral), and the presentation of cave paintings in books as glossy images devoid of all context, as if they were Renaissance master pieces.

Unlearning this perspective on Ice Age cave paintings has been a gradual development during the late twentieth and early twenty-first centuries. Archaeologists became more aware of non-western art traditions and treated them with proper academic respect (rather than the derogatory imperialist views of the late nineteenth century), while the application of scientific techniques have provided absolute dates and pigment analysis leading to an appreciation of the longevity and complexity of Ice Age art. But unlearning has also been facilitated by the practices of modern Western artists, themselves influenced by non-Western art. It is ironic that as Breuil was imposing the 'art gallery' perspective on Ice Age art during the 1950s, Jackson Pollock was undertaking his action paintings in New York (Plate 11.6). When I first saw a film of Pollock at work (sometime in the late 1970s) I was struck by how the act of creating his paintings, with its ritualistic connotations, was at least as important to him as the finished works themselves. This has always seemed to me as the key to understanding much of Palaeolithic art, one that is now recognized within the shamanistic interpretations that are currently so popular (e.g. Lewis-Williams 2002). I suspect that more attention to how recent Western painters have undertaken their work, especially the Abstract Expressionists, will be beneficial to our thought about Palaeolithic cave art.

Learning

Many aspects of prehistoric life are entirely unfamiliar to archaeologists today and contemporary art can facilitate their understanding. Few of us work with natural materials — chipping and grinding stone, twisting and knotting plant fibres, making mud bricks and *pisé* walls. Experimental archaeology is invaluable in helping us to understand the technical aspects of these activities but often serves to maintain our preconceptions about how such materials can be used. Artists can help us think anew. Josh Pollard identified this within his presentation: 'art has the potential to inform our understanding of materiality, if only by creating an intellectual space in which to think through the materialness of human and artefacts existence'.

As an illustration of this, consider the type of organic artefacts that derive from water-logged Mesolithic sites in northwest Europe. Many of these are no more than fragments but they provide a glimpse into the use made of

11.6 *Summertime No. 9A* (1948) by Jackson Pollock.

organic materials: wicker cages woven from branches of cherry wood, alder and pine roots; willow bark braided and tied to make fishing nets; canoes hollowed from logs of lime and paddles carved from ash; hazel rods used for fish traps; birch bark folded and sewn into bags for carrying flint blades (for a sample of vegetable-material, Mesolithic artefacts, see Burov 1998). The risks in making such impressive discoveries are two-fold; first, one is tempted to be so impressed that one forgets that even these are likely to be no more than the remnants of a far more extensive use of natural materials; second, archaeologists devote so much time to debating the function of such artefacts, such as whether wicker cages were fish traps or baskets, that they are liable to forget about their social and aesthetic qualities.

To avoid succumbing to such risks, archaeologists can ensure they are familiar with the work of artists such as Andy Goldsworthy. His work with leaves, thorns, stones, petals, snow, ice, sand, earth, light, and other natural materials has characteristically produced objects with four qualities: 1) they have no functional value; 2) they require high levels of technical skill and considerable time to produce; 3) unless cared for, they are ephemeral — they will rot, melt or be blown away; and 4) they are astonishingly beautiful to look at. These qualities are epitomized is his *Sweet Chestnut Green Horn* (Plate 11.7) made in the Yorkshire Sculpture park on 9 August 1987 — a continuous spiral of leaves with each laid in the fold of another and stitched together with thorns (see Goldsworthy 1990 for a splendid collection of photographs of this and other works). By looking at the Mesolithic artefacts with such 'Goldsworthy objects' in mind, one is reminded of what might be missing (leaves stitched on with thorns, colourful petals stuck on with sap) and that concerns with aesthetics may have been as important as functionality when such artefacts were originally made. More generally, Goldsworthy helps archaeologists create for themselves the 'intellectual space' required to think about the use of natural materials, and to sense the intimacy with the natural world that was part of prehistoric life and which is entirely lost to the vast majority of us today. One cannot help but feel that prehistoric people were doing the same as Goldsworthy when he states that 'working with nature means working on nature's terms . . . Movement, change, light, growth and decay are the lifeblood of nature, the energies that I try to trap through my work. I want to get under the surface' (Goldsworthy, cited by Josh Pollard, this volume).

Archaeologists have similar lessons to learn from other artists. Fat is a substance that many of us are unfamiliar with today and one that tends to

11.7 *Sweet Chestnut Green Horn* (1987) by Andy Goldsworthy.

carry wholly negative connotations. But those who lived as prehistoric hunter-gatherers and subsistence farmers are likely to have had a quite different relationship with this substance — its feel, smell and taste are likely to have been familiar and valued. We can, perhaps, find some help in appreciating the significance of fat via the work of Joseph Beuys. He was a German performance artist who became particularly renowned during the 1960s. Fat played a vital role in many of his artworks, notably his *Fat Chair* of 1963 (which had a large wedge of fat placed upon a chair). Beuys claimed that he was drawn to fat owing to his wartime experience: the Crimean Tartars had rescued him from the wreckage of his Junkers aircraft in 1944 and wrapped him in fat and felt to conserve his body heat. As a consequence these substances became pivotal to Beuys's work as symbols of the gift and conversation of life. By viewing the work of artists such as Beuys, archaeologists may gain a better appreciate of the significance of substances that leave no archaeological trace, that may have been central to prehistoric life, and about which cultural views may have changed substantially.

While fat rarely enters into archaeological dialogues, stone is more frequently discussed. Those who study megalithic tombs have made considerable progress in understanding how the immense slabs of stone used for walls and portals were likely to have been of far more significant than mere building blocks. Chris Scarre (DeMarrais *et al.* in press) provided a powerful argument that this was the case from tombs in northern and southwest Europe at the 'Rethinking Materiality' symposium in Cambridge (Demarrais *et al.* in press). He explained how archaeologists must seek to understand the 'prior associations' of the stone slabs if we are to appreciate the meaning of megalithic tombs. Once again, archaeologists can benefit here by appreciating the work of artists who have worked with stone slabs of megalithic proportions and drawn attention to the manner in which these sit at the interface between nature and culture; Richard Long can be invoked again but Ulrich Rückriem is perhaps a better example (Plates 11.8 & 11.9). He was a stone mason at Cologne Cathedral before becoming a sculptor. Some of his works involve the display of stone slabs that look entirely natural but which carry the marks from wedges that had been used to split and shape the slabs.

11.8 *Untitled* (2003) by Ulrich Rückriem. Installation view at Donald Young Gallery.
Rosa Porinjo Granite. Four parts: Four parts: approximately 30 h x 41 x 196 ³/₄ inches, each (70 h x 100 x 500 cm each). Photo credit: Tom Van Eynde. Courtesy the artist and Donald Young Gallery, Chicago.

The work of both Goldsworthy and Rückriem are as much about the transformation of materials as the materials themselves. Josh Pollard's presentation at the conference (this volume) was quite right to highlight the value of artists undertaking such work as material transformations are increasingly being recognized as a key element of prehistoric ritual. He used the example of Cornelia Parker's art-works, also described by Renfrew (this volume), and found a resonance between her concern with how the process of destruction transforms materials into a different forms and substances, and Neolithic burial ritual that appears to have involved deliberate burning and breakage of artefacts. As Pollard stated, 'rarely do we consider that some things were perhaps intended to break and decay as a part of their role in social practices, and that such transformation might have carried with it positive connotations'. In this regard, Parker's work appears to be most effective at directing archaeologists' attention to previous neglected aspects of human activity.

Pollard might have equally chosen examples from Goldsworthy's repertoire in which we see transformations of material such as soft leaves into quite unnatural forms, such as those usually associated with hard shells. Here one is immediately reminded of how stone was sometimes carved in prehistory to mimic other materials, such as prestigious metal artefacts. By being aware of the importance that artists such as Parker, Beuys and Goldsworthy place on the process of material transformation, archaeologists may appreciate that these had a greater significance in the past than they previously believed, which will in turn influence how they excavate and interpret prehistoric sites.

Communicating about the past: art or archaeology?

Archaeologists can learn from artists about new methods for communicating their ideas to academic colleagues and the general public, methods that go beyond the traditional lecture, academic paper or book. I have already commented how I have myself experimented with the use of a narrative based upon a walk as a means to write prehistory, this partly from the significance I place on walking as partly acquired from the work of Richard Long. But here I am thinking of how archaeologists may wish to use entirely different forms of

11.9 *Untitled* (2003) by Ulrich Rückriem. Detail.
Rosa Porinjo Granite. Four parts: Four parts: approximately 30 h x 41 x 196 ³/₄ inches, each (70 h x 100 x 500 cm each). Photo credit: Tom Van Eynde. Courtesy the artist and Donald Young Gallery, Chicago.

dialogue from the written word, such as video and performance. There is unquestionably a need for archaeologists to improve how they communicate about the process of archaeology and their understanding of the past. Some steps in this direction have already been taken, such as the interactive websites increasingly being used by on-going field projects.

Aaron Watson's presentation at the Cambridge meeting (see this volume) was on this theme and he succinctly captured the dilemma that many archaeologists face: 'How do we translate our embodied and subjective multisensory engagements with the archaeological record into established modes of academic discourse'? His presentation concerned Avebury and involved a combination of exquisite photographs, lecture and performance as a means to answer this question. He certainly achieved some success and I was left with a better appreciation of how he has experienced the Avebury monument on his many visits. I am sure that this will influence the manner in which I will experience the monument on my next visit.

The question that one is bound to ask, however, is whether Watson is now working as an artist drawing upon archaeological materials, just as Paul Nash had once done, rather than an archaeologist who is making use of the types of discourse normally reserved for art. I tend to think the former. His concern seems to be merely with the expression of his own experiences as opposed to discovering something about the past itself or the experiences of those who lived in the past. This marks the critical boundary between art and archaeology.

The essential difference

In all of my above remarks I have made clear that I see a vast overlap in the activities that fall under the titles of 'art' and 'archaeology'. Both of these can involve making subtle modifications of the landscape, the exploration of natural materials and processes of change; both are ultimately concerned with asking questions about the nature of the human condition. But there is a fundamental difference. Archaeology seeks to discover what happened in the past, when it happened and why in the form of objective knowledge. The fact that objectivity may be an unobtainable goal is not the issue: it is the quest to attain it within the theoretical and historical context within which one works that is significant. Archaeologists have a responsibility to make statements that go beyond one's own personal experiences and subjective beliefs; artists have no such constraints — it is legitimate for them to indulge in self-expression. Indeed this is what they are supposed to do.

The essential difference between art and archaeology is curiously encapsulated in the title of Colin Renfrew's recent volume, *Figuring it Out* (Renfrew 2003). He suggests that the need to figure out what one is looking at is a common experience for those who are faced with a monument from prehistory or a work of contemporary art. This can indeed be the case. The difference, however, is that whereas 'figuring it out' is an obligation for an archaeologist when faced with a prehistoric monument (or any assemblage of

archaeological evidence), there is no such obligation when viewing a work of contemporary art. Indeed 'figuring it out' is often precisely what we should *not* be doing — an emotional rather than an analytical response is the most appropriate when faced with a work by Long, Goldsworthy or any other artist. One can try to 'figure them out' — what meaning lies behind a line of sticks, a lump of fat placed upon a chair, or a construction of woven leaves — but there is no necessary obligation to do so. Conversely, archaeologists certainly have emotional responses to monuments and other types of archaeological evidence, but it is their analytical, 'figuring it out' response that is of most significance and which they are obliged to undertake.

As I explained above, the occasion of this Cambridge conference and the publication of Renfrew's *Figuring it Out*, has been the cause of some personal reflection about how art and archaeology have interwoven themselves throughout my own career. *Figuring it Out* is a profoundly important book and many of the arguments I have made above are done so at much greater length and with much more extensive knowledge about both art and archaeology by Colin Renfrew. The precise manner in which contemporary art influences the archaeology that any one of us undertakes will inevitably be a personal issue: my concern with Palaeolithic art drew me to Pollock — or perhaps it was the other way round — and with hindsight I suspect that seeing the depiction of Keith Arnatt's self-burial in the Tate was seminal in the change of direction of my own life from art to archaeology.

The resonances which we find between the processes of archaeology and the making of art, and those between the activities of prehistoric people and contemporary artists, may be of no great significance. It may indeed be the case that, as Renfrew explained, when archaeologists enter the world of Cornelia Parker they find a universe parallel to their own. But so what? It certainly is interesting and reassuring, something to enjoy and reflect upon. But does it ultimately help us understand the past? Perhaps. The work of contemporary artists may direct archaeologists into viewing the past and their archaeological practice in one manner rather than another. But so too do many other influences — political prejudices, theoretical persuasions, educational history. In this respect contemporary art has no more and no less to offer archaeologists than has any other types of work within the natural and social sciences, or any other activities that people engage in, such as sport, warfare, politics and music-making. Inspiration and ideas, learning and unlearning, may be forthcoming from all of these. Ultimately archaeologists have to take responsibility for their own archaeology and seek to fulfil the remit of understanding the past that they take upon themselves. We can never be entirely sure of why we hold one view about the past rather than another, or adopt one method of working rather than an alternative. I remain unsure whether Arnatt, Gilbert & George, and Long were influences on my decision to practise archaeology and how I go about doing so. Our own pasts, as well as that of prehistory, are shrouded in mystery and unknowns.

Acknowledgements

I am most grateful to Chris Gosden, Elizabeth DeMarrais and Colin Renfrew for inviting me to the 'Art as Archaeology and Archaeology as Art' meeting and allowing me the indulgent pleasure of reflecting on my own engagement with art and archaeology.

References

Burov, G.M., 1998. The use of vegetable materials in the Mesolithic of northeast Europe, in *Havesting the Sea, Farming the Forest*, eds. M. Zvelebil, R. Dennell & L. Domańska. Sheffield: Sheffield University Press, 53–64.

Causey, A., 1998. *Sculpture since 1984*. Oxford: Oxford University Press.

DeMarrais, E., C. Gosden & C. Renfrew (eds.), in press. *Rethinking Materiality: the Engagement of Mind with the Material World*. (McDonald Institute Monographs.) Cambridge: McDonald Institute for Archaeological Research.

Goldsworthy, A., 1990. *Andy Goldsworthy*. London: Penguin Books.

Gresty, H. (ed.), 1984. *1965 to 1972: When Attitudes became Form*. Cambridge: Kettle's Yard Gallery.

Lewis-Williams, D., 2002. *The Mind in the Cave*. London: Thames & Hudson.

Mithen, S., 2000. *Hunter-Gatherer Landscape Archaeology: the Southern Hebrides Mesolithic Project 1988–1998* (2 vols). (McDonald Institute Monographs.) Cambridge: McDonald Institute for Archaeological Research.

Mithen, S., 2003. *After the Ice: a Global Human History, 20,000–5000 BC*. London: Weidenfeld & Nicolson.

Renfrew, C., 2003. *Figuring it Out*. London: Thames & Hudson.

Illustration sources

Cover
Simon Callery. *Trench 10* (detail). Photograph ©John Riddy 2003.

Frontispiece
Field for the British Isles by Antony Gormley. Photo by Jan Uvelius. ©Antony Gormley.

Chapter 1 Introduction
1.1 *Monsieur Plume with Creases in his Trousers (Portrait of Henri Michaux)* (1947) by Jean Dubuffet. Image courtesy of Tate Modern. ©ADAGP, Paris and DACS, London 2004.
1.2 *Two colossal statues of Amenophis III, Thebes, Egypt.* ©Photo by Barry Kemp.
1.3 *Bicycle Wheel* (1913) by Marcel Duchamp. ©Succession Marcel Duchamp / ADAGP, Paris and DACS, London 2004.

Chapter 2 Art for archaeology
Colin Renfrew wishes to thank Dale McFarland of the Frith Street Gallery, London, for much-valued assistance in obtaining illustrations of the work of Cornelia Parker, and David and Lesley Mach for providing Plate 2.3. For permission to reproduce images he thanks: Richard Long for Plate 2.2, David Mach for Plate 2.3, Antony Gormley for Plate 2.1, Chris Evans for Plates 2.10–2.11 and Cornelia Parker for Plates 2.4–2.9 and 2.12.
2.1 *Learning to Be* (1992) by Antony Gormley in the grounds of Jesus College, Cambridge. Photo by Colin Renfrew.
2.2 *A Line in the Himalayas* (1975) by Richard Long. ©Richard Long.
2.3 Study for *The Trophy Room* (1995) by David Mach. ©David Mach.
2.4 *Cold Dark Matter — An Exploded View* (1991) by Cornelia Parker. Courtesy of Frith Street Gallery, London. ©Cornelia Parker.
2.5 *Mass (Colder, Darker Matter)* (1997) by Cornelia Parker. Courtesy of Frith Street Gallery, London. ©Cornelia Parker.
2.6 *Thirty Pieces of Silver* (1989) by Cornelia Parker (work in progress). Courtesy of Frith Street Gallery, London. ©Cornelia Parker.
2.7 *Thirty Pieces of Silver* (1989) (detail) by Cornelia Parker. Courtesy of Frith Street Gallery, London. ©Cornelia Parker.
2.8 *Avoided Object* (1995) by Cornelia Parker. Courtesy of Frith Street Gallery, London. ©Cornelia Parker.
2.9 *Wedding Ring Drawing (circumference of a living room)* (1996) by Cornelia Parker. Courtesy of Frith Street Gallery, London. ©Cornelia Parker.
2.10 Cornelia Parker in action at the excavations at Wardy Hill Ringwork in 1992. ©Courtesy of Christopher Evans.
2.11 Flag-ringed clay lump: an 'experiment' by Cornelia Parker at the Wardy Hill Ringwork excavations. ©Courtesy of Christopher Evans.
2.12 *Negatives of Whispers* (1997) by Cornelia Parker. Courtesy of Frith Street Gallery, London. ©Cornelia Parker.

Chapter 4 The art of decay
4.1 *Snowballs* (after Goldsworthy 2001). ©Drawing by Joshua Pollard.
4.2 *Thirty Pieces of Silver*, detail (after Parker 1996). ©Drawing by Joshua Pollard.
4.3 *Transformed Matter*, midden material in the ditches of the Windmill Hill enclosure (after Whittle *et al.* 1999). ©Drawing by Joshua Pollard.
4.4 *Recombined Matter*, a hybrid Körös figurine (after Korek 1972). ©Drawing by Joshua Pollard.

Chapter 5 Segsbury Project
5.1 Simon Callery. *Archive*. Oil on canvas. 253 × 360 cm. 1996. Collection: Tate, London. Photograph ©Andrew Crowley 1997.
5.2 Callery & Watson. *The Segsbury Project* (work in progress) 1996. Photograph ©Andrew Watson 1996.
5.3 Callery & Watson. *The Segsbury Project* overview. 378 joined black & white contact prints. 86 × 144.5 cm. 1996–1997. ©Simon Callery.
5.4 Callery & Watson. *The Segsbury Project* plan chests detail. Photograph ©Andrew Watson 2003.
5.5 Callery & Watson. *The Segsbury Project*. 1996–1997. Seven plan chests containing 378 black & white photographic prints. 165.5 × 931 × 70 cm. Photograph ©John Riddy 2003.
5.6 Simon Callery. *Trench 10* (detail). Photograph ©John Riddy 2003.
5.7 Installation view of Segsbury Project exhibition, Dover Castle, 2003. Photograph ©John Riddy 2003.
5.8 Simon Callery. *Trench 10*. Chalk, plaster and wood. 224 × 1919 × 513.5 cm. 2000–2003. Photograph ©John Riddy 2003.
5.9 Simon Callery. *Trench 10* surface detail. Photograph ©John Riddy 2003.
5.10 Installation view at Dover Castle of archaeological context for Segsbury Project exhibition. Photograph ©John Riddy 2003.
5.11 Simon Callery. *Flake White Entasis*. 2001. 329 × 192 cm. Oil & pencil on canvas with wood sub-frame. Photograph ©John Riddy 2003.
5.12 Simon Callery. *Fabrik*. 2000. 209 × 540 cm. Oil & pencil on canvas with wood sub-frame. Photograph ©John Riddy 2003.
5.13 Simon Callery. *Porch*. 2003. 439 × 221 cm. Oil & pencil on canvas with wood sub-frame. Photograph ©John Riddy 2003.

Chapter 6 Making space for monuments
6.1 The intensity of sound within Easter Aquorthies contrasted against open ground (after Watson & Keating 1999, fig. 2). ©Aaron Watson.
6.2 A selection of imagery from an audio-visual presentation (after Watson & Was 1999). ©Aaron Watson.
6.3 The mountain environment near to the Cumbrian stone axe sources. ©Aaron Watson.
6.4 The view over a stone scatter, Bowfell, Cumbria (1995). ©Aaron Watson.
6.5 *Stone Axe Sources and the Elements, Scafell Pike, Cumbria* (1995). ©Aaron Watson.
6.6 *Being in the Neolithic World: Cumbria* (2002). ©Aaron Watson.
6.7 Avebury from the southwest. ©Aaron Watson.
6.8 A plan of Avebury (after Watson 2001a, fig. 2). ©Aaron Watson.
6.9 A schematic representation of the circular view from the North Inner Circle within Avebury. ©Aaron Watson.
6.10 A schematic view from Avebury contrasted against control samples placed systematically in the wider landscape. ©Aaron Watson.
6.11 Schematic views from different monuments in the Avebury region. ©Aaron Watson.
6.12 *Transforming Monolith, Ring of Brodgar* (2002). ©Aaron Watson.
6.13 What shape is this stone? ©Aaron Watson.
6.14 *Photomontage of Avebury* (2003). ©Aaron Watson.

Chapter 7 *House Beautiful* and *The pot, the flint and the bone*

7.1–7.3 *The pot, the flint and the bone* ©The authors.

7.4 *House Beautiful.* ©The authors.

Chapter 8 Unearthing displacement

8.1a *The Last Defenders of Maiden Castle* (c. 1935) by Paul Nash. From *Country Life* (83) 1938.

8.1b *Found Objects Interpreted: Encounter of the Wild Horns* by Paul Nash, exhibited at the Redfern Gallery, London, 1937. From *Country Life* (82) 1937.

8.2a Title page of *Documents* (1930).

8.2b Title page, *International Surrealist Bulletin*, September 1936 (showing a Surrealist 'event' in front of the National Gallery, Trafalgar Square, London).

8.2c Reconstruction of the International Surrealist Exhibition, London, 1936.

8.3a Paul Nash's low-angle photograph of the Uffington Horse in 'Unseen landscapes' article, *Country Life*, 1938. From *Country Life* (83) 1938.

8.3b *The Vale of the White Horse* (1939) by Eric Ravilious, watercolour. ©Tate, London.

8.4 Double-page illustration in Piper's 'Prehistory from the air' article in *Axis*, 1937.

Chapter 9 Art of war

9.1 Two First World War French 75 mm artillery shells decorated with art nouveau floral motifs. ©Nicholas Saunders.

9.2 First World War artillery shell-case vase depicting a nude woman and floral motif in art nouveau style. Photo by Nicholas Saunders. ©Nicholas Saunders.

9.3 *The Card Game/The Card Party* (1917) by Fernand Léger. 129.5 × 194.5 cm, oil on canvas. Collection Kröller-Müller Museum, Otterlo, The Netherlands. Cat nr. 444 (Schild./ Paintings 1970) ©Kröller-Müller Foundation.

9.4 *Officer and Signallers* (1918) by Percy Wyndham Lewis, in which the figures appear almost as 3-D polished-brass trench-art sculptures. ©Imperial War Museum.

9.5 First World War trench art exhibited at the Salles du Jeu de Paume, Tuileries, in Paris in 1915 organized by the magazine *Le Pays de France*. Photo by Nicholas Saunders. ©Photo Nicholas Saunders.

9.6 'Victory Bell' depicting Stalin. Photo by Nicholas Saunders. ©Nicholas Saunders.

9.7 Distinctive 'Black and Gold' style artillery shell case from the 1992–5 Bosnian War. Photo by Nicholas Saunders. ©Nicholas Saunders.

Chapter 10 Art as process

10.1–10.4 *Another Place* by Antony Gormley, De Panne, Belgium. Photos by Antony Gormley. ©Antony Gormley.

10.5–10.7 *Another Place* by Antony Gormley, De Panne, Belgium. Photos by Antony Gormley. ©Antony Gormley.

10.8 *Another Place* by Antony Gormley, Norway. Photo by Antony Gormley. ©Antony Gormley.

10.9–10.11 *Another Place* by Antony Gormley, Norway, showing how the iron has spalled over time. Photos by Antony Gormley. ©Antony Gormley.

10.12 *Insider V* by Antony Gormley. Photo by Stephen White. ©Antony Gormley.

10.13 Casting *Critical Mass* at the Hargreave Foundry, Halifax. Photo by Elfi Tripamer. ©Antony Gormley.

10.14 A bodyform being revealed from the sand matrix. Photo by Elfi Tripamer. ©Antony Gormley.

10.15 *Critical Mass* at the Royal Academy, London. Photo by Antony Gormley. ©Antony Gormley.

10.16–10.18 *Critical Mass* at the Royal Academy, London. Photos by Antony Gormley. ©Antony Gormley.

10.19 Rollright Stone. Photo by Antony Gormley. ©Antony Gormley.

10.20 Tumulus. Photo by Antony Gormley. ©Antony Gormley.

10.21 *Third Tree*. Photo by Antony Gormley. ©Antony Gormley.

10.22–10.23 *Full Bowl* by Antony Gormley. Photo by Stephen White. ©Antony Gormley.

10.24 *Natural Selection* by Antony Gormley. Photo by Antony Gormley. ©Antony Gormley.

10.25 *Room* by Antony Gormley. Photo by Antony Gormley. ©Antony Gormley.

10.26 *Bed* by Antony Gormley. Photo by Antony Gormley. ©Antony Gormley.

10.27 *Heavy Stone* by Antony Gormley. Photo by Antony Gormley. ©Antony Gormley.

10.28 A typical day in the studio. Antony Gormley being covered in plaster. Photo by Elfi Tripamer. ©Antony Gormley.

10.29 *Land, Sea and Air II* by Antony Gormley. Photo by Antony Gormley. ©Antony Gormley.

10.30 *Learning to See* by Antony Gormley. Photo by Antony Gormley. ©Antony Gormley.

10.31 *Sense* by Antony Gormley. Photo by David Ward. ©Antony Gormley.

10.32 *Learning to Think* by Antony Gormley. Photo by Antti Kuivalainen. ©Antony Gormley.

10.33 *A Room for the Great Australian Desert* by Antony Gormley. Photo by Antony Gormley. ©Antony Gormley.

10.34 *Allotment* by Antony Gormley. Photo by Jan Uvelius. ©Antony Gormley.

10.35 *Field for the British Isles* by Antony Gormley. Photo by Jan Uvelius. ©Antony Gormley.

10.36 *Field for the British Isles* by Antony Gormley. Photo by David Ward. ©Antony Gormley.

Chapter 11 Contemporary Western art and archaeology

11.1 *Black Box* (1978) by Steven Mithen. Photo by Steven Mithen. ©Steven Mithen.

11.2 *The Singing Sculpture* by Gilbert & George. Sonnabend Gallery, New York 1991. ©the artists. Courtesy of Jay Jopling/White Cube (London).

11.3 *Burning Figure* (1978) by Steven Mithen. Photos by Steven Mithen. ©Steven Mithen.

11.4 *Self-Burial* (1969) by Keith Arnatt. Photo courtesy of Tate Modern. ©Tate, London 2004.

11.5 *Spiral Jetty* (April 1970) by Robert Smithson. Great Salt Lake, Utah. Black rock, salt crystals, earth, red water (algae). $3^1/_2 × 15 × 1500$ feet. ©Estate of Robert Smithson/licensed by VAGA, New York/DACS, London 2004. Courtesy James Cohan Gallery, New York. Collection: DIA Center for the Arts, New York. Photo by Gianfranco Gorgoni.

11.6 *Summertime No. 9A* (1948) by Jackson Pollock. Image courtesy of Tate Modern. ©ARS, NY and DACS, London 2004.

11.7 *Sweet Chestnut Green Horn* (1987) by Andy Goldsworthy. ©Andy Goldsworthy.

11.8 *Untitled* (2003) by Ulrich Rückriem. Installation view at Donald Young Gallery. Rosa Porinjo Granite. Four parts: Four parts: approximately 30 h × 41 × 196 ³/₄ inches, each (70 h × 100 × 500 cm each). ©Photo credit: Tom Van Eynde. Courtesy the artist and Donald Young Gallery, Chicago.

11.9 *Untitled* (2003) by Ulrich Rückriem. Detail. Rosa Porinjo Granite. Four parts: Four parts: approximately 30 h × 41 × 196 ³/₄ inches, each (70 h × 100 × 500 cm each). ©Photo credit: Tom Van Eynde. Courtesy the artist and Donald Young Gallery, Chicago.